Sony® α
DSLR-A700
Digital Field Guide

Sony® α DSLR–A700 Digital Field Guide

Alan Hess

WILEY

Wiley Publishing, Inc.

Sony® α DSLR-A700 Digital Field Guide

Published by
Wiley Publishing, Inc.
10475 Crosspoint Blvd.
Indianapolis, IN 46256
www.wiley.com

ISBN: 978-0-470-27031-8

Manufactured in the United States of America

10 9 8 7 6 5 4 3 2 1

For general information on our other products and services or to obtain technical support, please contact our Customer Care Department within the U.S. at (800) 762-2974, outside the U.S. at (317) 572-3993 or fax (317) 572-4002.

Wiley also publishes its books in a variety of electronic formats. Some content that appears in print may not be available in electronic books.

Library of Congress Control Number: 2008925790

WILEY

About the Author

Alan Hess is a freelance photographer based in San Diego, California. He has done commercial photography on a wide variety of subjects, from guitar manufacturing to a clothing catalog for women's workout wear. His concert and backstage images have appeared in numerous online and print publications and have been used for promotional purposes and music packaging.

Alan is a key contributor to the Lexar Pro Photographer Web site and has written articles on concert photography and technology.

Alan can be contacted through his Web site www.alanhessphotography.com.

Credits

Acquisitions Editor
Courtney Allen

Senior Project Editor
Cricket Krengel

Technical Editor
Ben Holland

Copy Editor
Scott Tullis

Editorial Manager
Robyn B. Siesky

Vice President & Group Executive Publisher
Richard Swadley

Vice President & Publisher
Barry Pruett

Business Manager
Amy Knies

Senior Marketing Manager
Sandy Smith

Project Coordinator
Erin Smith

Graphics and Production Specialists
Alissa D. Ellet
Jennifer Mayberry

Quality Control Technician
Jessica Kramer

Proofreading
Linda Quigley

Indexing
Broccoli Information Mgt.

Special Help
Jama Carter
Sarah Cisco

For Nadra

Acknowledgments

Special thanks to my family and friends for putting up with me always having a camera pointed at them. I really do appreciate all your patience.

Thanks to Courtney for getting this whole thing started and to Cricket for keeping it on track.

Thanks to Mark and Maile for all the encouragement and the constant "Is the book done yet?" e-mails.

Contents at a Glance

Contents

Chapter 2: Setting Up the Alpha A700 45

Part II: Creating Great Photos with the Sony Alpha A700 81

Chapter 3: Photography Essentials 83

Chapter 4: All About Light 103

Chapter 5: All About Lenses 125

Chapter 6: Photo Subjects 141

Chapter 7: Viewing, Downloading, and Printing Your Photos 229

Part III: Appendixes 239

Appendix A: Camera Care 241

Appendix B: Editing Software Options 247

Introduction

Welcome to the Sony Alpha DSLR-A700 Digital Field Guide. The A700 is a great camera — with its super-fast focusing, it practically focuses itself before you have it all the way up to your eyes, and with the Super Steady Shot vibration reduction built right into the camera body so that it works with all lenses, Sony has produced a camera that will keep professionals and novices happy for years.

With all the buttons, levers, and dials, it can be a daunting task to get the A700 to produce the images that you want. Just remember, the camera is only a tool, one that is used to capture your vision. My job here is to help you do that in a wide variety of scenarios.

There is nothing more exciting to me than going out and photographing, and there is nothing more frustrating than not getting the shot I thought I did. The purpose of this book is to help you get the results you want when shooting a variety of subjects. The idea behind it being in helping you get the best results in specific photographic situations, and also providing specifics on getting to know the A700.

If you are the type of person who just wants to jump in and start taking photos, then go ahead and check out the Quick Tour. The Quick Tour gives you a quick run-down on using the A700 so you can get shooting fast. Chapter 1 goes into the location and function of the many controls on the A700 in more detail, and it makes a great reference guide later on. Chapter 2 gives an overview of all the settings and menu choices, including my recommended settings and what each mode and setting is best used for.

Chapter 3 is a review on the basics of photography and how they relate to digital photography and the A700. Need a little brush up on getting the correct exposure and a reminder about the Rule of Thirds? It's in this chapter.

Because light is so important to photography, it has its own chapter, Chapter 4. Natural light and artificial light are both covered along with getting the best results when using a flash. Reflectors, diffusers, and studio lighting are all covered along with tips and techniques for using a dedicated flash to get professional-looking results.

While the camera is important, the right lens can make all the difference. Chapter 5 is all about lenses, and Sony's lenses in particular. Prime lenses compared to zoom lens, normal, wide, and telephoto lenses are all discussed here.

Chapter 6 is the meat of the book, with information to help you get the best images possible in a wide variety of situations. From taking travel photos on your next vacation to shooting a child's baseball game, from capturing a candid moment to shooting a still life

scene, Chapter 6 has the sample photos, shooting data, and tips for many different photographic opportunities.

Taking the photos is one thing, showing them to others is another thing entirely. Chapter 7 deals with getting the images from the camera to a computer or just using the camera to display the images on a television, including HDTV. It is also possible to print images directly with the PictBridge software, and that is also covered in Chapter 7.

Appendix A covers cleaning and keeping you camera and lens in good working order. Even with the new anti-dust coating and self-cleaning, knowing the correct way to remove dust and dirt is important. Less time trying to get the camera clean means more time to photograph, and photographing is what it is all about.

Appendix B covers the software that is bundled with the A700 along with some of the other choices for today's photographers. There are a great many different programs for photographers in today's digital age, and there is no way to cover them all, so I picked some of my favorites and those that are the most commonly used in digital photography today.

Read through the book now, and take it with you when you go out to photograph. While this book would look great on your bookshelf, it works even better if you keep it with your camera. Tuck it into your camera bag and you will have a handy reference guide to all the controls and menus of your camera and advice on how to capture the best shot in different situations.

Quick Tour

QT

Congratulations on owning a Sony A700, a feature-laden digital SLR that novices and professional photographers alike can use with equally stunning results. With manual controls and enough settings to make any professional photographer happy, the Sony A700 dSLR can also be used in a fully automatic mode, letting novices use the camera without being overwhelmed. This Quick Tour will help you get out and start taking photos right away.

Taking photos with your A700 is as simple as putting in the battery, attaching a lens, inserting a memory card, and opening the flash if necessary. Turn the Mode dial on the top of the camera to Auto and you are ready to go out and start photographing. Sure, the camera has many buttons and dials and menu settings, but you can start without using most of them.

Basic Setup of the A700

After the A700 has a charged battery, a freshly formatted memory card, and a lens attached, it is time to pick a Recording mode. The A700 has 12 Recording modes, 6 of which are specific scene selection modes. You select a mode by turning the Mode dial on the top left of the camera to the desired setting.

◆ **Auto.** Setting the camera to Auto turns the camera into a very big and powerful point-and-shoot camera.

◆ **Program Auto.** Turning the Mode dial to P sets the camera to Program Auto mode. Although the Program Auto mode also lets the camera pick the shutter speed and the aperture, this mode is adjustable by using the Front and Rear control dials. The Front control dial adjusts the shutter speed and the camera then picks the aperture; the Rear control dial changes the aperture and the camera then picks the shutter speed.

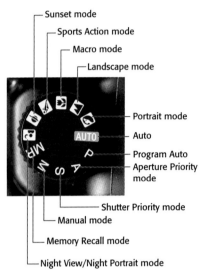

— Sunset mode
— Sports Action mode
— Macro mode
— Landscape mode
— Portrait mode
— Auto
— Program Auto
— Aperture Priority mode
— Shutter Priority mode
— Manual mode
— Memory Recall mode
— Night View/Night Portrait mode

QT.1 The Mode dial on the A700

✦ **Aperture Priority.** Turning the Mode dial to A sets the camera to Aperture Priority mode, which allows you to set the aperture and the camera automatically sets the shutter speed.

✦ **Shutter Priority.** Turning the Mode dial to S sets the camera to Shutter Priority mode. In this mode, you set the shutter speed and the camera automatically sets the aperture.

✦ **Manual.** Turning the Mode dial to M sets the camera to Manual mode. In Manual mode, you get to pick the shutter speed and the aperture. This gives you complete control over the exposure of the image.

✦ **Memory Recall.** The A700 can save three complete sets of user settings. These settings can then be recalled by turning the Mode dial to the MR position.

 Saving user settings for the Memory Recall mode is covered in detail in Chapter 2.

✦ **Scene selections.** These six Scene selections function as automatic modes that try to set the camera for more specific purposes than the Auto mode.

- **Portrait**
- **Landscape**
- **Macro**
- **Sports Action**
- **Sunset**
- **Night View / Night Portrait**

Cross-Reference *For more information on each of the Scene selections, see Chapter 2.*

Setting the Image Size and Quality

One of the most important decisions you need to make before taking any photographs is what image size and quality to use. These settings determine how many images can be stored on a memory card and what size prints can be made from your photos. Taking photos at the biggest file size with the best possible quality allows you to make the best possible prints in the future.

Setting the Image size is done in the Recording menu 1.

1. **Press the Menu button to open the camera's menu on the LCD.**

2. **Use the multi-selector to navigate to the Recording menu 1.**

3. **Use the multi-selector to navigate to the Image size menu choice and press the multi-selector's center button.** The Image size submenu gives you three choices: Large, Medium, and Small.

4. **Select the size you want with the multi-selector and press the multi-selector's center button.**

Note *The Image size menu is not available if the Quality is set to RAW or cRAW.*

The A700 is capable of saving photos in both JPEG and RAW file formats. You can also save each photo in both formats at the same time. The image Quality gives you seven choices for saving your files.

✦ RAW

✦ cRAW

✦ RAW & JPEG

✦ cRAW & JPEG

✦ Extra Fine JPEG

✦ Fine JPEG

✦ Standard JPEG

To change the image Quality, follow these steps:

1. **Press the Menu button to open the camera's menu on the LCD.**

2. **Use the multi-selector to navigate to the Recording menu 1.**

3. **Use the multi-selector to navigate to the Quality menu choice and press the multi-selector's center button.**

4. **The Quality submenu now offers you the seven choices for image quality.**

Cross-Reference *Image Size and Quality is covered in greater detail in Chapter 2*

Setting the Metering Mode

The A700 has a built-in light meter that measures the light in the scene, which is what the camera uses to determine the correct exposure for the scene.

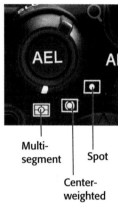

Multi-segment | Spot

Center-weighted

QT.2 The Metering mode lever

The A700 has three Metering modes. To choose between the Multi-segment, Center-weighed, or Spot modes, just turn the Metering mode lever to the desired mode.

✦ **Multi-segment.** The whole scene is divided into 40 separate areas, and the light is measured in each segment. Then the A700 uses this information to set the exposure of the whole scene. This mode is great for most general shooting.

✦ **Center-weighted.** Uses the whole scene to measure the brightness, but emphasizes the readings from the center section of the scene.

✦ **Spot.** Uses only the information from the Spot metering circle in the center of the frame.

Setting the ISO

The ISO setting determines how sensitive the image sensor is to light. The A700 has an ISO range of 100 to 6400 and an Auto mode. The higher the ISO, the less light is needed to get a proper exposure. Setting the ISO is quick and easy.

1. **Press the ISO button on the top of the camera to open the ISO menu on the LCD.**

2. **Use the multi-selector to navigate to an ISO value in the list.**

3. **Press the multi-selector's center button to use the selected ISO.**

 See Chapter 2 for more information on ISO.

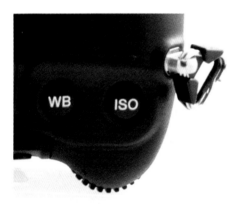

QT.3 The top of the camera showing the White Balance and ISO buttons

Setting the White Balance

Every light source has a specific color, and even though they all look similar to our eyes, the sensor in the A700 needs to know what light you are using in your photograph; otherwise the colors will not look natural. The way to do this is to set the white balance.

 White balance is covered in more detail in Chapter 2, and light in general is covered in Chapter 4.

Follow these steps to change the white balance setting:

1. **Press the White Balance (WB) button on top of the camera to open the White Balance menu.**

2. **Press the multi-selector up or down to select a white balance.**

3. **Press the multi-selector's center button to use the selected white balance.**

The white balance can also be changed by using the Quick Navigation screen:

1. **Press the Function (Fn) button on the back of the camera to open the Quick Navigation mode.**

2. **Use the multi-selector to navigate to the white balance setting and press the multi-selector's center button to open the White Balance menu.**

3. **Use the multi-selector to navigate to the white balance of your choice and press the multi-selector's center button to activate your choice.**

The A700 has nine different White Balance modes:

✦ **Auto White Balance**

✦ **Daylight**

✦ **Shade**

✦ **Cloudy**

✦ **Tungsten**

✦ **Fluorescent**

✦ **Flash**

✦ **Color Temperature**

✦ **Custom**

The Auto White Balance setting is the default and this setting is great for most photography.

Note *If you shoot in RAW file quality, setting the white balance isn't as important because the white balance can be changed and fine-tuned using software after the photo has been taken.*

Setting the Drive Mode

The Drive mode controls how many photos are taken when the Shutter button is pressed. The basic Drive modes are

✦ **Single-shot Advance.** The default setting takes a single image every time the Shutter button is pressed.

✦ **Continuous Advance.** The camera keeps taking photos as long as the Shutter button is held down. There are two Continuous Advance shooting modes.

 • **LO.** Shoots up to 3 images per second.

 • **HI.** Shoots up to 5 images per second.

Changing the Drive mode is as easy as pressing the Drive mode button on the top of the camera and opening the Drive menu. The multi-selector can then be used to select the Drive mode; pressing the multi-selector's center button sets the new Drive mode.

Cross-Reference *The Drive mode is also the location to set the A700 Bracketing modes The Drive menu and bracketing are covered in depth in Chapter 2.*

Setting the Focus Mode

The A700 has four Focus modes (three auto focus and one manual) that you can set using the Focus mode lever located on the front of the camera below the lens.

✦ **Single-Shot Auto focus.** Select this mode by turning the Focus mode lever to S. In this mode, the camera focus is locked when the Shutter button is pressed halfway down. This mode is great for taking photos of subjects that are stationary.

✦ **Continuous Auto focus.** In this mode, which you set by turning the Focus mode lever to C, the camera keeps focusing while the Shutter button is pressed halfway down. This mode is best for shooting moving subjects.

✦ **Automatic.** This mode is a combination of the Single-Shot Auto focus and Continuous Auto Focus modes. When the Focus mode lever is set to A, the Automatic Auto Focus mode switches between the Single-Shot and Continuous Auto Focus modes, depending on whether the subject is moving when the Shutter button is pressed halfway down.

✦ **Manual.** Turning the Focus mode lever to MF, the Manual mode setting disengages the camera's auto focus motor; you must adjust the lens's focus manually by turning the focusing ring.

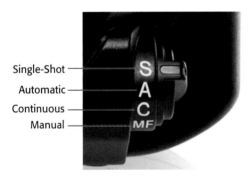

Single-Shot — S
Automatic — A
Continuous — C
Manual — MF

QT.4 The Focus mode lever on the A700

Setting the Focus Area

The auto focus capabilities of the A700 are amazingly fast, and with the Eye-Start sensor, the camera starts to focus even before you press the Shutter button. There are 11

auto focus sensors in the camera, with three different methods of deciding which of the focus sensors are used. The three different methods are

✦ **Wide auto focus area.** This is the default setting. When in this mode the camera decides which one of the 11 auto focus sensors is used.

✦ **Spot auto focus area.** This mode uses the center spot exclusively to determine what to focus on.

✦ **Local auto focus area mode.** This mode lets you use the multi-selector to pick the desired focus area from any of the 11 auto focus sensors.

To change the auto focus area

1. **Press the Menu button to open the menu screen and use the multi-selector to navigate to Recording menu 3.**

3. **Use the multi-selector to choose the AF area menu choice, and then press the multiselector's center button to open the AF area submenu.**

4. **Use the multi-selector to pick from Wide, Spot, or Local as the AF area.**

The auto focus area can also be changed by using the Quick Navigation screen.

1. **Press the Function button on the back of the camera to open the Quick Navigation menu.**

2. **Use the multi-selector to navigate to the AF area, which is in the center of the display, and press the multi-selector's center button to open the AF area menu.**

QT.5 The 11 auto focus sensors as seen through the viewfinder.

3. **Use the multi-selector to pick an Auto Focus mode, and press the multi-selector's center button to activate your choice.**

When you pick a sensor to use, it turns red briefly. Only the currently selected sensor will be red.

Reviewing Your Images

The A700's LCD has a resolution of 640 × 480 using 307,000 pixels. This screen is exceptionally bright and sharp and is great for reviewing your images. At any time, pressing the Playback button opens the most recently taken image on the LCD. Once an image is on the screen, you have several options for viewing:

◆ **Use the multi-selector or the Front or Rear control dials to navigate through your images.**

◆ **Press the Display button to switch among the three view modes: Display with information, Display without information, and Display with the 5-image thumbnails.** Each time you press the Display button, the display cycles to the next display mode.

QT.6 These three images show the three different view modes.

✦ **Press the Custom button to open the Histogram view.** Press it again reverts back to the previous view.

✦ **Press the AM/FM button to zoom in on a photo you are viewing.**

✦ **Press the Index button to open a thumbnail index screen.**

Using the Sony Alpha A700

Exploring the Sony Alpha A700

Going out and photographing with your Sony Alpha A700 set on Auto is easy, but to really unlock the capabilities of your camera, knowledge is the key. This chapter helps get you acquainted with the A700 and all of its controls and features.

The A700 is built on an aluminum chassis made of a magnesium alloy with a plastic-coated exterior and rubber environmental seals. The camera features a 12-megapixel CMOS sensor, an 11-point auto focus system, and a wide range of ISO speeds. With a 3-inch LCD, an impressive range of color modes (called Creative Styles), and Dynamic-Range Optimizer functions that are supported in RAW using the included Sony software, the A700 offers tremendous power to get great shots.

However, it also has many buttons, switches, levers, and dials, to control all these great features. This chapter guides you through what and where all the controls are.

Camera Controls

Holding the camera as you would when shooting, you should notice that the layout of the buttons and the controls seems to be just right. And, with the amazing amount of customization that is possible with the A700, some of the buttons can even be programmed to perform different functions.

> **Cross-Reference** *Chapter 2 covers customization; the definitions here apply to a camera with the factory default settings.*

On the front

The front of the A700 is not only the place where the lens is attached, it is also the location of a key control: the Focus mode lever. Knowing where all the controls are located is important when shooting. The time spent trying to locate the right lever or switch can be the difference between getting the shot and talking about the one that got away.

✦ **Remote sensor.** This is the sensor for the Remote Commander. If the remote does not seem to be working correctly, make sure that nothing is covering this sensor. The Remote Commander is covered later in this chapter.

✦ **Handgrip.** The ergonomic handgrip also houses the battery. The grip is comfortable and secure for horizontal and vertical shooting.

✦ **Grip sensor.** The A700 comes with the Eye-Start Auto Focusing system that starts focusing as your eye reaches the viewfinder. This automatic focusing system can also be triggered when the camera is hanging around your neck by the proximity of the viewfinder to your body. To stop this from happening, there is a second sensor on the handgrip. The Eye-Start focusing system does not turn on unless your hand is covering the handgrip sensor.

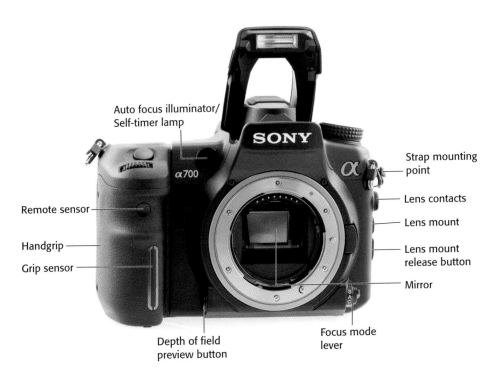

1.1 The front of the A700 without a lens mounted

✦ **Depth of field preview button.** After the subject is in focus, pressing the Depth of field preview button changes the view to show the actual aperture used. Note that the image is darker in the viewfinder because less light is passing through the lens.

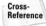 **Cross-Reference** *For more detailed information on depth of field and aperture, see Chapter 3.*

✦ **Focus mode lever.** This is where the Focus mode for the camera is set. The four choices are S, the Single-Shot Auto Focus mode; A, the Automatic Auto Focus mode; C, the Continuous Auto Focus mode; and MF, the Manual Focus mode.

✦ **Mirror.** The mirror reflects the light that is passing through the lens up to the viewfinder and lets the photographer see what the camera sees. When the Shutter button is pressed, the mirror moves out of the way so the light can reach the sensor. The mirror is inside the camera body and should not be touched.

✦ **Lens mount release button.** When pressed, this button unlocks the lens mount so the lens can be removed.

✦ **Lens mount.** This is where you attach the lens. The Sony lens mount is based on the Minolta A-type lens mount and can accept all Sony camera lenses and a variety of older Minolta A-type lenses.

✦ **Lens contacts.** These contacts communicate between the camera lens and the camera body.

✦ **Strap mounting point.** One of the two mounting points for the camera strap.

✦ **Auto focus illuminator / Self-timer lamp.** The auto focus illuminator helps the camera's auto focus system work in low light or with low-contrast subjects. When the Shutter button is pressed halfway down, the illuminator emits a red light until the focus is locked on. This light has a range of 3.3 to 23 feet (1 to 7 meters). This light can be turned off in the Recording menu. The Self-timer lamp flashes when the 10-second self-timer is used. The Self-timer is accessed in the Drive mode.

Cross-Reference *The Recording menu and the self-timer are covered in Chapter 2.*

On top

The top of the A700 differs from most digital cameras; it doesn't have any display screen. The space saved by this is used for dedicated buttons that control the ISO, Drive mode, and white balance.

✦ **Mode dial.** This is where you set the Recording mode on the camera. The choices are Auto, a fully automatic mode; P, Program Auto mode; A, Aperture Priority mode; S, Shutter Speed Priority mode; M, Manual mode; MR, Memory Recall mode; or one of the six scene modes.

Built-in flash

Front control dial

Shutter button

Exposure button

Mode dial

Drive mode button

White Balance button

ISO button

Hot shoe

Image sensor indicator

1.2 A top view of the camera

✦ **Built-in flash.** The flash is accessed by lifting up on the two small ridges on either side of the viewfinder. To close the flash, just push down from the top until it locks into place. Figure 1.1 shows the flash open.

✦ **Hot shoe.** This hot shoe lets you attach an external Sony flash unit such as the HVL-F56AM, HVL-F42AM, or the HVL-F36AM.

✦ **Image sensor plane indicator.** This marking on the camera body is used if you need to measure the exact distance from the subject to the image sensor.

✦ **Drive mode button.** This button opens the Drive mode menu on the LCD.

✦ **White Balance button.** This button opens the White Balance menu on the LCD.

✦ **ISO button.** This button opens the ISO menu on the LCD.

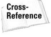 **Cross-Reference** *The Drive mode, the White Balance menu, and the ISO menu are covered in detail in Chapter 2.*

✦ **Exposure button.** This button opens the Exposure Compensation menu on the LCD.

✦ **Shutter button.** When pressed, the shutter moves out of the way and the photo is taken.

✦ **Front control dial.** The Front control dial controls the shutter speed when the camera is in M (Manual mode), P (Program Auto mode), and S (Shutter Priority mode). The Front control dial controls the aperture when the camera is in A (Aperture Priority mode).

On the back

The back of the camera is dominated by the large 3-inch LCD, but when you hold the camera with your right hand, you will notice that the controls used when shooting—especially the multi-selector and the Rear control dial—are all easily accessed with your right thumb.

✦ **Power switch.** This is the power switch. The A700 has a built-in sensor cleaning mode that vibrates the sensor every time the power is turned off. The slight vibration when turning the camera off is normal.

✦ **Menu button.** The Menu button opens the Main menu on the LCD.

✦ **Display button.** The Display button switches between the detailed display and the enlarged display in the Recording mode. The brightness of the LCD can be adjusted by pressing the Display button for a few seconds.

✦ **Trash button.** When you are reviewing images on the LCD, pressing this button opens the delete image dialogue. There is a choice to delete the image or to cancel, which returns the display to reviewing images mode. It is also

1.3 A rear view of the A700

possible to protect the images using the Protect feature in the Playback menu 1.

 The Protect feature is covered in detail in Chapter 2.

✦ **Playback button.** The Playback button is pressed to view the images already taken on the LCD.

✦ **LCD monitor.** The 3-inch LCD screen displays different information depending on the mode.

✦ **Function / Rotate button.** When in Shooting mode, the Function button switches between the Recording Information screen and the Quick Navigation screen. In Playback mode, the button opens the Rotate Image menu that is then controlled by the multi-selector.

✦ **Custom / Histogram button.** When in Viewing mode, pressing the Histogram button once displays the histogram and shooting data of the displayed image. Pressing the button a second time returns to the previous view. When in Shooting mode, this button can be programmed with a function of your choice. The default setting is the Creative Styles menu. It is possible for the Custom button to control any of the following: AF Lock, AF/MF control, Depth of field preview, ISO, white balance, exposure compensation, flash compensation, Drive mode, AF area, image size, image quality, D-Range Optimizer, Flash mode, and Memory.

✦ **Super SteadyShot.** This turns the Super SteadyShot vibration reduction on or off.

✦ **Multi-selector.** The multi-selector lets you select and execute a variety of different functions. The multi-selector works like a miniature joystick; it can be moved left, right, up, and down. It is used to navigate through the Quick Navigation screen and the A700's menu choices.

✦ **Access light.** This red light is on when the camera is writing information to the memory card. Do not turn the camera off while this light is on.

✦ **Rear control dial.** The Rear control dial controls the aperture when the camera is set in P (Program Auto) mode, M (Manual) mode, and A (Aperture Priority) mode. When in S (Shutter Priority) mode, the Rear control dial can control the shutter speed.

✦ **AF/MF Enlarge button.** When in Shooting mode, this button lets you easily switch between auto focus and manual focus without having to use the Focus mode lever on the front of the camera. When in Auto Focus mode, holding down the AF/MF button switches the focus to Manual mode and lets you focus using the focusing ring on the lens. When the camera is in Manual mode, pressing the AF/MF button engages Auto Focus mode. When in Viewing mode, pressing the button enlarges the image on the LCD.

✦ **Metering mode lever.** The Metering mode lever lets you pick one of the three Metering modes: Multi-segment, Center-weighted, or Spot metering. The actual Metering modes are covered later in this chapter.

✦ **AEL (AE Lock) / Slow Sync / Index button.** This button has three purposes depending on which mode the camera is in. When the camera is in Shooting mode, this button locks in a certain exposure. When you focus on an area or subject that you want to be metered for exposure, even if it is not going to be the main subject of your photograph, and press the AEL button, those exposure settings are then locked. You can reframe the image and take the photograph. The setting is canceled when the button is released. When the built-in flash is activated, the button sets the flash to Slow-sync mode. When in Preview mode, the button puts the preview in Index mode, and then you can use the Display button to cycle through a 4-image index, a 9-image index, and a 25-image index.

✦ **Viewfinder.** The optical glass pentaprism design shows a bright clear view of the scene shown through the lens. The display has three separate parts: the view through the lens, the focus sensors, and an information display below the image.

✦ **Diopter adjustment dial.** This adjustment dial lets you compensate for farsightedness and nearsightedness. Adjust the dial while looking through the viewfinder until the image is sharp. If you are farsighted, rotate the dial down; if you are nearsighted, rotate the dial upward.

✦ **Eyepiece sensor.** This sensor right below the viewfinder can determine if you are looking through the eyepiece. The default setting is for the LCD to turn off when the sensor determines that you are looking through the viewfinder.

On the bottom

The bottom of the A700 houses the battery and tripod mount.

✦ **Battery compartment.** The battery compartment is accessed by a recessed latch on the bottom of the camera. When the battery is fully inserted into the camera, it is held in place with a small blue latch so that even if the battery door is opened, the battery will not fall out. The latch needs to be pressed in to remove the battery. The battery compartment is spring-loaded, so when the latch is pushed in, the battery pops right out.

✦ **Threaded tripod socket.** The Sony Alpha A700 comes with a standard tripod socket that is aligned with the exact center of the lens.

Battery
compartment
(closed)

Threaded tripod
socket

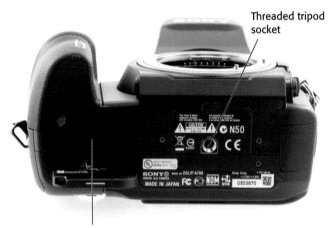

Battery
compartment
(open)

1.4 A bottom view of the camera

On the left side

The left side of the camera is covered with rubber doors. These doors are all connected to the camera, and while they can be opened, they cannot be removed. The doors cover the following:

✦ **Flash sync terminal.** The Sony Alpha A700 can use any flash or studio flash system with a flash sync voltage of 400V or less. To attach the sync cord, open the cover of the sync terminal and plug in the sync cord. When the A700 is connected to a flash using the flash sync terminal and the Super SteadyShot vibration reduction is turned on, the fastest shutter speed that can be used is 1/200 of a second. When the SuperSteady shot is turned off, the fastest shutter speed that can be used is 1/250 of a second.

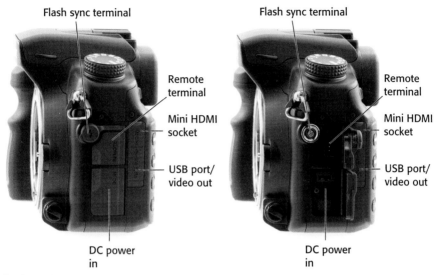

Flash sync terminal

Remote terminal

Mini HDMI socket

USB port/ video out

DC power in

Flash sync terminal

Remote terminal

Mini HDMI socket

USB port/ video out

DC power in

1.5 The left side of the A700

✦ **Remote terminal.** The RM-S1AM Remote can be used with the Sony Alpha A700 by opening the cover and inserting the plug of the remote. The remote lets you release the shutter without touching the camera or the Shutter button.

✦ **DC power in.** The optional AC-VQ900AM AC adaptor / battery charger can be used to power the camera using an ordinary house-hold power outlet. To use the adaptor, first turn off the power to the camera, and then plug the power cord into the DC-in terminal. You can then turn the camera on.

✦ **USB port / video out.** The camera can be connected directly to a computer using a USB cable with a mini USB connector to plug into the camera and a regular connec-tor to plug into the computer. The supplied mini USB-to-video RCA plug enables the A700 to be con-nected to a regular television.

✦ **Mini HDMI socket.** Using an HDMI cable that has a mini HDMI connector on one end for the camera and a connecter suitable for your television on the other, the A700 can be used with a high-definition television.

On the right side

The right side of the camera houses the memory of the camera. This is the place where the memory card goes.

✦ **Memory card cover.** Sliding it towards the back of the camera opens the memory card cover. The door is spring-loaded and opens easily. To close the cover, fold it back towards the camera and slide it forward until it clicks into place. If the camera is turned on when the door is opened, the LCD shows a cover open message.

Memory card
cover

CompactFlash
slot

 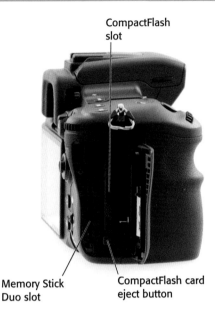

Memory Stick
Duo slot

CompactFlash card
eject button

1.6 The right-side view of the camera

✦ **Memory Stick Duo slot.** The Sony Alpha A700 can use Memory Stick Duo to save the images, and this slot is where it is inserted into the camera. The Memory Stick Duo is pushed into the camera until you hear it click. To remove the Memory Stick Duo, press down on the memory stick to release it.

✦ **CompactFlash slot.** The Sony Alpha A700 can use CompactFlash or Microdrive media, and this is where it is inserted into the camera. The CompactFlash card or Microdrive needs to be inserted with the label towards the back of the camera. Push on the CompactFlash card until it is firmly seated.

✦ **CompactFlash card eject button.** To eject a CompactFlash card or Microdrive, press down on this button until the card can be removed from the slot.

Remote Commander

The Remote Commander is a great accessory for your Sony Alpha A700, and the best part is that it doesn't cost anything extra. The Remote Commander can be used in two different ways. The first is when it is used to remotely trigger the camera's shutter, and the second is during playback of the images on a television screen.

To use the remote to take photos, set the Drive mode on the camera to Remote Commander. This is done by pressing the Drive mode button located on the top of the camera and then using the multi-selector to choose the Remote Commander mode. The Remote Commander has two buttons that trigger the shutter release. The first is the Shutter button, located on the top left of the remote. When this button is pressed, the shutter on the camera is immediately released. The second button on the remote is the 2-second button. When it is pressed, there is a 2-second delay before the shutter on the camera is released.

Shutter button 2-second button

Histogram

Display

Index

Rotate

Playback

Menu

Print

Slide show

Scale up/down

Delete

Navigation buttons

1.7 The Remote Commander

When the Sony Alpha A700 is connected to a television, the Remote Commander can control the playback of the images stored on the camera. The Remote Commander has a Slide show playback mode that is not available when using the camera to control the playback.

 Cross-Reference *Using the Remote Commander to play back the images is covered in detail in Chapter 7.*

✦ **Histogram.** This displays the histogram and the recording data of the displayed image the same way that the Histogram button on the back of the camera does. When the Histogram button is pressed, it displays the histogram and shooting data of the displayed image. Pressing the button a second time returns to the previous view.

✦ **Display.** This button cycles among three views: the image alone, the image with an information overlay, and the image with some details overlaid and a thumbnail strip on the top of the display.

✦ **Index.** The index opens a thumbnail view of the images and can be navigated using the navigation buttons.

✦ **Rotate.** The Rotate button opens a choice to rotate either left or right using the navigation buttons.

✦ **Playback.** This button switches between playing back the images and showing the camera settings screen.

✦ **Menu.** When in Playback mode, this opens the camera menus, and they can be set using the navigation buttons.

✦ **Slide show.** The Slide show button starts a slide show of the images. Pressing it a second time stops the slide show.

✦ **Scale up/down.** These two buttons let you zoom in and out of the photo. The navigation buttons let you move around in the zoomed view.

✦ **Delete.** The Delete button opens the delete photo option. The navigation buttons are used to make a selection.

✦ **Navigation buttons.** These navigation buttons take the place of the multi-selector on the back of the camera. The four direction buttons and the center button act to move between photos, move between selections, and make choices.

✦ **Print.** If you connect the camera to a HDTV using the HDMI cable and you connect the camera to a printer using the USB port on the camera, this button lets you print while viewing the images on the television. This only works when connected to a HDTV because connecting to a regular television requires the USB port on the camera.

Viewfinder Display

The viewfinder in the Sony Alpha A700 covers 95 percent of the frame, and because of its pentaprism design and optical glass construction, it is bright and clear. The viewfinder display is broken into two parts, the main viewing area and the information display along the bottom of the viewfinder.

The main display

The main display is where the photographed is composed. Being able to see what the sensor will record makes composing your photo easy.

✦ **AF area.** There are 11 auto focus indicators, four on the left, four on the right, one on the bottom, one on the top, and the Spot auto focus area in the center.

✦ **Spot AF area.** This is the small square directly in the middle of the viewfinder. It is the focus indicator for the Spot auto focus setting. When the focus has locked on, the indicator turns red for a moment, indicating that the setting is in use.

✦ **Spot metering area.** The circle around the Spot AF area defines the Spot metering area. This is the total area of the scene used in Spot exposure metering.

✦ **16:9 shooting area guidelines.** These crop guidelines are there to help when composing in the 16:9 aspect ratio Crop mode. Any information above or below the crop marks is not recorded when the 16:9 aspect ratio is set.

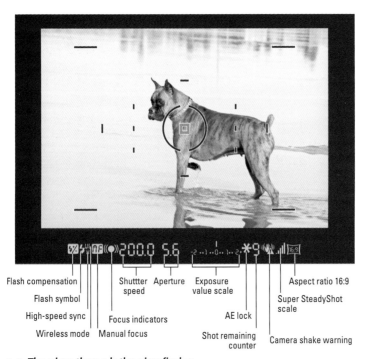

Flash compensation | Shutter speed | Aperture | Exposure value scale | Aspect ratio 16:9
Flash symbol | | | | Super SteadyShot scale
High-speed sync | Focus indicators | | AE lock
Wireless mode | Manual focus | | Shot remaining counter | Camera shake warning

1.8 The view through the viewfinder

The data display

The data display across the bottom of the display gives you instant access to the most important settings without having to take your eye away from the viewfinder.

✦ **Flash compensation.** When using the flash, you can adjust the amount of light without changing the exposure. When any flash compensation is used, the flash compensation indicator is visible in the viewfinder.

✦ **Flash symbol.** When the flash symbol is flashing, the flash is being charged. When the light turns solid, the flash is charged and ready to fire.

✦ **WL.** When an external flash is used in Wireless mode, the WL indicator is lit.

✦ **H or HSS.** Some external flashes can use a High-speed sync mode. When in the High-speed sync mode, an H or HSS appears in the viewfinder.

✦ **MF.** When in Manual Focus mode, this indicator lights up.

✦ **Focus indicators.** The focus indicators show whether the focus is locked and ready to shoot, focused on a moving subject and ready to shoot, in the process of focusing, or unable to focus on the subject.

✦ **Shutter speed.** This shows the current shutter speed.

✦ **Aperture.** This shows the current aperture.

✦ **EV scale.** The EV or Exposure Value scale in the viewfinder shows the exposure set by the photographer and what the camera's metering system believes to be the correct exposure. The

small bar over the scale shows the current exposure setting in regard to what the camera believes is the correct setting. The EV scale also indicates when the bracketing is active by showing either three or five bars above the scale.

✦ **AE lock.** When the AEL button is pressed, the exposure value currently determined by the camera becomes the standard value. The AE lock indicator is visible in the viewfinder when the AEL button is pressed.

 Cross-Reference *Exposure Value is covered in detail in Chapter 2*

✦ **Shots remaining counter.** This shows how many photos can still be taken. The display starts at 9 and counts down as the photos are taken; as the images are written to the memory card, the counter goes back up. When the memory card is full and no more images can be saved, the counter reads 0. If you try to take photos after the card is full, the word FULL flashes across the display and the counter reads 0.

✦ **Camera shake warning.** This indicator flashes even if the Super SteadyShot is turned on. The camera calculates the likelihood of camera shake using the focal length and shutter speed.

✦ **Super SteadyShot scale.** The scale is shown when the Super SteadyShot is activated. The higher the scale, the more shaking is present. To get the sharpest image possible, there should be no bars.

✦ **Aspect ratio 16:9.** This indicates when the camera is set to the 16:9 aspect ratio.

LCD Display

The 3-inch screen on the back of the camera provides a single display area that keeps all the pertinent information in one place. This also means that the display changes to accommodate the mode the camera is in. Because the LCD is the only display on the camera, it does double duty. In the Recording Information display mode, it shows the current camera settings, and when in the Playback display mode, it shows a review of the images already taken.

Recording Information display

The Recording Information mode shows the current settings of the A700. When the A700 is turned on, the display automatically opens the Recording Information display.

This display is viable for five seconds and then the display turns off. This can be adjusted using the info.disp.time setting located in the Setup menu 1.

 Chapter 2 has more details on changing menu settings.

The Recording Information display has two different modes: a Detailed mode and an Enlarged mode, which are cycled through by pressing the Display button. The Enlarged mode shows some but not all of the information in the Detailed mode. In the Enlarged mode the information is presented in a larger format, making it easier to read quickly. One of the great little touches in the A700 is that when the camera is rotated from horizontal to vertical, the display changes its orientation automatically, making it easier to read no matter how you are shooting.

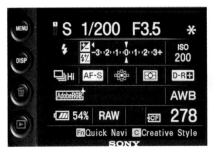 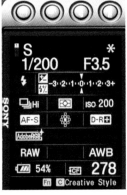

1.9 This shows the LCD screen's detailed Recording Information display in the horizontal mode and in the vertical mode. The information on the display rotates to match the orientation of the camera.

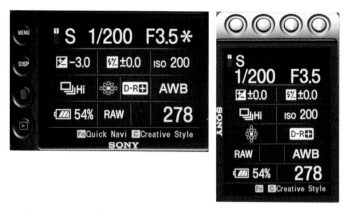

1.10 This shows the LCD screen's enlarged Recording Information display in the horizontal mode and the vertical mode. With less information visible than in the Detailed mode, the screen is easy to read even in low light.

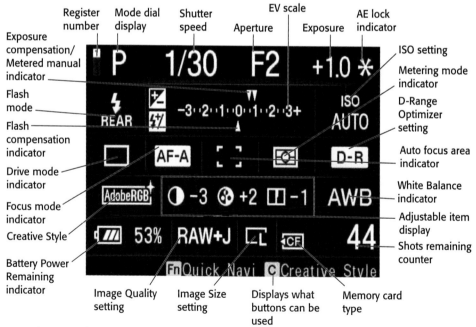

Register number — Mode dial display — Shutter speed — Aperture — EV scale — Exposure — AE lock indicator

Exposure compensation/ Metered manual indicator

Flash mode

Flash compensation indicator

Drive mode indicator

Focus mode indicator

Creative Style

Battery Power Remaining indicator

ISO setting

Metering mode indicator

D-Range Optimizer setting

Auto focus area indicator

White Balance indicator

Adjustable item display

Shots remaining counter

Image Quality setting — Image Size setting — Displays what buttons can be used — Memory card type

1.11 The Recording Information display

The following bulleted list details the Recording Information display.

✦ **Register number.** The A700 can have three user-defined settings. When the Mode dial is set to MR (Memory Recall mode), the selected set of settings displays here.

✦ **Mode dial display.** The display here shows the Mode dial's setting.

✦ **Shutter speed indicator.** Displays the current shutter speed.

✦ **Aperture indicator.** Displays the current f-stop.

✦ **Exposure.** This display is blank unless the photographer has made any exposure compensation adjustments; otherwise, it shows the amount of exposure compensation.

✦ **AE lock indicator.** Displays an asterisk when the AE lock is pressed and the AE lock is in use.

✦ **Flash mode**. The indicator shows whether the Flash mode is set to Autoflash, Fill Flash, Rear Sync, or Wireless. It also shows if Red-eye reduction has been set.

✦ **Exposure compensation / Metered manual indicator.** The display shows a small arrow above the EV scale, showing what the camera believes is the difference between your exposure and the correct exposure. When the arrow is above the 0, the EV scale, the camera meter, and the photographer's settings agree. When the arrow appears toward the right, it indicates overexposure, which causes the photo to be too light. When the arrow appears to the left, it indicates underexposure, which causes the photo to be too dark.

✦ **Flash compensation indicator.** If any flash compensation is set, a small arrow appears under the EV Scale, showing the amount of compensation.

✦ **EV scale.** The EV or Exposure Value scale shows what the camera believes is the correct exposure, which is set at 0. The scale also shows three steps of overexposure and three steps of underexposure. The scale is also used as a guide for exposure compensation and flash compensation.

✦ **ISO setting.** The current ISO setting is shown here below the word ISO. The ISO is shown as a number from 100 to 6400. The word AUTO appears if the ISO is set to Auto.

✦ **Drive mode indicator.** The Drive mode indicator shows what Drive mode the camera is in. There are eight modes that can be set. Most modes have more than one choice, for a total of 22 available settings that can be shown.

✦ **Focus mode indicator.** This shows which of the four Focus modes is selected: AF-S when the camera is set on Single-Shot Auto Focus, AF-A when the camera is set to Automatic Auto Focus, AF-C for Continuous Auto Focus, and MF for Manual Focus.

✦ **Auto focus area indicator.** Shows if the Wide, Spot, or Local Auto Focus area is selected.

✦ **Metering mode indicator.** Shows if the Multi-segment, Center-weighted, or the Spot metering mode is being used.

✦ **D-Range Optimizer setting.** When the D-Range Optimizer is turned on, the mode it is set for is

shown here. D-R for Standard, D-R+ for Advanced Auto, and D-R+ with Lv1 to Lv5 for the Advanced mode with multiple levels.

Cross-Reference *The D-Range Optimizer settings are covered in depth in Chapter 2.*

✦ **Creative Style.** There are 14 different Creative Style settings: Standard, Vivid, Neutral, AdobeRGB, Clear, Deep, Light, Portrait, Landscape, Sunset, Night, Autumn, B/W, and Sepia.

Cross-Reference *The Creative Styles are discussed in depth in Chapter 2.*

✦ **Adjustable item display.** This area shows adjustments made to the Creative Style in Contrast, Saturation, Sharpness, Brightness, and Zone Matching.

✦ **White balance indicator.** This shows the current white balance setting.

✦ **Battery power remaining indicator.** The remaining power in the battery is shown as both a graphical representation and a numerical percentage.

✦ **Image Quality setting.** This display shows the Image Quality setting as RAW, cRAW, RAW+J, cRAW+J, X.FINE, FINE, or STD.

✦ **Image Size setting.** This displays the size of the image: Large, Medium, or Small in either the 3:2 aspect ratio or the 16:9 aspect ratio.

✦ **Memory card type indicator.** When a CompactFlash card is being used, the letters CF appear in this box and MS appears if you are using a Memory Stick Duo card.

✦ **Shots remaining counter.** This is pretty self-explanatory. It shows the amount of shots that can still be saved on the memory card using the current settings.

Note that the bottom area of the display changes depending on what is on the main area of the screen. The bottom area can have any of the following: multi-selector directions, Menu button, Menu return, Delete button, Enlarge button, Custom button, Function button, Playback button, Front and Rear control dial, Front control dial, or Rear control dial.

Playback screen

Pressing the Playback button on the rear of the camera accesses the Playback display mode where you can review your images. When in Playback mode, press the Display button to cycle through the three different Viewing modes: the image alone, the image with shooting data, and the image with a thumbnail display of the last five images taken.

Pressing the Playback button again returns the display to the Recording Information display.

Image alone view

In this view, the entire display is filled with a single image. The Front or Rear control dials or the multi-selector can be used to cycle through the images on the memory card in the camera. Press the Display button to change to the Image with shooting data view.

Image with shooting data view

When the display is in the Image with shooting data view, the shooting data is superimposed across the top and bottom of the displayed image.

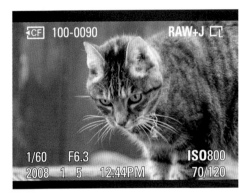

1.12 The screen during basic playback (not all icons are shown)

The information across the top of the screen consists of:

✦ **Memory card indicator.** This shows which memory card is being accessed, either the CF CompactFlash or the MS memory stick.

✦ **Folder and file number.** This shows the folder number followed by the file number.

✦ **Protect display.** If the image is protected, the protect symbol appears here.

✦ **DPOF.** Images can be marked for future printing. If the image has been selected to print, the DPOF3 symbol appears here.

✦ **Image quality.** The image quality of the photo appears here.

✦ **Image size.** The image size of the photo appears here.

✦ **Image.** The image appears here.

The information across the bottom of the screen consists of:

✦ **Shutter speed.** The shutter speed of the current image appears here.

✦ **Aperture.** The f-stop of the current image appears here.

✦ **ISO sensitivity.** The actual ISO of the current image appears here, even if the photo was taken using AUTO ISO.

✦ **Date of recording.** The date and time that the image was taken is shown here.

✦ **File number / total number of images.** This shows the sequence number of the selected image and the total images taken.

Image with thumbnail strip view

Pressing the Display button when in the Image with shooting data view brings up the Image with thumbnail view. This view has a five image thumbnail strip across the top of the image and a limited set of shooting data across the bottom.

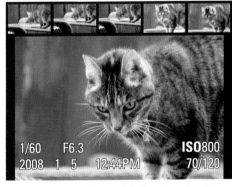

1.13 Image preview with the thumbnail strip shown

The top area has a thumbnail strip that holds, at the most, five images. The image that is currently selected has a red bar beneath it. The multi-selector can be used to navigate between images. The bottom area has the following shooting data:

✦ **Shutter speed.** The shutter speed of the current image appears here.

✦ **Aperture.** The f-stop of the current image appears here.

✦ **ISO sensitivity.** The actual ISO of the current image appears here, even if the photo was taken using AUTO ISO.

✦ **Date of recording.** The date and time that the image was taken is shown here.

✦ **File number / total number of images.** This shows the sequence number of the selected image and the total images taken.

Histogram view

Pressing the Histogram button while in Playback mode opens the Histogram view. This view has the most amount of information. Once the Histogram button has been pressed, the view in Playback mode will be in Histogram view until the Histogram button is pressed again. The Histogram display has a full set of shooting data on the left side of the display with the histograms on the right.

This histogram itself is broken into four graphs. They are, from top to bottom: Luminance, Red, Green, and Blue. Each shows the luminance distribution from darkest to lightest across the bottom of the graphs, with the amount of pixels being affected in the heights of the graphs. The overall luminance of the scene is shown in the top graph, and each of the color graphs shows the luminance for that color. The

more information that appears on the left of the chart, the darker the image; and the more information that appears on the right on the chart, the brighter the scene.

Across the top, you see the following:

✦ **Memory card indicator.** This shows which memory card is being accessed, either the CF CompactFlash or the MS memory stick.

✦ **Folder and file number.** This shows the folder number followed by the file number.

✦ **Protect display.** If the image is protected, the protect symbol appears here.

✦ **DPOF.** Images can be marked for future printing. If the image has been selected to print, the DPOF3 symbol appears visible here.

✦ **Image quality.** The image quality of the photo appears here.

✦ **Image size.** The image size of the photo appears here.

✦ **Image.** The image appears here. Overexposed areas can blink between black and white.

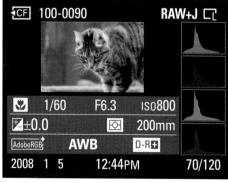

1.14 Image preview with the Histogram view shown

Across the bottom, there are four rows of information that contain the following:

✦ **Mode indicator.** This shows the mode that was set when the image was taken. The display matches the setting on the mode dial.

✦ **Shutter speed.** The shutter speed of the current image appears here.

✦ **Aperture.** The f-stop of the current image appears here.

✦ **ISO sensitivity.** The actual ISO of the current image appears here, even if the photo was taken using AUTO ISO.

✦ **Exposure Value.** This displays how much over or under the exposure compensation was set, compared to the 0 of the standard exposure.

✦ **Flash compensation indicator.** This displays the flash compensation , if any, used in creating the photo.

✦ **Metering mode indicator.** This displays the Metering mode that was used to capture that image.

✦ **Focal length indicator.** The focal length that was used appears here.

✦ **Creative Style.** The creative style used when the image was captured is shown here.

✦ **White balance.** The white balance used for this image is shown here.

✦ **D-Range Optimizer.** The D-Range setting is shown here.

✦ **Date of recording.** The date and time that the image was taken is shown here.

✦ **File number / total number of images.** This shows the sequence number of the selected image and the total images taken.

Index view

The Index view is opened by pressing the AE lock / Index button. The view changes to an index screen showing nine images, three columns of three images. Navigating through the images can be done with the multi-selector and pressing the multi-selector's center button selects that image and opens it in the Playback screen.

When in the Index mode, press the Display button to switch from a nine image index preview to a twenty-five image index preview. Press the Display button again and the display changes to a four-image index preview.

Image Files

Digital cameras use a digital image sensor to capture images, and the images are saved as image files on your memory card. The aspect ratio, file quality, and file size you select before shooting all play a part in the creation of the image file.

Aspect ratio

The *aspect ratio* is the width of the image divided by the image height. The Sony Alpha A700 has a feature not found on most cameras: the ability to record not only in the standard photographic ratio of 3:2 but in the 16:9 aspect ratio as well.

1.15 This image was photographed in the 3:2 aspect ratio. The faded areas at the top and the bottom show what information would not be recorded when the camera is set to the 16:9 aspect ratio.

✦ **3:2.** This is the standard aspect ratio used in photography. Because the sensor is in the same aspect ratio, this ratio uses all the available pixels.

✦ **16:9.** This is the aspect ratio of high-definition televisions. Sony is a leader in the high-definition television field, and with the HDMI output on the camera, this camera can produce high-definition images in a native format for the 16:9 televisions. Because the 16:9 aspect ratio does not use areas on the top and the bottom of the sensor, the resulting image is smaller in size than one taken using the 3:2 aspect ratio.

File quality setting

When a photograph is taken, the image is saved to the memory card. The file format is the type of file and the format of the information that is written to the memory card. The Sony Alpha A700 has seven different file format settings.

✦ **RAW.** The information in this format is the RAW data that the camera sensor captures.

✦ **cRAW.** The cRAW mode is a compressed RAW mode. This file format saves space by compressing the image 60 to 70 percent compared to the regular RAW mode. Everything else is the same as the regular RAW mode.

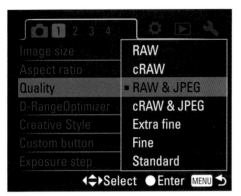

1.16 The File Quality menu makes picking a file quality easy and fast.

also be set by pressing the Function button to open the Quick Navigation menu, and then using the multi-selector to choose the current file quality; by pressing the multi-selector center button, the file quality can then be changed.

File size setting

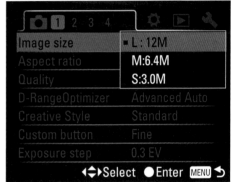

1.17 The Image Size menu changes depending on the aspect ratio used. This menu shows the file sizes for the 3:2 aspect ratio, but does not show the actual dimensions of the image.

✦ **RAW & JPEG.** This mode saves two files every time you take a photograph. One copy is in the RAW mode, and the other is in the JPEG Fine mode.

✦ **cRAW & JPEG.** This is the same as the RAW & JPEG mode except that the RAW file is compressed, saving space.

✦ **Extra Fine.** This stores the images using a JPEG file format with very little compression.

✦ **Fine.** This setting stores the images using a JPEG file format with more compression than Extra Fine, creating a smaller file.

✦ **Standard.** This setting stores the image using the JPEG file format with the highest amount of file compression. The higher the compression, the lower the image quality.

Changing the file quality is done by pressing the Menu button and then using the multi-selector to navigate to Recording menu 1 and selecting Quality from the menu. It can

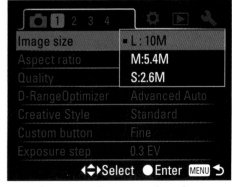

1.18 The Image Size menu when the aspect ratio is set to 16:9. The file sizes are smaller than the 3:2 counterparts.

Table 1.1
Size Chart

	3:2 Aspect Ratio	16:9 Aspect Ratio
Large	12M, 4272 × 2848 pixels	10M, 4272 × 2400 pixels
Medium	6.4M, 3104 × 2054 pixels	5.4M, 3104 × 1744 pixels
Small	3.0M, 2128 × 1424 pixels	2.6M, 2128 × 1200 pixels

The A700 has three file size settings: Large, Medium, and Small. Each of the file formats can be set to one of the three sizes as shown in Table 1.1. The sizes are dependant on the aspect ratio.

ISO Sensitivity

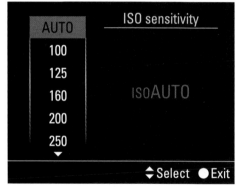

1.19 Using the ISO button and the multi-selector, the ISO can be changed easily.

The ISO settings determine how sensitive the image sensor is to light. The Sony A700 ISO settings range from 100 all the way to 6400, with 100 being the least sensitive to light and 6400 being the most sensitive to light. To get a higher sensitivity to light, the signal from the sensor is amplified, increasing the amount of digital *noise* that is introduced to the file. Digital noise is unwanted

spots of random color that show up in areas that should have smooth color. The more the signal is amplified, the more noise is introduced. The A700 also has an Auto ISO mode that sets the ISO value between 200 and 1600.

Viewing Images on the Camera

At any time, you can press the Playback button to view on the LCD the most recently taken image. Once an image is on the screen, you have many options for viewing and deciding an image's fate.

✦ **Navigate through the images using the multi-selector or the Front or Rear control dials.**

✦ **Press the Display button to switch among the three view modes.** Each time you press the Disp button, the display cycles to the next display mode. The three modes are

• **Display with information.** In this mode, the image is overlaid with the filename, file type, file size, shutter speed, aperture, ISO, date and time the image was recorded, and the image

number / total images that are on the card. The type of storage, CompactFlash or Memory stick, is also displayed on the top-left corner of the image. The Front or Rear control dial or the multi-selector can be used to cycle through the images on the memory card.

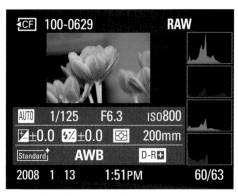

1.20 The Histogram view

- **Display without information.** In this mode, the image is displayed without any information at all. The Front or Rear control dial or the multi-selector can be used to cycle through the images on the memory card.

- **Display with 5-image thumbnails.** In this mode, the display is broken into two parts; the thumbnail strip along the top and the main image on the bottom. Shutter speed, aperture, ISO, the date and time the image was taken, and the image number / total images taken are all displayed over the bottom of the main image. The Front or Rear control dial or the multi-selector can be used to cycle through the images on the memory card. The selected image will have a red line under it on the thumbnail strip.

✦ **Press the Custom button to open the Histogram view.** Press it again to revert back to the previous view. Use the histogram to help you determine if you have a good exposure.

✦ **Zoom in on any photo using the AM/MF button.** To help identify this button's dual purpose, there is a blue magnifying icon next to the button. When in the Zoom mode, the Front control dial scrolls from one photo to the next, and the Rear control dial changes the percentage of the zoom. Pressing the multi-selector moves the zoomed image around within the LCD screen. Pressing the multi-selector's center button changes the display by showing the entire image with a red box located in the middle of the image. This red box is the area of the image that is displayed when the multi-selector's center button is pressed a second time. The red box can be moved around the image by using the multi-selector to select the area of the image you want to look at closer. While in this mode, the Rear control dial changes the amount of zoom and graphically shows this change by making the red box bigger or smaller. The Front control dial changes from one image to the next. Pressing the AM/MF button returns the view to the previous mode.

1.21 The Zoom screen

1.22 The Index screen

✦ **Pressing the Index button opens a thumbnail index screen.** This screen shows three columns of three images per screen. It is a fast and easy way to navigate through your images. You can use the multi-selector to navigate through the images and the multi-selector's center button to select the high-lighted image. The Front control dial navigates among images, and the Rear control dial navigates by screen. You can also change which folder on the memory card is being viewed. When the folder icon on the left side of the screen is selected and the multi-selector's center button is pressed, you can change the folder using the multi-selector.

✦ **Press the Delete button to delete the image that is on the screen.** After the Delete button has been pressed, a confirmation screen asks if the image should be deleted or if you want to cancel this action. After an image has been deleted, there is no way to get the image back. Taking this action is something to seriously consider before executing.

Note *Although the 3-inch LCD is great for doing quick reviews, it isn't ideal for doing critical reviews. The A700 LCD just can't compare to a computer or television screen. I do use the review to quickly check my photos, making sure that the image is properly exposed.*

1.23 The Delete confirmation screen

Caution *When viewing your images on the camera, battery life is seriously impacted. Using the LCD to view images depletes the battery extremely fast.*

White Balance Setting

The color of an object changes depending on the color of the light that reflects off of it. The human eye and brain translate this when looking at objects in different color light. Hold a white piece of paper outside in sunshine and it looks white, and then hold that same piece of paper in the shade and it looks white. The human brain naturally adjusts because you know the paper should be white. The sensor in the A700 records the values as it sees them, not knowing what the situation is. It is up to the photographer to set the white balance, and in doing so, tell the camera what the scene is.

1.24 The White Balance menu is clear and easy to read and can easily be navigated using the multi-selector.

The A700 has a wide range of white balance settings that cover a wide range of lighting situations. Most of the settings can also be fine-tuned to achieve more natural-looking colors.

Cross-Reference *White balance is covered in detail in Chapter 2.*

✦ **Auto White Balance.** Auto White Balance or AWB sets the white balance automatically.

✦ **Daylight.** This setting is for photos taken in the bright direct sunlight outdoors. You can fine-tune the setting by adding or subtracting up to 3 stops. Adding increases the color temperature and increases the red tone, and decreasing turns the image paler.

✦ **Shade.** This is for when the subject is in the shade on a bright sunny day. This setting can be fine-tuned by 3 stops, where adding increases the red tone and decreasing reduces the red tone.

✦ **Cloudy.** This setting is best used for shooting outdoors under a cloudy sky. This setting can be fine-tuned by 3 stops, where adding increases the red tone and decreasing reduces the red tone.

✦ **Tungsten.** Tungsten lights are used mainly in incandescent lighting, and are used in everything from household lamps to flashlights to commercial lighting. This setting can be fine-tuned by 3 stops, where adding increases the red tone and decreasing reduces the red tone.

✦ **Fluorescent.** Fluorescent lighting is very common and can seem harsh and displeasing. When shooting in fluorescent lights, not setting the white balance can cause a loss of reds in the image. The white balance can be fine-tuned from a positive 4 to a negative 2. Adding increases the amount of red. Because fluorescent lights can cause a subject to look pale to begin with, adding red is more important than subtracting it.

✦ **Flash.** This is color balanced for using the built-in flash and Sony external flashes. This setting can be fine-tuned by 3 stops, where adding increases the red tone and decreasing reduces the red tone.

✦ **Color temperature / Color filter.** The white balance can be set using a color temperature. The color temperature can be set between 2500K and 9900K. Once the color temperature is set, it can be adjusted from Green (G) to Magenta (M) the same way a color compensation filter is used in film photography. There are a total of 18 steps of adjustments, 9 for green and 9 for magenta.

Cross-Reference *Color temperature is covered in greater detail in Chapter 4.*

✦ **Custom white balance.** Using a Custom white balance is great for scenes with multiple types of light. The A700 lets you store three Custom white balance settings, each one accessible from the White Balance menu.

Cross-Reference *Setting a Custom white balance is covered in Chapter 2.*

Note *The white balance can be changed with software after the photo has been taken. This used to only be possible when the photo was taken in the RAW format. With the release of Adobe Photoshop CS3, it is now possible to change the white balance on JPEG files as well.*

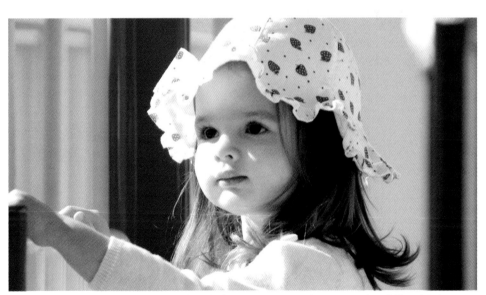

1.25 Images taken in the wrong white balance can cause dramatic color shifts. This image was taken with the white balance set to AWB (Auto White Balance) which rendered great colors.

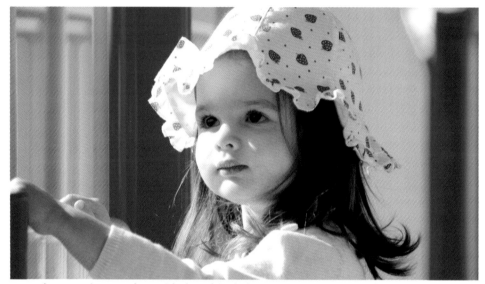

1.26 The same image taken with the white balance set to Tungsten makes the colors look unnatural with a strong blue cast.

Metering Modes

The Sony Alpha A700 has three Metering modes: Spot, Center-weighted, and Multi-segment.

✦ **Multi-segment metering.** The Sony Alpha A700 uses a 40-segment metering system. There are 39 sensors in a honeycomb pattern for the main area and one sensor that covers the surrounding area. The metering system is linked to the auto focus system so that the main subject is exposed correctly.

1.27 The Metering mode lever makes it easy to switch among Metering modes.

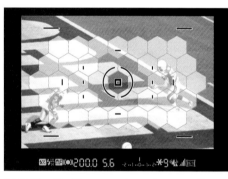

1.28 The Multi-segment mode uses all 39 of the honeycomb sensors and the outside area as the 40th sensor. The Center-weighted metering mode uses the red and yellow segments, and Spot metering uses the red center sensor area.

✦ **Center-weighted metering.** The entire scene is metered, but the center of the scene is given greater emphasis over the outer areas.

✦ **Spot metering.** This mode uses the light measured in the center area to calculate the exposure. This is used when the exposure of a part of the subject is more important than the whole scene. The center area used to calculate this exposure is shown on the viewfinder.

Scene Exposure Modes

There are six Scene Exposure modes, and they can be easily set by turning the Mode dial to the desired Scene Exposure mode. Any changes that you make while in one of the Scene Exposure modes resets if the Mode dial is moved.

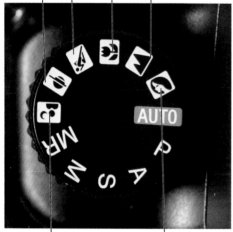

Sunset mode Sports Action mode Macro mode Landscape mode

Night View/ Night Portrait mode Portrait mode

1.29 The Mode dial makes it easy to quickly switch Scene Exposure modes.

✦ **Portrait.** Setting the Exposure mode to Portrait sets a larger aperture (smaller number), which decreases the depth of field. This keeps the subject in focus but the background out of focus. Portrait mode also sets the D-Range Optimizer to Advanced Auto.

✦ **Landscape.** In Landscape mode, the camera sets a smaller aperture (larger number), which increases the depth of field. Using the smallest aperture possible helps keep everything from the foreground to the background in acceptable focus.

✦ **Macro.** Macro mode sets the shutter speed as high as possible and tries to keep the aperture at f/5.6 if possible. Macro mode also sets the D-Range Optimizer to Advanced Auto.

✦ **Sports Action.** Sports photography is all about stopping the action, and this setting tries to use the fastest shutter speed possible. It also sets the Drive mode to Continuous High-Speed Advance, and it changes the Focus mode to Continuous Auto Focus if necessary. Sports Action mode also sets the D-Range Optimizer to standard.

✦ **Sunset.** In Sunset mode the camera sets a smaller aperture (larger number), which increases the depth of field. Sunset mode turns the D-Range Optimizer off.

✦ **Night View / Night Portrait.** The camera sets a slower shutter speed to try to capture the night scene. The difference between Night View and Portrait is the use of the flash; the flash is activated in Night Portrait mode. D-Range Optimizer is turned off in this mode.

Semiautomatic and Manual Exposure Modes

The Mode dial is used to set the Semi-automatic and Manual Exposure mode. It's as easy as turning the dial to the desired mode.

✦ **Auto.** Setting the camera to the Auto mode gives control of all exposure settings to the camera. The A700 allows you to change the white balance, ISO, Creative Style, D-Range Optimizer, Flash mode, exposure compensation and flash compensation, Focus mode, Drive mode, image quality, and image size. When the dial is moved from the Auto setting to any of the other modes settings and then back to Auto, all the changes except for image quality and image size are reset to the default settings.

✦ **Program Exposure.** Although the Program mode and the Auto mode might seem similar, they differ in some very important ways. The shutter speed or the aperture can be adjusted by using the Front and Rear control dials. Any changes that are made in this mode are reset if the Mode dial is moved.

✦ **Aperture Priority.** In the Aperture Priority mode, you set the aperture, and the camera sets a shutter speed to achieve proper exposure based on the Metering mode. The aperture is set by using either the Front or Rear control dial.

✦ **Shutter Priority.** In Shutter Priority mode, you set the shutter speed and the camera sets the aperture

to achieve proper exposure based on the Metering mode. The shutter speed is set by using either the Front or Rear control dial.

✦ **Manual Exposure.** In this mode, you set both the aperture and the shutter speed. By default, the Rear control dial controls the aperture, and the Front control dial controls the shutter speed. As the aperture and shutter speed are changed, the camera displays how close your selected exposure is to the metered exposure on the EV scale.

Drive Modes

The A700 has eight different Drive modes. The Drive modes are set using the Drive menu, which is accessed by pressing the Drive mode button on the top of the camera. The drive menu can also be accessed by pressing the Function button to bring up the Quick Navigation screen and using the multi-selector to navigate to the Drive mode.

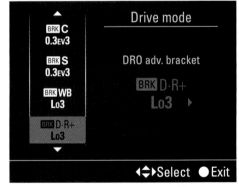

1.30 The Drive menu is accessed by pressing the Drive mode button or by using the Quick Navigation screen.

✦ **Single Frame Advance.** In this mode, the camera takes one exposure every time the shutter is pressed.

✦ **Continuous Advance.** There are two settings in the Continuous Advance mode: Hi and Lo.

 • **Hi Continuous Advance mode.** The A700 shoots at a maximum of 5 frames a second when the shutter speed is 1/250 or higher, manual focus is used, image quality is Fine, and file size is Large.

 • **Lo Continuous Advance mode.** The A700 shoots at 3 frames a second. The number of images that can be shot continuously depends on the quality and size of the image.

✦ **Self-timer.** There are two modes in the Self-timer mode; a 2-second timer mode and a 10-second timer mode.

 • **2-second mode.** This mode locks the mirror up before taking the photograph, making it very useful in reducing camera shake. Once you engage the 2-second mode, it cannot be cancelled before the photograph is taken.

 • **10-second mode.** This mode is useful when you want to be in the photograph. The self-timer lamp located on the front of the camera flashes before the shot is taken in the 10-second mode. The 10-second mode can be cancelled by pressing the Drive mode button before the photograph is taken.

✦ **Continuous Bracketing.** There are six different Continuous Bracketing modes available on the A700. Holding the Shutter button down takes three or five shots in rapid succession.

 • **0.3ev3.** This setting lets you take three photos continuously with the exposure shifted by .03 of a stop. The order of the images is correct exposure, underexposed by 0.3 of a stop, and overexposed by 0.3 of a stop.

 • **0.3ev5.** This setting lets you take five photos continuously with the exposure shifted by .03 of a stop. The order of the images is correct exposure, underexposed by .03 of a stop, overexposed by 0.3, underexposed by 0.6 of a stop, and overexposed by 0.6 of a stop.

 • **0.5ev3.** This setting lets you take three photos continuously with the exposure shifted by.05 of a stop. The order of the images is correct exposure, underexposed by 0.5 of a stop, and overexposed by 0.5 of a stop.

 • **0.5ev5.** This setting lets you take five photos continuously with the exposure shifted by .05 of a stop. The order of the images is correct exposure, underexposed by .05 of a stop, overexposed by 0.5 of a stop, underexposed by 1 step, and overexposed by 1 stop.

- **0.7ev3.** This setting lets your take three photos continuously with the exposure shifted by .07 of a stop. The order of the images is correct exposure, underexposed by 0.7 of a stop, and overexposed by 0.7 of a stop.

- **0.7ev5.** This setting lets you take five photos continuously with the exposure shifted by .07 of a stop. The order of the images is correct exposure, underexposed by .07 of a stop, overexposed by 0.7 of a stop, underexposed by 1.4 stops, and overexposed by 1.4 stops.

✦ **Single Frame bracketing.** Single Frame bracketing is the same as Continuous Frame bracketing except that the Shutter button must be pressed for each photo.

✦ **White balance bracketing.** White balance bracketing takes three photos every time the Shutter button is pressed. The three images are identical except that the first photo has the set white balance, the second has less red and is paler, and the third has more red. The amount of change between the three can be set in the Drive menu using the Lo3 and Hi3 choices. The Hi3 adds and subtracts greater amounts of red than the Lo3 setting does.

✦ **DRO bracketing.** Each time the Shutter button is released, the A700 takes three different photos, each with separate optimization of colors. The three images are recorded in the following order: low, mid, high. The D-Range Optimization (DRO) bracketing

Drive mode has two choices. The Lo3 choice lowers the DRO bracketing when taking the photo, and the Hi3 choice amplifies the DRO bracketing. These settings can be applied in the Drive mode menu. DRO is covered later in this chapter.

✦ **Remote Control.** In this mode, the A700 is triggered either by the Shutter button or the 2-second button on the Remote Commander. The 2-second button on the remote locks the mirror up before the photo is taken, minimizing camera shake as much as possible.

Creative Styles

There are 14 different Creative Styles (previously called Color modes) preprogrammed into the A700, but the Creative Styles menu that opens when the Custom button is pressed only has places for 7 of the 14 styles. The first four menu choices are unswitchable, meaning they cannot be changed. The styles are

✦ **Standard.** Captures a wide variety of scenes with rich colors.

✦ **Vivid.** Useful for capturing scenes with bright colors; the saturation and contrast are both increased.

✦ **Neutral.** Both sharpness and saturation are decreased in this color space. This is recommended for images that will be adjusted on a computer.

✦ **AdobeRGB.** Captures images using the AdobeRGB color space. This is the most well-known color space for professional photographers.

Each of these four choices can also be adjusted by changing their contrast, saturation, and sharpness.

The three remaining choices can be assigned any of the 14 styles, including the four that are assigned to the unswitchable choices. When any of the 14 styles are set to one of the three empty slots, they can be adjusted in five different ways: contrast, saturation, sharpness, brightness, and zone matching. The remaining styles are

✦ **Clear.** Darkens the overall color tone and increases the contrast.

✦ **Deep.** Reduces the contrast, bringing out more detail in dark, solid color areas.

✦ **Light.** Brightens the overall tone of the image.

✦ **Portrait.** Skin tones are captured in a soft tone, making this mode the choice for portraits.

✦ **Landscape.** Contrast, saturation, and sharpness are increased to capture landscapes.

✦ **Sunset.** Helps to capture the reds of sunset.

✦ **Night View.** The contrast is weakened, giving a more realistic view of night scenes.

✦ **Autumn Leaves.** Pushes the colors to capture the reds and yellows of autumn.

✦ **B/W.** Captures the image in black and white.

✦ **Sepia.** Captures the image in sepia (a yellow-brown tone). This gives the image an old world look closely associated with the photographs of the Old West.

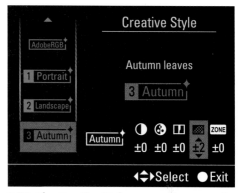

1.31 The Creative Styles menu is accessed by pressing the Creative Style button and is easily navigated by using the multi-selector.

The Creative Styles cannot be used with any of the Scene Exposure modes. If you press the Custom button when in any of the Scene Exposure modes, the LCD displays an Invalid Operation screen and you have to press the multi-selector center button to continue.

D-Range Optimization

Dynamic Range Optimization or DRO technology lets the A700 analyze the image and helps to recover details in the dark and bright areas of the scene. Each of the Scene Exposure modes sets the DRO automatically, but they can be changed. The changes are not permanent, and if the Mode dial is moved from one scene to the next, the DRO resets to the default for that particular Scene Exposure mode.

Pressing the Function button opens the Quick Navigation screen and using the multi-selector navigates to the D-Range Optimization setting. Pressing the multi-selector center button opens the D-Range

Optimization menu and allows you to set the D-Range Optimization. Press the Menu button and use the multi-selector to open the Recording menu 1; then set the desired mode. The D-Range Optimization works in all file qualities and sizes.

There are four D-Range Optimization choices:

✦ **Off.** When the DRO is turned off, it does not correct any brightness or contrast.

✦ **Standard.** In the Standard mode, the DRO adjusts the brightness and the contrast of the entire image.

✦ **Advanced Auto.** The contrast and color reproduction of the scene is optimized by areas of color in the scene.

✦ **Advanced Level.** Five levels of optimization are available. They all optimize the color reproduction and contrast of the scene, but in varying degrees from weak (Lv1) to strong (Lv5).

Setting Up the Alpha A700

As discussed in the Quick Tour, going out and shooting good photographs with the A700 on Auto mode is relatively easy, but if all you wanted was a fully automatic camera, most likely you would not be using the A700. This chapter delves into the more advanced features and settings available to you, and there are a lot of them. The A700 is one of the most customizable cameras I have ever used. Not only is there a huge selection of options, but there are multiple ways to access most settings.

Choosing the Exposure Mode

The Mode dial on the top left of the camera is where the first decision has to be made. The dial has twelve different exposure settings, and picking the right one is very important to getting the image you want. The settings are grouped into two sets. The first set is the basic Exposure modes; the second set is the Scene selection modes.

Basic Exposure modes

The six basic Exposure modes are Auto (A) mode, Program Auto (P) mode , Aperture Priority (A) mode, Shutter Speed Priority (S) mode, Manual (M) mode, and Memory Recall (MR) mode. Selecting any of these modes is done by rotating the Mode dial to the corresponding letter.

Auto mode

Using the Auto mode is a great place to start when first using your camera. This mode is fully automatic, and the camera

adjusts the settings automatically without any input from you. This mode turns your A700 into an expensive point-and-shoot camera, and although it doesn't offer you many choices, it does a great job in most situations. Even when the A700 is on Auto mode, you can still change settings. These settings last until the camera is turned off or the Mode dial is moved from the Auto setting to any of the other settings. Using the Function button to open the Quick Navigation screen, you can change the Flash mode, exposure compensation, flash compensation, ISO, Drive mode, auto focus area, Dynamic-Range Optimizer, Creative Style, white balance, image quality, and image size. You can also access the drive, white balance, ISO, and exposure compensation from their individual buttons. The only settings that stay after the camera has been turned off or the Mode dial has been changed from Auto are the file quality and image size. When the built-in flash is up, the default mode is for the flash to fire when the camera determines there is not enough available light.

Program Auto mode

In Program Auto mode, the camera sets both the shutter speed and the aperture in the same way as it does in Auto mode. The big difference is that you can override the shutter speed choice or the aperture choice, but not both at the same time.

Set the Mode dial to P and look through the viewfinder and compose your photo. Pressing the Shutter button halfway down causes the camera to set the exposure and display the shutter speed and aperture in the viewfinder. Rotating the Front control dial changes the shutter speed and the camera then sets a new aperture to achieve proper exposure. This is great for when you

want to quickly adjust the shutter speed for a couple of shots. When you change the shutter speed, the display on the LCD changes from P to PS. Rotating the Rear control dial changes the aperture and the camera then sets a new shutter speed. This is a great way to quickly adjust the depth of field. When you change the aperture, the display on the LCD changes from P to PA.

If the built-in flash is popped up when the camera is in Program Auto mode, it fires regardless of the amount of ambient light. Opening the flash also resets any changes you made to the aperture or shutter speed.

This mode is great to shoot in if you want to treat your camera like a point-and-shoot but with the ability to override the camera defaults if necessary. It also gives better flash control, especially when used as fill flash in bright light. I usually keep my camera on P mode as the default setting. This makes it easy to grab and use in an instant.

Aperture Priority mode

In Aperture Priority mode, you pick the aperture, and the camera sets the shutter speed. To set the camera to Aperture Priority mode, turn the Mode dial to A. The aperture can be set with either the Front or Rear control dial. The range of apertures available is determined by the lens that is attached to your camera. By default, the aperture values can be set in 1/3 stop increments.

When the built-in flash is open, the flash fires regardless of the amount of ambient light.

I use Aperture Priority when I shoot portraits and especially when I shoot landscapes. This setting lets me control the background better than any other mode. I can set the aperture to keep the background out of

focus for portraits — a shallow depth of field — or to keep everything in focus for landscapes — a deep depth of field. Either way, the camera sets the shutter speed for the best exposure.

 Cross-Reference *For more on depth of field, see Chapter 3.*

Shutter Speed Priority mode

In Shutter Speed Priority mode, you pick the shutter speed, and the camera picks the aperture. Turn the Mode dial to S to set the camera to Shutter Speed Priority mode. The Front or Rear control dials set the shutter speed between 30 seconds and 1/8000 of a second.

When using the built-in flash with the Super SteadyShot activated, the range of shutter speeds is from 30 seconds to 1/200 second. When using the built-in flash with the Super SteadyShot turned off, the range of shutter speeds is 30 seconds to 1/250 second. If the built-in flash is open, the flash fires regardless of the amount of ambient light in the scene.

This mode is essential for sports and action photography where freezing the action takes high shutter speeds. When it is more important to control the action, I shoot in S (Shutter Speed Priority) mode.

Manual mode

In the Manual mode you pick both the shutter speed and the aperture; the camera shows you if it thinks that your exposures will be over- or underexposed but won't change any settings. Turning the Mode dial to M puts the camera into Manual mode. When in Manual mode, the Front control dial controls the shutter speed and the Rear control dial controls the aperture.

When in Manual mode, the built-in flash fires if open regardless of the amount of ambient light.

I use Manual mode when I work in the studio. Because the A700 has no idea how much light is being put out by my studio flashes, I need to manually dial in the exposure. I also use the Manual mode when shooting light trails and nighttime shooting. The metering system tends to overexpose the scene due to the large amount of black in the scene.

 Cross-Reference *Chapter 4 has more on studio flashes and lighting.*

Memory Recall mode

The A700 has a unique Memory Recall mode, which lets you save up to three groups of settings to be used later. When the Mode dial is turned to MR, the multi-selector can be used to choose between three different saved settings. The A700 lets the user set a huge variety of modes and settings.

You can save any combination of the following settings: Drive mode, ISO Sensitivity, white balance, exposure compensation, Metering mode, Focus mode, image size, Aspect ratio, image quality, D-Range optimizer (DRO), Creative Style, Custom button, Exposure step, Flash mode, Flash control, Power ratio, flash compensation, ISO Auto maximum, ISO Auto minimum, AF-A setup, AF area, AF area position, Priority setup, AF illuminator, AF with shutter, Long Exposure Noise Reduction, High ISO Noise Reduction, and Recording mode.

When saving the Recording mode, it is important to remember that the exposure value is saved along with the mode. When the Recording mode is set to A, the aperture

value is also saved; when the Recording mode is set to S, the shutter speed is also recorded; and when the Recording mode is set to M, both the shutter speed and the aperture values are recorded. These become the starting values when that set is recalled.

Registering your own settings is deceptively easy. Simply follow these steps:

1. **Adjust the camera settings exactly the way that you want them.** This includes the Recording mode, Drive mode, ISO, white balance, exposure compensation, Metering mode, Focus mode, image size, Aspect ratio, image quality, D-Range Optimizer, Creative Style, Custom button setting, Exposure step, Flash mode, Flash control, Power ratio, flash compensation, ISO Auto maximum, ISO Auto minimum, AF-A setup, AF area, AF area position, Priority setup, AF illuminator setting, AF w/shutter, Long Exposure Noise Reduction, and High ISO Noise Reduction.

2. **Press the Menu button on the back of the camera.**

3. **Use the multi-selector to navigate to Recording menu 4.**

4. **Press the multi-selector's center button to active the Memory menu.**

5. **The Select register menu opens.** Use the multi-selector to choose the first, second, or third memory registers.

6. **Press the multi-selector's center button to save the current settings to the chosen memory register.**

To retrieve the saved settings, rotate the Mode dial to the MR position to open the Memory Recall screen on the LCD. Select the register number to be recalled by pressing the multi-selector's center button. After the selection has been made, the dials and levers might not match the actual settings of the camera. For example, if the Exposure Metering mode was set to Spot by having the Metering mode lever set to the Spot selection, and the Memory Recall mode was using the Multi-segment metering, the camera will use Multi-segment metering as long as you are using that memory setting.

Tip *It is important to refer to the information on the Recording Information display and not the actual levers on the camera.*

Choosing a Scene selection

Instead of choosing one of the basic Exposure modes, setting the Mode dial to one of the Scene selections sets the camera for a specific purpose. The best part of the Scene selections is that they are great starting points. Each Scene selection can be adjusted by pressing the Function button and adjusting everything from the focus area to the white balance. These settings are not saved if the Mode dial is moved to another Exposure mode.

When using the Scene selections, the Metering mode on the A700 is set to Multi-segment no matter what the Metering mode lever is set to. You can, however, change the Metering mode by using the Metering mode lever when in any of the scenes. The Metering mode defaults back to Multi-segment if the Mode dial is moved to another Exposure mode. The Creative Style

menu is disabled when in a Scene selection mode. If the Creative Style button is pressed in any of the modes, the LCD displays an Invalid Operation message.

Portrait

Portrait mode is aimed at helping get the best results when shooting an individual portrait. When you set the Mode dial to Portrait, the camera tries to use the largest aperture (smaller f/number), decreasing the depth of field. The shallow depth of field keeps the subject in focus but softens the background and the foreground, making the subject of the photo stand out.

Other settings can all be changed, but the defaults are

✦ Auto Flash mode (if flash is up), no exposure or flash compensation

✦ Auto ISO

✦ Drive mode set to Single-Shot Advance

✦ AF area set to Wide

✦ Dynamic-Range Optimizer set to Advanced Auto

✦ White balance set to AWB

The Portrait mode also sets the Auto Focus mode to AF-A, Automatic Auto Focus, regardless of what the Focus mode lever is set on. The Auto Focus mode can be changed by using the Focus mode lever, but regardless of what the setting is, it defaults back to AF-A if the Mode dial is moved.

Pressing the dedicated Drive, WB, and ISO buttons opens the associated dedicated menus, and pressing the Function button opens the Quick Navigation screen, allowing you to change the other settings. You can also change the file quality and the image size in Quick Navigation mode, but these

changes do not reset when changing the camera from one mode to another.

Landscape

The Landscape mode sets a smaller aperture (larger f/number) to increase the depth of field. A deep depth of field keeps more of the image in focus from foreground to background. Several of the default settings when in Landscape mode can be changed by pressing the Function button to access the Quick Navigation screen. These settings include

✦ Flash mode to Auto, the flash compensation and the exposure compensation to 0

✦ ISO set to Auto

✦ Drive mode set to Single Frame Advance

✦ AF area set to Wide

✦ Dynamic-Range Optimizer set to Advanced Auto

✦ White balance set to AWB

Any changes made to these settings are reset if the Mode dial is moved.

Landscape mode also changes the Auto Focus mode to AF-A, Automatic Auto Focus, no matter what the Focus mode lever is set to. You can change the mode by using the Focus mode lever. All settings changed when in Landscape mode return to defaults if the Mode dial is moved.

Macro

The A700's Macro setting tries to keep the shutter speed fast enough to avoid blur and the aperture small enough to produce ample depth of field to keep the whole image in focus. If the flash is raised, the Flash mode is set to Auto and the flash

compensation is set to 0 by default. The other default settings are the exposure compensation set to 0, the ISO set to Auto, the Drive mode set to Single Frame Advance, the AF area set to Wide, and the D-Range Optimizer set to Advanced Auto. All of these settings can be changed by pressing the Fn (Function) button to access the Quick Navigation screen.

Sports Action

The Sports Action setting uses the fastest shutter speed possible to freeze the action. The default settings are

- ✦ Flash mode set to Auto
- ✦ Exposure and flash compensation set to 0
- ✦ ISO set to Auto
- ✦ Drive mode set to Continuous Hi
- ✦ AF area set to Wide
- ✦ Dynamic-Range Optimizer set to Standard
- ✦ White balance set to AWB

These settings can be adjusted by using the dedicated Drive, WB, and ISO buttons, or by using the Quick Navigation screen accessed through the Function button.

The Sports Action setting also sets the Auto Focus mode to AF-C, Continuous Auto Focus, to help capture moving objects. You can change the Auto Focus mode by moving the Focus mode lever, but if the Mode dial is moved to another setting, it defaults back to AF-C.

Sunset

The Sunset mode uses a smaller aperture to increase the depth of field in the scene. The Sunset mode sets

- ✦ Flash mode to Auto
- ✦ Exposure and flash compensation to 0
- ✦ ISO to Auto
- ✦ Drive mode to Single Frame Advance
- ✦ AF area to Wide
- ✦ White balance to AWB
- ✦ Turns the Dynamic-Range Optimizer off

You can adjust any of these settings either by using the dedicated Drive, WB, or ISO buttons, or by using the Function button to access the Quick Navigation screen. The Auto Focus mode is set to AF-A, Automatic Auto Focus, but this can be changed with the Focus mode lever.

Night View / Night Portrait

The difference between Night View and Night Portrait is the use of the flash. When the flash is up, the camera assumes that the photo is a night portrait, and when the flash is down, it is a night view photo. In both Night View and Night Portrait mode, the defaults are

- ✦ Shutter speed reduced to make use of all available light
- ✦ Exposure compensation set to 0
- ✦ ISO set to Auto
- ✦ Drive mode set to Single Shot Advance
- ✦ AF area is set to Wide
- ✦ Dynamic-Range Optimizer off
- ✦ White balance is set to AWB

Additionally, in the Night Portrait mode, the flash is set to Auto and the flash compensation is set to 0.

Because the shutter speed is reduced, a tripod is suggested for sharp images when using the night modes.

Using the Function Button

The Function (Fn) button on the back of the A700 is the single most useful button before pressing the shutter release. This button lets you access the important settings quickly and efficiently by opening the Quick Navigation screen on the LCD. When the Quick Navigation screen is accessed, the values that can be changed are shown in white, those that cannot be changed are shown in gray, and the current selection is shown in orange. Navigating through the choices is done with the multi-selector, and changing the values can be done with either the Front or Rear control dial. You can also open the custom menus for each selection by using the center button on the multi-selector.

Being able to change the exposure, AF area, Drive mode, white balance, ISO, Dynamic-Range Optimizer, flash compensation, image size, and image quality even when in the Enlarged Display mode, along with the Creative Style and Flash mode when in Normal mode, makes adjusting for changing shooting conditions really fast. There is no need to navigate through a series of menus or to remember which buttons to press; just navigate on the LCD screen to the setting you want to change and rotate the Rear control dial or press the multi-selector's center button. It is that fast and simple.

Note *Two important shooting settings are not accessible through the Quick Navigation screen: the Focus mode and the Metering mode.*

File Quality, Size, and Aspect Ratio

Digital cameras introduced a whole new set of challenges to photographers. The digital sensor captures the photo information, and it is up to the photographer to decide how the data is stored by the camera. The A700 has three different settings that affect the file that is produced when an image is saved to the memory card: file quality, file size, and aspect ratio. These settings can be changed at any time and do not reset if the camera is turned off or the Mode dial is moved. These settings default the image quality to Fine, the image size to Large, and the aspect ratio to 3:2 if the Recording mode is reset in Recording menu 4 or by using the reset default in Setup menu 3.

Choosing the file quality

File quality can have a huge impact on the way you set up your digital workflow. There are positives and negatives to each of the file qualities, and knowing these before you start to take photos is important. The two file types the A700 produces are JPEG and RAW. And, there are seven different JPEG/RAW settings you can choose from when setting the file quality of the images you capture.

✦ **RAW.** When using this setting, each image is stored in the basic RAW format. This mode saves the image as an uncompressed RAW file. The information from the A700's sensor is saved without any processing. Images taken in this mode cannot be used without first being converted into a useable format. Because RAW files save the raw data from the camera, the white balance can be adjusted in the computer after the images

Digital Workflow

Developing photographs used to take place in a lab with trays of chemicals and big mechanical enlarges. With digital photography, that old darkroom has been replaced with a digital darkroom, and instead of using the right mix of chemicals to develop your photos, you use a computer. The digital workflow describes the process from downloading your images to the computer to getting a final product. Everybody has a slightly different workflow. My basic workflow is as follows.

I download the images to my computer using a card reader. I sort the images using software, and then I adjust the best images for printing or use on the Internet, or sometimes both.

have been taken with no loss to image quality.

✦ **cRAW.** The cRAW format is a compressed form of the RAW format. This mode is the same as RAW except that it uses a lossless compression algorithm to save more images to the memory card.

✦ **RAW & JPEG.** This setting stores the photo in both the RAW and JPEG formats. This is my favorite mode; it saves each photo in the two formats simultaneously. This is the best of both worlds, you have the RAW file if major work needs to be done to the image, but you also have a version that is usable right out of the camera. The down side is that this takes up more space on the memory cards than just using RAW or just using JPEG. If you want to start shooting using RAW, this is a great place to start because you get both types of files.

✦ **cRAW & JPEG.** This setting stores the photo in both the cRAW and JPEG formats. This uses the compressed RAW file instead of the regular RAW file but is otherwise identical to the RAW & JPEG setting.

✦ **Extra Fine.** This is a JPEG mode that is only slightly compressed. This file quality gives the best quality JPEG image. If you want to be able to use your images directly from the camera and have no need or want to work with RAW files, then this is the mode for you. One reason to use JPEG over RAW is when the Drive mode is set to continuous HI. Because the file sizes are smaller, they get saved faster and the camera can keep shooting for longer periods of time.

✦ **Fine.** This is a JPEG mode with more compression than Extra Fine. This default image quality is a trade-off between Extra Fine and Standard. The images are better than Standard, but they also take up more space on the memory card. Even though this is the default mode for the camera, using Extra Fine produces better results. If you are only going to print a 4×6 inch picture, then this suffices.

✦ **Standard.** This JPEG mode uses the most compression to make the smallest file sizes. The only time I ever use this is when I am absolutely positively sure that the image will only be used on the Internet or in e-mail.

JPEG

The JPEG (Joint Photographic Experts Group) file format was created in 1992 and approved in 1994 to create a standard way to compress photographic files. The advantages to JPEG files are that they are relatively small and universally readable. The JPEG format is also used to store and display images on the World Wide Web, and images stored in this format do not need any other processing for the photographer to use them. Because of their smaller size, more images can be stored on a memory card and less space is needed on a computer to store them.

The downside to the JPEG format is that the image is compressed, removing data that cannot be recovered later, to make the file size smaller. JPEG files are saved as 8-bit data, meaning that each level of color can have only 256 possible values compared to 4,096 values in a 12-bit RAW file. The image settings you apply when you take the photo, especially the white balance, can't be changed after the fact without a lot of post-processing work.

RAW

RAW files contain the raw unprocessed data taken directly from the camera's sensor. The biggest advantage that RAW files have over JPEG files is the ability to change the settings the image was taken with after the image has been captured.

The downside of the RAW format is that the file needs to be processed before it can be used. The RAW file needs to be processed by a computer using special software that can read the RAW file. The image can then be saved as a file that is useable by the Internet or printer. RAW file formats are usually proprietary formats created by each individual camera company, and the RAW

file format in the A700 is ARW. These files have all the information that the sensor captured, making the files much bigger than their JPEG counterparts. This increase in size means that fewer images can be stored on a memory card, and it takes longer to write the information from the camera buffer to the memory card.

Advances in software and hardware have started to blur the lines between the two file formats. It is now possible to correct the white balance of a JPEG file in the same manner as a RAW file using Adobe Photoshop CS3 and Adobe Camera Raw. The new UDMA CompactFlash cards like the Lexar UDMA 300x Professional series lets information be written to the memory cards faster than ever before; and with card sizes of 8 gigabytes, you can store over 400 RAW files to one card. Sony has also produced a compressed version of their RAW file to help with the file size of the RAW images.

The A700 can store the same photo in both the RAW and JPEG formats at the same time. The setting that I use most of the time is the RAW & JPEG with the image size set to large and the aspect ratio set to 3:2. I find that this way I have the best of both worlds, with a processed file that is ready to be e-mailed or used on a Web site and the RAW file in case something goes wrong.

Tip | *The speed increase and the price decrease of the new CompactFlash cards makes it possible to capture full-size RAW files faster than ever and have enough memory for any occasion.*

Setting the image size

When the file quality is set to RAW & JPEG or cRAW & JPEG, the image size is being applied only to the JPEG files. There are

three image sizes available on the A700: large, medium, and small. All image sizes are described using M, which stands for megapixel (one million pixels).

✦ **Large.** The large image size is 12.0M when in Large mode, creating file sizes of 4272 × 2848 pixels in the 3:2 aspect ratio. When in the 16:9 aspect ratio, the large image size is 10.0M, creating a file with 4272 × 2400 pixels.

✦ **Medium.** The large image size is 6.4M when in Large mode, creating file sizes of 3104 × 2064 pixels in the 3:2 aspect ratio. When in the 16:9 aspect ratio, the large image size is 5.0M creating a file with 3104 × 1744 pixels.

✦ **Small.** The large image size is 3.0M when in Large mode, creating file sizes of 2128 × 1424 pixels in the 3:2 aspect ratio. When in the 16:9 aspect ratio, the large image size is 2.6M, creating a file with 2128 × 1200 pixels.

Setting the image size is easily done.

1. **Press the Menu button to open the A700's menus.**

2. **Use the multi-selector to navigate to Recording Menu 1.**

3. **Use the multi-selector to navigate to Image size.** If Image size is grayed out, the Image quality is set to RAW or cRAW and the Image size cannot be set.

4. **Press the multi-selector's center button to open the Image Size menu.**

5. **Select the image size using the multi-selector.**

6. **Press the multi-selector's center button to start using the selected image size.**

7. **Press the Menu button to return to the Recording Images screen.**

Setting the aspect ratio

The *aspect ratio* is the width-to-height ratio of the image. The Sony Alpha A700 lets you choose between two different aspect ratios — 3:2 and 16:9. The aspect ratio also affects the final size of the image; because the 16:9 ratio doesn't use the full area of the sensor, the file sizes are slightly smaller.

✦ **3:2 aspect ratio.** The 3:2 aspect ratio is the standard ratio for 35mm film cameras and 6-×-4-inch prints. This is the aspect ratio to use to get the same dimensions as traditional film and print sizes. This is the default aspect ratio, and is what I recommend for most photos. If you plan on printing your images using any standard printer or paper, this is the ratio to use.

✦ **16:9 aspect ratio.** The 16:9 aspect ratio is used to describe wide-screen televisions. The 16:9 aspect ratio is the standard for high definition, and because the Sony Alpha A700 can output its signal straight from the camera to a high-definition television using the HDMI port, you can set the aspect ratio to match. Although this is definitely a great way to view images, I would still recommend not using this mode unless your main purpose is to show the images on an HDTV. Any image taken in this aspect ratio must be severely cropped to fit a standard photo size.

To set the aspect ratio, do the following:

1. **Press the Menu button to open the A700's menus.**

2. **Use the multi-selector to navigate to Recording Menu 1.**

3. **Use the multi-selector to navigate to aspect ratio.**

4. **Press the multi-selector's center button to open the aspect ratio menu.**

5. **Select the aspect size using the multi-selector.**

6. **Press the multi-selector's center button to start using the selected aspect ratio.**

7. **Press the Menu button to return to the Recording Images screen.**

White Balance

The type of light illuminating your subject affects its color, and the information the sensor records needs to be adjusted to match the type of light. This is done by setting the white balance.

Although daylight is considered to be white, add some clouds and the day can take on a blue cast. Shoot indoors under a fluorescent light and your subject can take on a green cast or a red cast when shooting with an incandescent light as your light source. In order to counteract this from happening, you need to set your camera to the right white balance for the situation.

On the Sony Alpha A700, you can choose from preset white balances that include Auto White Balance (AWB), Daylight, Shade, Cloudy, Tungsten, Fluorescent, Flash, and Color Temperature. You can also set your own Custom white balance.

Tip *If you shoot RAW, the white balance can be changed after the photo has been taken. And although getting the correct white balance in the first place is preferred, the ability to adjust the white balance later is one of the best reasons to use the RAW file types.*

Setting the white balance

Setting the white balance is done using the White Balance menu. There are two ways to access the White Balance menu. The most basic is to press the White Balance button on top of the camera. However, you can also get there from the Quick Navigation screen:

1. **Press the Function button to open the Quick Navigation screen.**

2. **Use the multi-selector to navigate to the white balance setting.**

3. **Press the multi-selector's center button to open the White Balance menu.**

Once the White Balance menu is open, the camera can be set to one of nine different white balance settings.

◆ **Auto white balance**

◆ **Daylight**

◆ **Shade**

◆ **Cloudy**

◆ **Tungsten**

◆ **Fluorescent**

◆ **Flash**

◆ **Color Temperature / Color filter**

◆ **Custom white balance**

To select a white balance, use the Front control dial or push the multi-selector up or down. Activate the selected white balance by either pressing the Shutter button or pressing the multi-selector's center button.

The Daylight, Shade, Cloudy, Tungsten, Fluorescent, and Flash white balance settings can all be fine-tuned using the White Balance menu. Once one of these white balance settings has been selected, pushing the multi-selector left or right or rotating the Rear control dial modifies the white balance.

The Color Temperature white balance setting can also be adjusted, and for added fine-tuning, it can also have a color filter applied to the setting. When the Color Temperature white space is selected, rotating the Rear control dial or pushing the multi-selector left or right sets the Color Temperature from 2500k to 9900k. After the Color Temperature has been set, pushing the multi-selector down allows for a Color filter to be applied to the white balance.

Cross-Reference *For more on color temperatures, see Chapter 4.*

The final white balance mode is Custom white balance. The Custom white balance setting is used when the scene you are photographing has multiple lights with different values or the type of lighting differs from the standard options. The A700 can save three different custom white balance settings. Rotating the Rear control dial allows you to either select one of the three Custom white balances or set a new one.

Setting a Custom white balance is done as follows:

1. **Open the White Balance menu by pressing the White Balance button.**

2. **Select the Custom white balance from the White Balance menu.**

3. **Rotate the Rear control dial until the word SET appears.**

4. **Press the multi-selector's center button and the LCD presents the following message: "Use spot metering area. Press shutter to calibrate."**

5. **Aim the camera at an area of solid white in your scene that is well lit, and make sure that the Spot metering circle is fully filled with white.** The image does not have to be in focus.

Tip *Any piece of white paper will work. I carry a folded piece of 8½ × 11 paper in my camera bag just in case I need to set a Custom white balance.*

6. **Press the Shutter button.**

7. **The LCD changes to show the image you just took with the color temperature on the bottom and a choice to select which of the three memory spots you want to save the current setting in.**

8. **Use the Front or Rear control dial or the multi-selector to choose register 1, 2, or 3.**

9. **Press the Shutter button or the multi-selector's center button to set the Custom white balance.**

If the color temperature is outside of the range that the A700 can record, a "Custom WB error" message appears on the center of the LCD. It is still possible to save this as a custom color space, but the white balance will not be accurate.

If the flash is used when setting the Custom white balance, the light from the flash is

used in calculating the color temperature, and to get the same results when using the that Custom white balance, the flash needs to be used.

Selecting a saved Custom white balance is done as follows:

1. **Open the White Balance menu by pressing the White Balance button.**

2. **Select the Custom white balance from the White Balance menu.**

3. **Rotate the Rear control dial or push the multi-selector left or right to select either one of the three Custom white balances.**

4. **When the Custom white balance is selected, either press the Shutter button or the multi-selector's center button.**

Cross-Reference *For more details on the white balance settings, see Chapter 1.*

Setting the ISO

The ISO range of the A700 is from 100 to 6400. The higher the ISO, the lower the amount of light needed to obtain a correct exposure; however, digital noise can become a problem at higher ISO settings. When the ISO is set to 1600 or higher, the camera actually performs noise reduction that can be adjusted in Recording menu 3, but it cannot be turned off.

Tip *Use ISO settings above 1600 only if absolutely necessary.*

Setting the ISO is quick and simple.

1. **Press the ISO button to open the ISO menu.**

2. **Use the Front or Rear control dials or the multi-selector to choose an ISO from the menu.**

3. **Press the multi-selector's center button or press the Shutter button lightly to set the ISO selected.**

The ISO menu is also accessible through the Quick Navigation screen.

1. **Press the Function button to open the Quick Navigation screen.**

2. **Use the multi-selector to navigate to the ISO number.**

3. **Press the multi-selector's center button to open the ISO menu.**

4. **Use the Front or Rear control dials or the multi-selector to choose an ISO from the menu.**

5. **Press the multi-selector's center button or press the Shutter button lightly to set the ISO selected.**

The ISO menu has the following choices: Auto, 100, 125, 160, 200, 250, 320, 400, 500, 640, 800, 1000, 1250, 1600, 2000, 2500, 3200, 4000, 5000, and 6400. In addition to these standard ISO settings, the ISO menu has a setting that automatically adjusts the ISO between 200 and 800. This Auto mode is the default setting for the camera in all the exposure modes except Manual. In the Manual mode, the default ISO is set at 200. The Auto ISO range can be changed by using the ISO Auto max and ISO Auto min menus in the Recording menu 2.

Tip *When using Auto ISO, the camera automatically picks an ISO that allows the shutter speed to be kept as high as possible to reduce camera shake.*

Setting the Dynamic-Range Optimizer

Sony has developed a system that analyzes the scene and automatically adjusts the image to improve the image quality called Dynamic-Range Optimizer (DRO). The *dynamic range* of the camera refers to its ability to capture both shadow detail and highlight detail at the same time. The Dynamic-Range Optimizer in the A700 works to recover shadow detail and highlight detail by automatically adjusting the brightness and contrast of the image.

 Note *The DRO can be applied to RAW images using the Sony Image Data Converter SR software. For more on the Sony software and RAW file conversion, check out Appendix B.*

The D-Range Optimizer is accessed through the Quick Navigation screen.

1. **Press the Function button to open the Quick Navigation screen.**

2. **Use the multi-selector to navigate to the DRO setting.**

3. **Press the multi-selector's center button to open the DRO menu.**

4. **Use the Front control dial or the multi-selector to choose one of the DRO settings.** The choices in the DRO menu are

 - **Off.** When the DRO is off, no adjustments are made to the brightness or contrast.

 - **Standard.** Adjusts the brightness and contrast of the whole scene overall.

- **Standard Auto.** Adjusts the color and contrast of the whole image by only adjusting the areas in the scene that are too dark or too light.

- **Advanced Level 1–5.** Adjusts the color and contrast of the whole image by only adjusting the areas that are too dark or too light. This menu choice can be adjusted by moving the multi-selector left or right to change the level of adjustment. The level can be set between the weakest (level 1) and the strongest (level 5).

5. **Press the multi-selector's center button or the Shutter button to set the selected DRO.**

The A700's default setting is to have the DRO turned on in all shooting modes.

Setting the Drive Mode

The Drive mode controls how many photos are taken when the Shutter button is pressed. The Drive mode is also the place to set the Bracketing modes and use the Remote Commander. To set the Drive mode, follow these steps:

1. **Press the Drive mode button on the top of the camera to open the Drive mode menu.**

2. **Use the Front control dial or the multi-selector to select the Drive mode.**

3. **Use the Rear control dial or the multi-selector to adjust the selected Drive mode.**

4. **Press the Shutter button or the multi-selector's center button to set the Drive mode.**

There are three basic Drive modes.

✦ **Single Shot.** The camera takes only one photograph every time the Shutter button is fully pressed. This is the default setting for the Auto, Portrait, Landscape, Macro, Sunset, and Night View / Night Portrait modes.

✦ **Continuous shooting.** There are two different continuous shooting modes. Note that the shooting speeds are measured under the following conditions: The image size is set to L:12M, the file quality is set to Fine, manual focus is used, and the shutter is 1/125 of a second or faster. The speed of the memory card can also affect the continuous shooting speed.

 • **Hi.** This setting shoots up to 5 frames a second.

 • **Lo.** This setting shoots up to 3 frames a second.

Continuous shooting is the default setting for the Sports Action mode and is made for capturing fast-moving subjects. Push the multi-selector left or right, or use the Rear control dial to switch between the Lo and Hi options.

✦ **Self-timer shooting.** The A700 has two modes for using the self-timer.

 • **2-second timer mode.** This mode moves the mirror up before taking a photograph, reducing any camera shake that could be caused by the mirror moving out of the way before the shutter is moved.

 • **10-second timer mode.** This mode sets the camera to take a photograph after 10 seconds are up. When in the 10-second timer mode, the camera beeps and the self-timer light flashes. The beeping and flashing increase in speed with 2 seconds left to go in the countdown.

Push the multi-selector left or right, or use the Rear control dial to switch between the 2-second and 10-second modes.

Bracketing modes

The Drive mode menu is also the location where the Bracketing modes are set. Bracketing modes let the camera make multiple exposures of the same scene, using slightly different settings to ensure one has the correct exposure. The A700 has four different Bracketing modes, two that bracket the exposure settings, one that brackets the white balance, and one that brackets the Dynamic-Range Optimizer settings.

✦ **Bracketing Continuous.** The camera takes three or five photos while you hold the Shutter button down. At the end of the sequence, you need to release the Shutter button before taking the next photograph or series of photographs. I prefer to use the Continuous Bracketing mode because there is less chance that the composition will change between the exposures. Nothing is more frustrating than getting the best exposure on one photograph, while getting the best composition on another in the same sequence. Chances are higher of this happening when the Bracketing Single mode is used. Push the multi-selector left or right, or use the

Rear control dial to switch between the continuous Bracketing modes.

✦ **Bracketing Single.** When in this mode, the camera takes three or five images in a row, but you must press the Shutter button each and every time until the sequence is over. Push the multi-selector left or right, or use the Rear control dial to switch between the Single Bracketing modes.

> **Cross-Reference** *The Continuous and Single bracketing choices are covered in more detail in Chapter 1.*

✦ **White balance bracketing.** The camera records three images each time the Shutter button is pressed. There are two white balance settings:

- **Lo3.** Shifts the white balance slightly between the three images.

- **Hi3.** Shifts the white balance twice as much as Lo3 between images. The Hi3 mode has a much wider adjustment value.

✦ **Dynamic-Range Optimizer Advanced Bracketing.** There are two DRO advanced Bracketing modes. Both modes record three simultaneous images each time the Shutter button is pressed. The DRO optimizes the color and contrast separately in each of the three images.

- **Lo3.** Applies the DRO using slight adjustments between each of the three images.

- **Hi3.** Applies the DRO using bigger adjustments between each of the three images.

Push the multi-selector left or right, or use the Rear control dial to switch between the Lo3 and Hi3 modes.

Remote Commander

Setting the Drive mode to Remote Commander lets the supplied Remote Commander trigger the shutter in the A700.

The Remote Commander has two different buttons that control the shutter release. The first, the actual Shutter button, releases the shutter immediately. It has the exact same effect as pressing the Shutter button on the camera. The other button on the Remote Commander that controls the shutter release is the 2-second button, which locks the mirror up and then triggers the shutter's release. Having the camera on a tripod and using the 2-second button keeps all camera and lens vibration to an absolute minimum.

> **Note** *When the Drive mode is set to Remote Commander, the other Drive modes cannot be used. This includes the Bracketing modes, and so if you want to bracket a shot, it must be taken without using the remote.*

> **Cross-Reference** *The Remote Commander is also used to control playback when attached to a television. For more on this, see Chapter 7.*

Focusing the A700

The autofocus system in the A700 is comprised of 11 wide-area sensors attached to a very fast-focusing drive motor. The A700 also features Eye-Start focusing. With it, the scene jumps into focus amazingly fast, resulting in fewer missed photo opportunities.

Eye-Start focusing system

The A700 starts to focus even before your eye is all the way to the viewfinder. This technology is called Eye-Start focusing, and it cuts down on the time it takes to focus. There is a sensor under the viewfinder that, when the camera is brought up to your face, starts the focusing system. The A700 has a second sensor on the front of the handgrip that, in the default mode, needs to be covered for the Eye-Start system to work. This second sensor can be turned off using the Eye-Start Trigger menu in the Custom menu 1.

Selecting the auto focus area

The A700 has three auto focus settings, each useful for different types of photography: Wide, Spot, and Local.

To select the auto focus area:

1. **Press the Function button to open the Quick Navigation screen.**

2. **Use the multi-selector to navigate to the auto focus area.**

3. **Press the multi-selector to open the auto focus area menu.**

4. **Use the Front or Rear control dials or the multi-selector to choose the auto focus area.**

5. **Press the Shutter button or the multi-selector to activate the selected Auto Focus mode.**

The auto focus area can also be accessed from Recording menu 3.

1. **Press the Menu button on the back of the camera to open the Menu screen.**

2. **Use the multi-selector or the Rear control dial to select the Recording menu 3.**

3. **Use the multi-selector to navigate to AF area and press the multi-selector's center button to open the AF area menu.**

4. **Use the Front or Read control dial or the multi-selector to choose which auto focus area to use.**

5. **Press the Shutter button or the multi-selector's center button to activate the selected Focus mode.**

The three auto focus area choices are

✦ **Wide Area.** The Wide Area Focus mode is the default setting for all modes and scenes on the A700. The Wide Area Auto Focus mode puts the decision on which of the 11 auto focus sensors to use in the hands of the camera, not the photographer. This mode works surprisingly well and works for most scenes. A handy little feature of the A700 is your ability to quickly engage the Spot Auto Focus Area setting while in the Wide mode. Press the multi-selector's center button and the auto focus immediately switches to the Spot mode.

✦ **Spot.** Spot focusing uses only the center auto focus spot, the small box in the center of the viewfinder.

✦ **Local.** The Local Auto Focus Area setting lets the photographer decide which of the 11 sensors to use. I love the ability this mode gives you to decide exactly where to focus. In this mode, use the multi-selector to navigate through the different focus sensors. When you are on the sensor you want to

use, stop; there is no need to do anything else. As you move from sensor to sensor, they immediately become active as they are selected. As you move through the sensors, they briefly flash red.

Auto Focus modes

The A700 has four Focus modes -- three that are auto focus and one that is manual focus. Setting the Focus mode is as easy as turning the Focus mode lever on the front bottom of the camera.

✦ **Single Shot Auto Focus.** When the A700 is set to AF-S, the camera focuses and locks on when the Shutter button is pressed halfway down. This mode is best for shooting stationary objects.

✦ **Automatic Auto Focus.** Setting the camera to AF-A puts the camera into an Automatic Auto Focus mode. This mode automatically switches between the Single Shot Auto Focus and the Continuous Auto Focus modes. When the subject of the photograph is not moving, the focus is locked when the Shutter button is pressed halfway. When the subject is moving, the camera continues to focus.

✦ **Continuous Auto Focus.** The AF-C mode continues to focus as long as the Shutter button is pressed halfway down. If the Wide Area Auto Focus area is selected, the AF sensors move to track the movement. This mode is best for photographing moving subjects and is the default setting for the Sports Action mode.

✦ **Manual Focus.** The MF or Manual Focus mode lets you focus manually using the focus ring on the lens. If the camera can determine what you are focusing on, the focusing indicator lights up in the viewfinder when focus has been achieved. When using a tele-converter, the focusing action might not be as smooth as when the lens alone is used.

 Cross-Reference *Tele-converters are discussed in more detail in Chapter 5.*

The A700 offers a shortcut that switches between any of the Auto Focus modes to Manual Focus, or between the Manual Focus and Single Shot Auto Focus with a press of a button – the AF/MF button to be precise. When the camera is in one of the Auto Focus modes and the AF/MF button is pressed, the Focus mode is temporarily switched to Manual Focus. The Manual mode stays in effect for as long as you keep the AF/MF button pressed.

When the camera is in Manual Focus mode, pressing and holding the AF/MF button triggers the auto focus until it locks. After the button is released, focusing can once again be done manually with the focusing ring on the lens.

Creative Styles

The Sony A700 has a set of 14 preprogrammed styles, called Creative Styles, which you can use with optimal results for various situations. Each of these affects the image in a different way. They are

✦ Standard

✦ Vivid

✦ Neutral

✦ AdobeRGB

✦ Clear

✦ Deep

✦ Light

✦ Portrait

✦ Landscape

✦ Sunset

✦ Night View

✦ Autumn Leaves

✦ B&W

✦ Sepia

2.2 The same image taken using the Vivid Creative Style.

It is important to remember, however, that they affect images stored only in the JPEG format. If you are shooting and saving the images in RAW mode, the Creative Styles are not applied or visible when opening the RAW file in any software other than the Sony Image Data Converter SR.

Note *If you use Adobe Photoshop with Adobe Camera Raw 4.2, it reads the Sony RAW files, but Creative Style information is not applied.*

Tip *If you use the Sony software, a RAW image appears with the Creative Style setting intact. And, because the image is in the RAW format, the settings can be changed and actually be applied to any other RAW image.*

2.1 An image taken using the Sepia Creative Style.

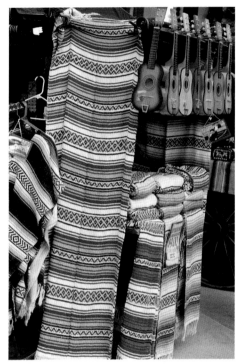

2.3 The same image taken using the B&W Creative Style.

The Creative Styles menu is where the Creative Styles are set and modified, and it can be opened in three ways.

✦ **Press the Custom button.**

✦ **Through the Quick Navigation screen.**

 1. Press the Function button to open the Quick Navigation screen.

 2. Use the multi-selector to navigate to the Creative Style setting.

 3. Press the multi-selector's center button to open the Creative Styles menu.

✦ **Through the A700's menu screen.**

1. Press the Menu button to open the menu screen.

2. Use the multi-selector to navigate to Recording menu 1.

3. Select the Creative Styles menu choice and press the multi-selector's center button to access the Creative Styles menu.

Even though there are 14 different Creative Styles, they cannot all be set at the same time for use because the Creative Styles menu can only store seven Creative Styles. The first four are assigned by default. They are Standard, Vivid, Neutral, and AdobeRGB. You can, however, adjust the contrast, saturation, and sharpness for each.

The next three spaces on the Creative Styles menu can be set to any of the 14 Creative Styles and those three spaces can be modified in five ways: contrast, saturation, sharpness, brightness, and zone matching.

 For more information on the individual styles, see Chapter 1.

To set a user-assignable Creative Styles:

1. **Open the Creative Styles menu.**

2. **Rotate the Front or Rear control dial or push down on the multi-selector to choose one of the assignable spaces.** These spaces are easily identified by having the numbers 1, 2, or 3 in front of the Style name.

3. **Push the multi-selector to the right to highlight the Creative Style name.**

4. **Push the multi-selector up or down to change the selected Creative Style.** Once the style has been selected, it is active immediately.

5. **At this point there are three options:**

 • **Press the Shutter or Custom button to return to the Recording Information screen.**

 • **Push the multi-selector to the left and pick another assignable space to modify.**

 • **Push the multi-selector to the right and fine-tune the Creative Style you just selected.**

To fine-tune the Creative Styles:

1. **Open the Creative Styles menu.**

2. **Select the Creative Style you want to fine-tune by using the Front or Rear control dial or the multi-selector.**

3. **With the selected Creative Style highlighted, push the multi-selector to the right.**

4. **Use the multi-selector to modify the following:**

 • **Contrast**

 • **Saturation**

 • **Sharpness**

 • **Brightness**

 • **Zone matching**

5. **When you have made all the adjustments you want, press the Shutter or Custom button to return to the Recording Information screen.**

Finally, now that you have assigned and tweaked the Creative Styles, follow these steps to use one when shooting.

1. **Press the Function button to open the Quick Navigation screen.**

2. **Use the multi-selector to navigate to the Creative Style setting.**

3. **Use the Front or Rear control dials to scroll through the seven assigned Creative Styles in the Creative Styles menu to choose one.** You can then press the multi-selector's center button to open the Creative Styles menu if more adjustment to the setting is needed.

Using the Built-In Flash

The A700 has a built-in flash that, although not as powerful or versatile as an external flash, does a great job without adding any extra gear or expense. When the flash is up, it is automatically turned on.

Selecting the Flash mode

There are four Flash modes accessible from the Quick Navigation screen. If you are using the Enlarged Display mode, there is no way to access the flash control with the Quick Navigation screen, so you can use the Recording menu 2.

✦ **Auto.** The flash fires if the camera calculates that it is needed. This mode is not accessible in the Program Auto mode, the Aperture Priority mode, the Shutter Speed Priority mode, or the Manual mode.

✦ **Fill Flash.** The flash fires when it is up regardless of the amount of light.

✦ **Rear Sync.** When the Fill Flash mode is used, the flash is fired at the beginning of the exposure. This can cause objects that are moving during the exposure to freeze at the start of the exposure, making them seem unnatural (they often look like they are moving the wrong direction). When the flash is set to Rear-sync mode, the flash fires at the end of the exposure, freezing moving objects at the end of the exposure and creating a more natural look.

✦ **Wireless.** The A700 can trigger an external flash that is not attached to the camera by using the built-in flash and the Wireless mode. Wireless mode shooting requires an HVL-F56AM flash or an HVL-F36AM flash.

> **Cross-Reference** *For more on wireless flash use, see Chapter 4.*

Flash compensation

When shooting with the flash, you can adjust the amount of light the flash outputs without changing the exposure reading of the scene.

Adjusting the flash compensation is easy to do with the Quick Navigation screen and the multi-selector. Pressing the Function button opens the Quick Navigation screen, and the multi-selector accesses the flash compensation screen. The flash output can be adjusted three stops in either direction.

> **Cross-Reference** *Using a flash is covered in greater detail in Chapter 4.*

To set the flash compensation, do the following:

1. **Turn the camera on.**

2. **Pull up the built-in flash or attach a dedicated flash and turn it on.**

3. **Press the Function button to bring up the Quick Navigation screen.**

4. **Use the multi-selector to select the flash compensation, and press the multi-selector's center button.**

5. **Use the multi-selector to adjust the flash compensation by up to 3 stops.**

6. **Press the multi-selector's center button to set the flash compensation.**

A700 Menus

The menus in the A700 are broken down into four types: Recording, Custom, Playback, and Setup. To access the menus, press the Menu button at any time. To return to Shooting mode, press the Shutter button or the Menu button. Navigating through the menus can be done in a variety of ways. The Front control dial scrolls through the menu items one at a time, and the Rear control dial scrolls through the menus one at a time. The multi-selector acts like a miniature joystick, letting you scroll through either the menu items or the menus one at a time. The multi-selector's center button selects the menu item to be changed.

The A700 uses icons to designate which menu is currently open. These icons are located across the top of the LCD when any of the A700 menus are open. There are four icons, each one in its own tab.

Recording menu 1

The Recording menu is the default menu when the Menu button is pressed for the first time after the camera is turned on or when the last menu opened was one of the four Recording menus. This is set in the Menu Start setting in Setup menu 3 by using the Top choice. The icon for the Recording menu is a small camera. When in Recording menu 1, the number 1 next to the camera icon in the Recording menu tab on the top of the LCD is in an orange box.

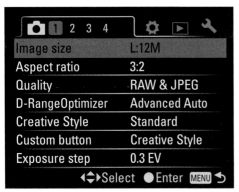

2.4 Recording menu 1

Image size

This is the setting that determines the size of the image. The default is L:12M, which is the largest file size. The other choices are M:6.4M and S:3.0M. These choices change depending on the aspect ratio. When in the 16:9 aspect ratio the choices are L:10M, M:5.4M, and S:2.6M. This menu choice is grayed out and not available if the Quality setting is set to RAW or cRAW. The image size only affects the JPEG file type.

Aspect ratio

There are two choices for the aspect ratio: the traditional 3:2 aspect ratio, and the wide screen ratio of 16:9.

Quality

This is where the image quality is set. The default is Fine, which is the second-to-lowest file quality. Other choices are RAW, cRAW, RAW & JPEG, cRAW & JPEG, Extra Fine, and Standard.

D-RangeOptimizer

The Dynamic-Range Optimizer or DRO can be set to Off, Standard (D-R), Advanced Auto, (D-R+), or Advanced with a level adjustment from 1 (lv1) to 5 (lv5).

Creative Style

Seven choices are available from the Creative Styles menu screen, which is accessed from the Quick Navigation screen. Because 14 choices are available to fill the three switchable spots and each of the 14 are adjustable in five different ways, this is the place to set up all those choices. The first four Creative Style slots are pre-assigned and, while the items can't be changed, each item can be adjusted in three different ways. The multi-selector can be used to adjust the contrast, saturation, and sharpness of each style. The three assignable Creative Style slots can be set to any of the 14 styles, including the four that are already in the unswitchable slots. The styles that are assigned to these three slots can have their contrast, saturation, sharpness, brightness, and zone matching adjusted. The B/W (black and white) and Sepia styles cannot have their saturation adjusted.

Custom button

The Custom button can be set to open one of 15 different menus. The default Custom button opens the Creative Styles menu, but it can be set to AF lock, AF/MF control, Depth of field preview, ISO, white balance, exposure compensation, flash compensation, Drive mode, AF area, image size, image quality,

Dynamic-Range Optimization, Flash mode, and Memory. When this menu choice is selected by pressing the multi-selector's center button, the list of the 15 choices opens and can be navigated by using the multi-selector. Once a new function is selected, pressing the multi-selector's center button assigns the new menu to the Custom button.

Exposure step

The shutter speed, aperture, and exposure can be adjusted by .5 steps or the default of .3 steps.

Recording menu 2

The icon for the Recording menu is a small camera. When in Recording menu 2, the number 2 in the Recording menu tab on the top of the LCD is in an orange box.

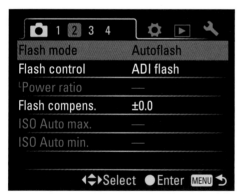

2.5 Recording menu 2

Flash mode

The built-in flash can be set to one of four different modes: Autoflash, Fill Flash, Rear Sync, and Wireless. The Autoflash setting cannot be set when in Program Auto mode, Aperture Priority mode, Shutter Speed Priority mode, Manual mode or Memory Recall mode. The choice will be grayed out and the default setting will be Fill Flash mode.

 Chapter 4 has more on the Flash modes.

Flash control

There are three flash control modes. Each mode sets the amount of flash light differently.

✦ **ADI.** This is the default mode. It stands for Advanced Distance Integration. In this mode, the flash fires a short pre-flash right before the flash is fired. The camera sets the amount of flash light based on the amount of light reflected back to the camera and the distance from the subject. The ADI flash mode can be used only with lenses that support this. There are certain times that the camera cannot determine the distance to the subject even when using supported lenses. If there is any type of light modifier being used on the flash — a diffusion dome on a dedicated flash, for example — the flash control will need to be set to Pre-flash TTL. When a neutral density filter or a close-up lens is being used, the flash control needs to be set to Pre-flash TTL.

✦ **Pre-flash TTL.** This mode is the same as the ADI flash mode, except that the distance information is not used in determining the amount of light the flash produces.

✦ **Manual.** This flash mode causes the built-in flash to fire with a certain amount of light regardless of the brightness of the subject. The Manual flash mode cannot be used when the flash mode is set to Auto. The Manual mode can only be used with the built-in flash.

Power ratio

The power ratio is used to set the amount of light that the flash outputs when the flash control is set to Manual. There are five different settings, and each one lowers the amount of light that the flash puts out. The settings are displayed as a ratio from 1:1 power to 1:16 power. This selection is grayed out if the Flash control is not set to Manual.

Flash compens.

The flash compensation lets you change the amount of light without changing the exposure of the scene. The flash compensation can be set from -3 to +3 using the multi-selector.

ISO Auto max.

The ISO Auto maximum setting can be changed if the Mode dial is set to P (Program Auto), A (Aperture Priority), or S (Shutter Priority). The setting can be changed from the default of 800 to either 1600 or 400. It cannot be changed if the camera is in any one of the Scene selection modes or Manual mode. The menu choice will be grayed out.

ISO Auto min.

The ISO Auto minimum setting can be changed if the Mode dial is set to P (Program Auto), A (Aperture Priority), or S (Shutter Priority). The setting can be changed from the default of 200 to 400. It cannot be changed if the camera is in any one of the Scene selection modes or Manual mode. The menu choice will be grayed out.

Recording menu 3

The icon for the Recording menu is a small camera. When in Recording menu 3, the number 3 in the Recording menu tab on the top of the LCD is in an orange box.

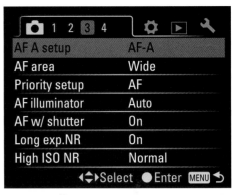

2.6 Recording menu 3

AF A setup

The A position on the Focus mode lever is assigned to Automatic Auto Focus by default, but it can be assigned to DMF (Direct Manual Focus). DMF mode lets you make fine adjustments using the focus dial on the lens after the camera has achieved focus using auto focus. Pressing the Shutter button halfway down gets the camera to auto focus, and before the button is released, focus can be fine-tuned by using the focus ring on the lens. If the Shutter button is released, the focus is lost and the process starts over.

AF area

Three auto focus areas can be set here: Wide area, Spot, and Local. You can also access these same settings for the focus area using the Quick Navigation screen.

Priority setup

The Priority setup selects a setting used for the shutter release. With the default setting, AF, the shutter cannot be released until focus has been confirmed. You can set the Priority Release setting to Release, which allows the shutter to be released even if the focus is not locked.

AF illuminator

The Auto Focus illuminator light fires when shooting low-contrast scenes or in low light to help the camera achieve focus. This menu setting allows you to turn the illuminator off. The default is set to Auto.

AF w/ shutter

The default setting is for the Shutter button to adjust the focus. By pressing the button halfway down, the auto focus is activated and locked. You can turn this function off, and in that case, the multi-selector's center button acts to adjust and lock the focus. When this is set to Off, the shutter can be released even if focus has not been achieved.

Long exp.NR

Long exposures can introduce noise into the image. When Long Exposure Noise Reduction is turned on, as it is by default, any exposure of one second or longer is subject to noise reduction after the image has been captured. The LCD displays "Processing" while the noise reduction is being applied. You cannot use the camera to take another photo until the noise reduction processing is complete. If the Drive mode is set to Continuous shooting or Continuous bracketing, then the Long Exposure Noise Reduction is not performed no matter what this menu choice is set to.

High ISO NR

When photos are taken at ISO speeds of 1600 and above, High ISO Noise Reduction is applied automatically. The amount of noise reduction is set at this menu choice. The default is Normal, but the noise reduction can also be set to High or Low, increasing or decreasing the amount of noise reduction applied to the image. The High setting causes the Continuous shooting speed to drop to 3.5 images per second.

Recording menu 4

The icon for the Recording menu is a small camera. When in Recording menu 4, the number 4 in the Recording menu tab on the top of the LCD is in an orange box.

2.7 Recording menu 4

Memory

This is where the settings used in MR (Memory Recall) Exposure mode are stored.

Rec mode reset

This resets all the menus in Recording menus 1 through 4 back to the factory defaults, including the file size and image quality. All the settings from Recording menus 1, 2, 3, and 4 are reset to the camera defaults, but this does not reset any of the changes you might have made in the Custom menus or the Setup menus.

Custom menu 1

The Custom menu icon is a small gear. When in the Custom menu 1, the number 1 next to the gear icon in the Custom menu tab on the top of the LCD is in an orange box.

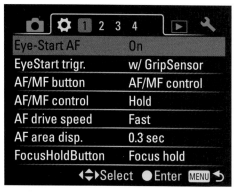

2.8 Custom menu 1

Eye-Start AF

When Eye-Start Auto Focus is set to On, the Eye-Start focus sensor is active and the camera starts to focus when the camera is brought up to your eye. The default setting is On.

EyeStart trigr.

The two options for the Eye-Start trigger are w/ GripSensor and w/o GripSensor. The default setting is w/ GripSensor. When this is set, the Eye-Start sensor does not activate unless the GripSensor is also covered. If you want to use the Eye-Start focusing when the camera is mounted on a tripod, you either have to make sure that your hand is covering the sensor or the sensor is turned off.

If the Eye-Start Auto Focus is turned on, and the Eye-Start trigger is set to w/o Grip-Sensor, the camera starts to focus if anything gets close enough to the Eye-Start sensor. This can include your clothes if the camera is turned on and hanging around your neck or over your shoulder. This diminishes the battery life.

AF/MF button

The default AF/MF button quickly and temporarily switches between auto focus and manual focus. This button can be used as an AF lock, which locks the focus when the button is pressed.

AF/MF control

When the AF/MF button is set to AF/MF control, the way the button works can be changed here. The default setting is Hold, which switches between auto focus and manual focus when the AF/MF button is held down. The Toggle setting switches between auto focus and manual focus each time the button is pressed.

AF drive speed

The default setting of Fast confirms the focus quickly, and the Slow setting takes more time to achieve focus lock. The Slow setting is best used for subjects that are harder to focus on.

AF area disp.

When the Shutter button is pressed, the auto focus area being used lights up briefly in the viewfinder. The default is for this to be on for 1/3 of a second, but it can be made longer to 2/3 of a second or turned off completely. When the display is turned off, the only way that the Focus area displays lights is when pressing the multi-selector's center button.

FocusHoldButton

If you use a lens that is equipped with a Focus Hold button, the function of the button can be changed. The default is for the button on the lens to be used as a focus hold, but it can be set as a Depth of field preview.

 For more information on lenses and those with Focus Hold buttons, see Chapter 5.

Custom menu 2

The Custom menu icon is a small gear. When in the Custom menu 2, the number 2 next to the gear icon in the Custom menu tab on the top of the LCD is in an orange box.

2.9 Custom menu 2

AEL button

The Auto Exposure Lock button has four different functions depending on what setting is chosen for this menu choice. The default is for the AEL hold setting, which locks the exposure value that the camera is currently calculating as long as the button is being pressed. There is also an AEL toggle mode, which locks the current exposure in with a press of the AEL button, and unlocks the exposure with a second press of the button.

The other two modes are Spot Metering AEL hold and Spot Metering AEL toggle. These two modes mirror the first two modes with one important difference. When either of these two modes is being used and the button is pressed, the camera does a quick spot-meter reading regardless of the Metering mode that the camera is set for.

Ctrl dial setup

In P (Program Auto) mode and M (Manual) mode, the Front control dial controls the shutter and the Rear control dial controls the aperture. This is the default setting, but it can be reversed using this setting. This setting has no affect when shooting in A (Aperture Priority) mode or S (Shutter Speed Priority) mode.

Dial exp.comp

There are three options for this setting: Front dial, Rear dial, and the default, Off. With the Front dial choice selected, the exposure is adjusted by the Front control dial only; when set for Rear dial, the exposure is adjusted by the Rear control dial; and when the selection is set to Off, neither control dial is used.

The functions of the Front and Rear control dials are shown in Table 2.1 when the control dial setup is set to the default.

Caution *Remember that the Front and Rear control dial functions change if the control is reversed in the Control dial menu.*

Ctrl dial lock

You can lock the Front and Rear control dials so they are not accidentally moved, which would change your exposure settings. The default is to have this ability turned off, but if you turn it on, the dials are locked until the Shutter button is lightly pressed. Both control dials will relock after 5 seconds of nonuse.

Button ops.

The default setting, Exclusive display, displays the exclusive menu for the ISO button, White Balance button, Drive mode button,

Table 2.1
Front and Rear Control Dial Default Functions

Mode	Off	Front Dial	Rear Dial
Program Auto – Front control dial	Shutter speed adjustment	Changes the exposure	Shutter speed adjustment
Program Auto – Rear control dial	Aperture adjustment	Aperture adjustment	Changes the exposure
Aperture Priority – Front control dial	Changes the aperture	Changes the exposure	Changes the aperture
Aperture Priority – Rear control dial	Changes the aperture	Changes the aperture	Changes the exposure
Shutter Priority – Front control dial	Changes the shutter speed	Changes the exposure	Changes the shutter speed
Shutter Priority – Rear control dial	Changes the shutter speed	Changes the shutter speed	Changes the exposure
Manual mode – Front control dial	Changes the shutter speed	Changes the shutter speed	Changes the shutter speed
Manual mode – Rear control dial	Changes the aperture	Changes the aperture	Changes the aperture

Exposure button, or Custom button on the LCD when pressed. When this setting is set to Quick Navigation, no matter what button is pressed, the LCD displays the Quick Navigation screen.

Release w/oCard

When this option is enabled, the shutter release works without having a memory card inserted into the camera. The default setting of the camera allows this. If this is left enabled, it is possible to use the camera and take photos, but no images are saved because there is no memory card.

Tip *Disable this option so you don't accidentally shoot a great shot without a card present.*

Release w/oLens

When this option is enabled, the shutter can be released with no lens attached to the camera. The default setting is for this to be disabled. It is very rare that you would ever have to use this. An example of when you might use this is if you are attaching the A700 to a non-standard lens that does not use the lens contacts; for example, an astronomical telescope.

Custom menu 3

The Custom menu icon is a small gear. When in the Custom menu 3, the number 3 next to the gear icon in the Custom menu tab on the top of the LCD is in an orange box.

2.10 Custom menu 3

Red eye reduc.

Red-eye reduction is available only with the built-in flash. The options here are On and Off. When it is turned on, the built-in flash fires a quick, low light burst to try to minimize red eye. Red-eye reduction is turned off by default.

Exp.comp.set

When exposure compensation is used, the camera changes the shutter speed, aperture, the amount of light from the flash, and the ISO when Auto ISO is on. You can remove the amount of flash light from the adjustment by changing this setting to Ambient only from the default of Ambient&flash.

Bracket order

When the Drive mode is set to shoot in Bracketing mode, the order of the images is correct exposure, underexposed, then overexposed. Here you can change the order of the images to underexposed, correct exposure, and overexposed.

Auto review

After the photograph is taken, it can be displayed on the LCD for a predetermined amount of time. The default setting displays the image for 2 seconds, but it can be set for 5 seconds or 10 seconds. The review can also be turned off.

Auto off w/ VF

When the Auto off with viewfinder is set to On, which is the default setting, the LCD turns off when the Eye-Start sensor is triggered. This turns the display off when you look through the camera viewfinder. This can also be turned off so that the display stays on when you look through the viewfinder.

Rec.info.disp.

One of the great features of the A700 is the fact that the recording info display rotates when the camera changes orientation. This feature can be turned off using this menu.

Img.orientation

The orientation of the photograph can be stored with the photograph automatically. When this is turned on, as it is by default, the orientation of the image is saved along with the image, but it may not be displayed when using software other than Sony Image Data Converter SR.

Custom menu 4

This is the menu where you can reset all the custom settings back to the factory defaults. All the settings from Custom menus one, two, and three are reset to the camera defaults, but this does not reset any of the changes you might have made in the Recording menus or the Setup menus.

2.11 Custom menu 4

Playback menu 1

The Playback menu icon is a right facing arrow in a small square. If Playback menu 1 or 2 was the last menu opened, then this will be the menu opened when the Menu button is pressed and the Menu start menu in Setup menu 3 is set to Top.

2.12 Playback menu 1

Delete

The Delete menu has two options: Marked images, which deletes only the selected images, or All images, which deletes all the images on the memory card. Any image that is protected cannot be deleted.

Caution *Once an image has been deleted, it cannot be recovered.*

Selecting the Marked images choice causes the most recently taken image to appear on the LCD. Scroll through the images using the multi-selector or the Front control dial. To mark a photo for deletion, press the Multi-selector's center button; a green trash can symbol superimposes over the middle of the image. On the bottom left of the display there is a trash can icon followed with the number of images that have be selected for deletion. When all the images that you want to delete are marked, press the Menu button to open a menu choice that lists the number of photos that are about to be deleted and the choice to delete or cancel. Use the multi-selector to continue with the deletion or to cancel out of the process. If the process is cancelled, the LCD shows the last image that was marked for deletion. You can either continue to mark images for deletion or cancel out completely by pressing the Playback button.

Selecting the All images choice gives you the option to delete all the images on the memory card. Use the multi-selector to either select Delete or Cancel and then press the multi-selector's center button to execute your choice. Selecting Cancel returns the display to the Playback menu 1. Selecting Delete deletes all the images on your card.

If there are no images on the memory card, the Delete menu will be grayed out.

Format

This formats the camera's memory card, getting the card ready to be used with the A700. A memory card needs to be formatted before its first use and should periodically be reformatted.

 Caution *Formatting erases all images on the card, including the protected images and any images or files that may be on the card from any other source.*

Protect

Images can be protected to stop them from being accidentally deleted. The Protect menu setting offers three choices: Marked images, All images, and Cancel all. The first choice is to protect the marked images. When this is selected, the LCD shows the most recent photo taken, and the multi-selector or the Front control dial can be used to scroll through the photos; the multi-selector's center button can be used to protect any image. When an image is protected, a green key icon is superimposed over the middle of the image. When you are done selecting images you want to protect, press the Menu button and you can protect the images or cancel.

Protecting an image stops it from being accidentally deleted, but it does not stop the image from being lost when the card is formatted.

DPOF setup

DPOF (Digital Print Order Format) allows you to mark which images you want to print and how many copies of each image to print. The DPOF does not work with RAW images, and you can print only up to nine copies of each image. The three menu choices are Marked images, All images, and Cancel all.

When you choose Marked Images the LCD shows the last image taken. You can then scroll through the images using the multi-selector. When you find an image that you want to mark for printing, press the multi-selector's center button. DPOF1 appears in

green superimposed on the center of the image. Each subsequent click of the multi-selector's center button increases the number until DPOF9, and then the option resets and the image is no longer selected. You can also use the Rear control dial to increase the number of prints for each individual image, and the Front control dial to scroll though the images. When all the images that you want to print are marked, press the Menu button. You are asked if the amount of prints is correct, and you are given two choices: Accept or Cancel.

If you mark all images for printing, a Number of Copies menu appears and asks for the number of prints per each image. You can't choose different print amounts for each individual image. "Cancel all" removes any DPOF markings from all images on the memory card.

Date imprint

You can imprint the date when printing images directly from the camera. The default is for the camera not to print the date. The position, size, and orientation of the date depends on the printer used. Check your printer manual for more information.

Index print

You can create an index print of all the images on the memory card. The number of images that can be printed on a sheet depends on the printer and the size of paper used. RAW files do not print on index prints.

PlaybackDisplay

The two settings here are Auto Rotate and Manual Rotate. The Auto Rotate setting rotates photos taken in the portrait mode so that they are displayed in portrait orientation.

When the setting is set to Manual Rotate, the images all appear in landscape mode. When the camera is connected to a television, this setting is ignored and all images appear according to the orientation of the image.

Playback menu 2

Playback menu 2 is where the slide show is located. There is no other way to play the slide show on the camera. When connected to a television, the Remote Commander can be used to play the slide show.

 Cross-Reference *For more on the slide show using the Remote Commander, see Chapter 7.*

2.13 Playback menu 2

Slide show

The slide show function plays back the images on the memory card in the order that they were recorded. Select Slide show from the menu and press the multi-selector's center button. This starts the slide show, which runs until the last image appears. To pause the slide show, press the multi-selector's center button again. Pressing the Menu button stops the slide show.

Interval

The amount of time each slide is shown during the side show is set here. The options are 1 second, the default 3 seconds, 5 seconds, 10 seconds, and 30 seconds.

Setup menu 1

The Setup menu icon is a small wrench. The Setup menu 1 deals with the LCD and the display output of the camera. It is also the place to set the date and time.

2.14 Setup menu 1

LCD brightness

The LCD brightness level can be adjusted to suit different lighting conditions. Using the multi-selector, the LCD can be adjusted by five steps brighter or duller.

Info.disp.time

When shooting, the LCD displays the shooting information, which appears for a default of 5 seconds. It can be changed to 10 seconds, 30 seconds, and 1 minute.

Power save

This setting controls the amount of time it takes for the camera to go into the Power

save mode. The default is 3 minutes, but it can be set for 1 minute, 5 minutes, 10 minutes, or 30 minutes.

When the camera is connected to a television using a regular video cable, the camera goes into Power save mode after 30 minutes regardless of this setting. When the camera is connected to a television using an HDMI cable and the camera is attached to an AC adapter/charger, the Power save does not work.

Video output

The video output format can be set to NTSC, for use in Japan and the USA, or PAL, the video setting for Europe.

HDMI output

When the camera is connected to an HDTV using an HDMI cable, the output from the camera is determined automatically. You can make changes in the output signal to make the image clearer if necessary. The three settings are HD(1080i), HD(720p), and SD. Check your television manual to find out which setting to use.

Language

You can select the language that the menus use. The language choices are English, French, Spanish, Italian, Chinese, and Japanese.

Date/Time setup

The date and time can be adjusted using the multi-selector.

Setup menu 2

When in Setup menu 2, the number 2 next to the wrench icon is lit in orange.

2.15 Setup menu 2

Memory card

The A700 can use either a CompactFlash card or a Memory Stick Duo card. This menu choice is where you tell the camera which one to use. The default is CompactFlash.

File number

The camera uses two methods to assign file numbers to images as it takes pictures. The default is the Series method. In this method, the file numbers start at 0001 and increase even when a new memory card is used.

The second method is the Reset method. In this mode, the file numbers start at 0001 each time the folder is changed or the recording date changes when using the Date form folder. If there are already files in a folder, the next number in the sequence for that folder is used.

Folder name

There are two folder name modes: Standard and Date. In the Standard form the folder name does not change, and all photos are stored in a single folder. In the Date form, a new folder is created every time the recording date changes. The format shows a folder number, followed by the last digit of the year, and then the month and day.

Select folder / New folder

When the Standard folder mode is used, you can select which folder to store the images in, and if you can create new folders. Each new folder gets a new sequential number. You can create folders numbered up to 999. When a new memory card is inserted and a new folder is created, it will have the next sequential number of the folders on that memory card.

USB connection

When a USB cable is plugged into the camera, there are three modes that the camera can be in. The first is Mass Storage, the default setting. This setting lets images stored on the memory cards be copied to the computer, and the camera acts as a regular external storage device. The PTP option lets the camera be connected to a PictBridge-compliant printer so that prints can be made directly from the camera. The Remote PC mode lets the camera be used tethered to the computer in conjunction with the Camera Remote Software that is included with the camera. The images taken this way are stored on the computer and not the memory card in the camera.

MassStrg.card

If both a CompactFlash card and a Memory Stick Duo are inserted in the camera, either the selected card or both cards can be seen when the camera is connected to the computer. The default is only the selected card, but it can be set to both cards.

Setup menu 3

When in Setup menu 3, the number 3 next to the wrench icon is lit in orange.

2.16 Setup menu 3

Menu start

The default setting for when the Menu button is pressed is to open the Recording menu 1 or Playback menu 1 if the last menu used was Playback menu 1. This setting is called Top but can be changed here so that the last menu viewed is the menu that is opened when the Menu button is pressed.

Delete confirm.

When deleting images or folders, a confirmation screen appears; on the default screen the Cancel choice is highlighted. This menu changes the default to Delete.

Audio signals

This turns the camera sounds on or off.

Cleaning mode

You must select this mode if you plan to clean the camera. The Cleaning mode moves the mirror out of the way and allows for the sensor to be cleaned. Dust and dirt can cause spots to appear on your images and when this happens, it is time to clean the sensor.

Reset default

This option resets all the menus and functions of the camera back to the factory defaults. The only items not reset are date and time.

Creating Great Photos with the Sony Alpha A700

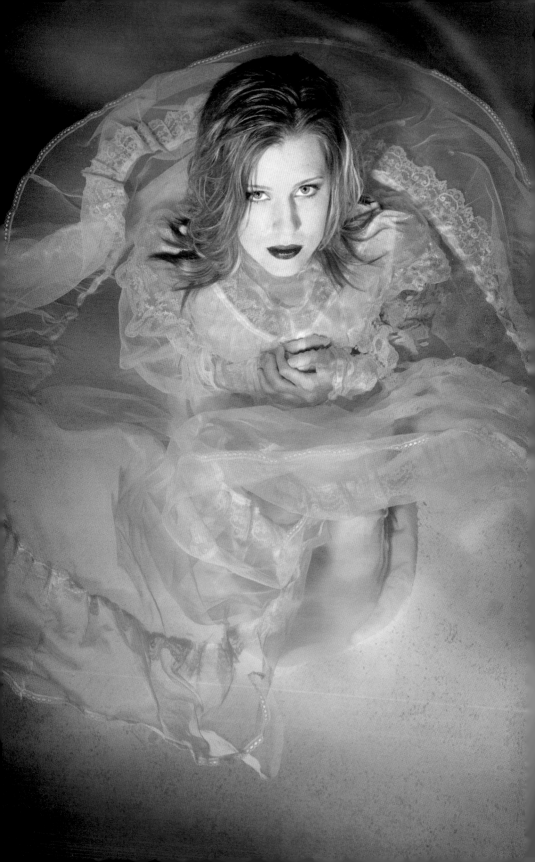

Photography Essentials

Some things in photography don't change. It doesn't matter what camera you are shooting with or what the subject matter is, exposure and composition are essential components to creating great photographs. Although the basics can be understood in an afternoon, they can take many years to master. This chapter covers what you need to know to get started.

If you have upgraded to this camera from the Sony A100 or one of the older Konica Minolta cameras, you most likely have a good understanding of the basics of photography, but give this chapter a look. Hopefully there is something new for you or maybe just a review to brush up on the basics.

If you come to the Sony A700 from a point-and-shoot camera, or even as a first camera, this chapter gives you the information needed to help you take the best photographs possible. A good understanding of exposure and the basics of composition help you create the images you want.

Understanding Exposure

All digital cameras create an image by focusing light through a lens onto a sensor. When the perfect amount of light reaches the sensor, there is enough light to show details in the darkest areas, but not so much light that the lightest parts are too bright. The goal of a good exposure is to have details in both the lightest and the darkest parts of the image. When I first picked up a camera many years ago, the idea that the camera could figure out the settings needed for a good exposure seemed like a magic trick. Most of the time, I ended up using a separate light meter to determine what settings to use. Today's cameras have fantastic built-in light meters, and letting the camera determine the exposure is very easy.

Because the light meter in the camera is always on, even when shooting in Manual mode, the camera lets you know what the light meter thinks is the correct exposure. Understanding what affects exposure enables you to be in control, which in turn allows you to improve your photography skills.

The four main things that affect exposure are

✦ **Light.** The amount of light reaching the lens affects how you approach a shot. This can be any light that you see, from the sun lighting up an outdoor scene to a table lamp lighting up a room. It makes no difference to the sensor what the source of the light is or how much light is there.

✦ **Aperture.** This is the amount of light passing through the lens. The light that reaches the lens can be reduced before it reaches the sensor. A hole in the lens — called the aperture or diaphragm, which can be made larger and smaller — controls the amount of light that passes though a lens. This works a lot like the iris of the human eye. The iris controls the size of the pupil, making the pupil larger — letting in more light — so you can see in darker situations and making the pupil smaller — letting in less light — so you can still see in very bright situations. The relative size of the aperture is called the *f-stop*.

✦ **Shutter speed.** This is the amount of light passing through the shutter. Before the light reaches the sensor, the shutter has to be moved out of the way. The length of time that the shutter is open is

referred to as *shutter speed*. The brighter the light coming through the lens, the less amount of time the shutter has to be open.

✦ **ISO.** The sensor in your digital camera acts like film does in traditional cameras. The sensitivity of both film and digital sensors is measured using the International Organization for Standards (ISO) rating. The higher the ISO rating, the lower the amount of light needed. When the light hits the sensor, the information is captured electronically, and the resulting data is stored on the memory card. When the amount of light is too low to achieve proper exposure, the sensor's output can be amplified to match the film ISO standards.

These four factors work together to produce an exposure.

Controlling Exposure

As the photographer you can control the amount of light reaching the sensor by changing one or more of the four things that affect the exposure. If each of the four factors only affected exposure, life would be easy; but changing the light, aperture, shutter speed, and ISO all have other consequences.

Light

Looking to see how much light is in your photograph is the starting point in evaluating your exposure settings. Light is the most important part of evaluating the scene you

want to capture. For example, is the subject of your photograph in bright light or in the shadows? Where does the light fall, and what is the quality of the light? Is the light a soft glow from a candle or harsh, direct light from the sun? Is part of your artistic vision the actual color of the light? The color of the light at a sunset is different from the color of the light inside a concert hall. Although the light in your scene is the most important part of the exposure equation, it can also be the hardest of the four things that affect exposure to change. Without extra equipment, increasing or decreasing ambient light is difficult. It might be possible to physically move yourself or your subjects, but this likely changes the composition of your photograph. Luckily for you, many products are available to help shape, modify, increase, or decrease the light in your scene.

> **Cross-Reference** *Light is such an important factor in photography that Chapter 4 is devoted entirely to light.*

Aperture

Aperture is measured in f-stops and is written as f/2.8, f/3.5, f/4, f/5.6, f/8, f/11, and so on. The larger the f/number (f/22), the smaller the opening — allowing less light to reach the sensor. The smaller the number (f/2.8), the larger the opening — allowing more light to reach the sensor. Essentially, an f-stop is a unit of change. For example, when changing by whole stops, f/5.6 lets in half as much light as f/4, and f/2.8 lets in twice as much light as f/4. Although changing the f-stop results in more or less light getting through the lens, this action has other consequences as well, as explained in the following list.

✦ **Depth of field.** When you use aperture to change the exposure, you are also changing the depth of field. The *depth of field* (DOF) is the distance in front of and behind the subject that appears to be in focus. Because only one plane of an image is in exact focus, everything else is technically out of focus. The area in front of and behind this focus point that is still acceptably sharp is called the depth of field area. The depth of field area starts one-third in front of the focus point and extends two-thirds behind it. When you use a smaller f-number (larger aperture opening), you get a shallower depth of field. When you use a larger f-number (smaller aperture opening), you get a deeper depth of field. This depth of field control lets you selectively focus on different items in the same view. Landscape photographs and big group portraits need to have a greater depth of field; both the foreground and the background need to be in focus.

The other factor that affects depth of field is the distance of the camera from the subject of the photo. The greater the distance between the lens and the subject, the greater the depth of field area; and conversely when the lens is very close to your subject, the depth of field area decreases. To increase the depth of field, use a smaller f-number, move farther away from the subject, and use a shorter focal length. To decrease the depth of field, use a larger f-number, move closer to your subject, and use a longer focal length.

3.1 Using f/1.4 creates a very shallow depth of field. With the focus on the bear, the tiger and the background are out of focus.

3.2 Using f/16 creates a much deeper depth of field, and without changing the focus, both animals are in acceptable focus.

Aperture Terminology

Professional photographers use the following terms when talking about apertures and the lens:

✦ **Shooting wide open.** This refers to photographing using the smallest f-number (the widest aperture opening) possible on any given lens. This lets in the most amount of light through the lens.

✦ **Stopping the lens down.** This refers to when you change from a small f-number to a larger f-number, reducing the amount of light that passes through the lens.

✦ **Sharpness.** Most lenses today are sharper in the middle range of f-stops, not at the smallest opening or the largest. The optimal f-stop is usually two stops up from the smallest f-stop. If your lens has a range from f/2.8 to f/22, the optimal f-stop is f/5.6.

✦ **Focal length.** The focal length of a lens is the distance from the optical center of the lens when it is focused at infinity to its focal plane (sensor), described in millimeters (mm). The amount of area in front of the camera that can be captured on the sensor using that lens is called the angle of view. A telephoto lens captures a smaller amount of the scene than a wide-angle lens, so it has a narrower angle of view. The focal length of a lens is measured in millimeters. For example, an 18-70mm f/3.5-5.6 zoom lens has a focal range of 18-70mm. At 18mm the f-stop is f/3.5, and at 70mm the f-stop is f/5.6.

✦ **Diffraction.** When you use the highest f-stops, f/16 and f/22, an effect called *diffraction* occurs. This is a reduction in the sharpness of the overall image. The aperture opening is so small that you are using very little of the lens, and the glass in the lens, to focus your image. It is best to avoid these extreme f-stops if possible.

Shutter speed

Shutter speed, which is measured in fractions of a full second (unless it is over 1 second), controls the length of time that the shutter is open and letting light reach the sensor. Because changing the shutter speed changes the amount of light reaching the sensor, it has a direct effect on exposure. The shutter speeds of the A700 are 30 seconds to 1/4000 second in steps of 1/3. The camera also has a Bulb setting, which allows you to keep the shutter open as long as the Shutter button is held down. Increasing the shutter speed reduces the amount of time that the shutter is open, letting in less light. Decreasing the shutter speed increases the amount of time the shutter is open, letting in more light. When you increase the shutter speed by one full stop, you halve the amount of light that reaches the sensor. When you decrease the shutter speed by one full stop, you double the amount of light that reaches the sensor.

Changing the shutter speed changes the way movement is captured in the photograph. When the subject of your photo is moving, you need to decide if you want to freeze the action or show the motion. A faster shutter speed, such as 1/2000, freezes the action; and a slower shutter speed, such as 1/15, produces motion blur.

✦ **Freezing action.** To capture a moment in time, the shutter of the camera opens and closes in a fraction of a second. To stop a dog running on the beach or a child jumping for joy, the shutter needs to be open for a very small amount of time to avoid blur. The faster the action, the higher the shutter speed needs to be. The general guide for stopping motion is 1/60 second or faster. When shooting a fast-moving scene, setting the camera's exposure mode to Shutter Speed Priority mode (S) lets you concentrate on freezing the action while the camera adjusts the f-stop.

3.3 To freeze the long jumper flying through the air, I used a shutter speed of 1/1250 second at f/5 with ISO 200.

Camera Shake

An issue that affects what shutter speed you use that has nothing to do with your subject is camera shake. This is the blurring that occurs when you hand-hold a camera with too slow of a shutter speed, resulting in a softening of your image's focus. The longer the focal length of your lens, the worse the camera shake. The rule to avoid camera shake is to use a shutter speed that is 1 divided by the focal length of the lens. For example, if you are using an 80mm lens, the minimum shutter speed needs to be 1/80 second. Another way to avoid camera shake is to use a tripod. The A700 has vibration reduction, called Super SteadyShot, built into the camera, and with this turned on, you can use a shutter speed that is 2 to 3 stops slower without camera shake.

Tip *If the camera still tells you that the scene is underexposed, you can always increase the ISO to make sure that the whole scene is properly exposed and the action is frozen.*

✦ **Motion blur.** Sometimes you may prefer to show motion in your photographs. By leaving the shutter open longer, objects in motion in your scene do not appear in sharp focus; they instead look blurred, and the nonmoving items in the scene are in sharp focus. You can also use a longer shutter speed and follow the action with the camera. By keeping the camera moving at the same speed as the subject while the shutter is open, the subject stays in focus and the background blurs. This technique is called *panning.*

ISO

The ISO range on the A700 is from 100 to 6400. The higher the ISO number, the less light you need to produce a correctly exposed photograph. However, when you use a higher ISO value, you introduce *digital noise*. At a higher ISO setting, the camera amplifies the signal from the sensor, resulting in more background electronic noise in the photo.

When too much light reaches the sensor, the image is overexposed; too little light and the image is underexposed. Each and every photographic situation requires you to decide what is most important to the image and set the shutter speed, aperture, and ISO accordingly. Sometimes you may be able to adjust the light as well.

3.4 The camera was panned while the horses ran by, adding a sense of motion to the photo by keeping the horses in acceptable focus while blurring the background. Shutter speed of 1/90 second at f/5.6 with ISO 400.

3.5 This photograph was taken indoors using an ISO of 6400. Even with the ISO noise reduction built into the camera, the noise is still noticeable.

A bright sunny day has plenty of light, enabling you to pick from a variety of f-stops and shutter speeds. A more challenging situation occurs when there is not a lot of light. Getting the correct exposure is a balancing act: As the amount of light decreases, you can increase the ISO, decrease the shutter speed, or use a smaller f-number (wider opening). Because you know the pros and cons of each, you can now decide what settings you want to change. By keeping the ISO as low as possible, you avoid introducing noise into the photograph. By keeping the f-stop at the optimal f-stop, you get the sharpest focus in your photos and not too shallow a depth of field. By keeping the shutter speed high, you can freeze the action and avoid motion blur.

Equivalent exposures

Certain combinations of shutter speed, aperture, and ISO give you the same exposure. In other words, the same amount of light will reach the sensor. At an ISO of 200, a shutter speed of 1/500 second, and an f-stop of 2.8 (f/2.8), you get an equivalent exposure when using an ISO of 200, a shutter speed of 1/60 second, and an f-stop of 8 (f/8). This means that the light reaching the sensor is the same. When you decrease the aperture, you are letting less light in through the lens, and so to get proper exposure you need to increase the amount of time that the shutter is open.

3.6 The photo on the left was shot at f/3 and 1/40 second, and the photo on the right was shot at f/5.6 and 1/13 second. Both photos were taken at an ISO of 400. The exposure of both images is the same even though they were taken with different shutter speeds and apertures.

Fine-Tuning Exposure

There are times when using the values supplied by the A700's built-in light meter results in an exposure that needs a little fine-tuning. Here are a few different ways that this can be done.

Exposure compensation

The A700 has an exposure compensation adjustment that can increase or decrease the overall exposure from –3 to +3 exposure equivalents (EV) in one-third or one-half step increments, in all exposure modes. This setting is very useful when you want to slightly over- or underexpose the scene.

Manual mode

The easiest way to adjust exposure is to shoot in Manual mode. Being able to set the f-stop and shutter speed to any combination you want lets you decide exactly what the exposure will be. You can still see what the camera believes the correct exposure should be and you can use it as a guide, but the camera does not set or change anything.

Exposure Metering modes

Selecting the proper Metering mode can help in getting the correct exposure. Spot metering ignores the entire scene with the exception of the Spot metering circle. It only measures the light that is in that area, giving you the greatest control over what the camera uses to calculate exposure. Center-weighted metering uses the entire scene, but gives more emphasis to the center area.

 Cross-Reference *To read more about changing the exposure mode, see the section on exposure modes in Chapter 2.*

Bracketing

Bracketing is a technique of taking multiple photographs of the same scene at different levels of exposure. This lets you slightly under- and overexpose a scene. The time to use bracketing is when you are shooting a static subject and you have the camera in the same position so as not to change the composition. When this is the case, you can shoot multiple photographs at different exposures to ensure you get the final result that you want.

Bracketing can be done manually by changing the exposure compensation or by shooting in Manual mode. When shooting in Manual mode, the shutter speed and aperture can both be adjusted to underexpose or overexpose the scene. Doing this manually takes time and practice, but luckily the A700 can bracket automatically. This is done by setting the drive mode of the A700 to one of the Bracketing modes.

3.7 A three-bracket exposure created with exposures set automatically by the camera: underexposed (top), correctly exposed (middle), and overexposed (bottom)

 Cross-Reference *For more information on setting the Drive mode, read Chapter 2.*

 Note *When your subject is moving, bracketing the exposures is not a good idea because the best exposure may not be the one with the best composition.*

Sometimes you may want more light to reach the sensor than the camera thinks is necessary. At these times you should overexpose the scene slightly:

✦ **Large areas of bright sky.** Scenes with large areas of bright sky cause the rest of the scene to be underexposed. To make sure that the rest of the scene has correct exposure, you must overexpose the image.

✦ **Direct sunlight.** When you shoot into the sun, the strength of the light causes other areas of your scene to be underexposed.

✦ **Bright light sources in the scene.** Scenes that have a light source in them can cause the scene to be underexposed. This could be a streetlamp in an evening street scene or a very bright reflection on water at the beach.

✦ **Lots of light tones.** Scenes that have large areas of very light tones also need to be overexposed. A scene shot in snow or on a bright sandy beach tends to be underexposed if left up to the camera.

✦ **Brides.** Brides in white dresses also tend to throw off the metering. The large white area of the dress causes the camera to underexpose the rest of the scene.

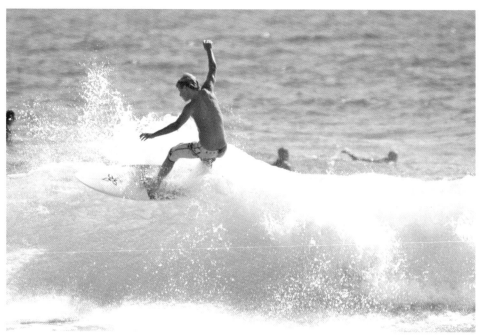

3.8 The exposure was set for the surfer, not the water. This overexposed the water, but because the photo is of the surfer, this is acceptable.

Sometimes you may also want to underexpose your photographs so less light reaches the sensor:

✦ **Lots of dark in a scene.** There are times when a large portion of dark area fills the scene — a groom and his wedding party all wearing black tuxedoes, for example.

✦ **Darker-complexioned subjects.** Portraits or headshots of dark-skinned people need to be underexposed.

✦ **Dark foreground with subject in the background.** If the foreground contains a large dark area but the subject is farther back, you should underexpose the scene.

Using the histogram

One of the greatest things about digital photography is the ability to get instant feedback on the image you just created. This changed the way that I photograph. I no longer had to wait to get back to the lab and develop the film to see if the exposure was correct or not. Even though the A700 has a clean, crisp, 3-inch screen to view your photos on, the Histogram view is more important when determining if the camera has captured the exposure correctly. The A700 has a dedicated Histogram button that opens a display showing not only the histogram for the whole scene but the histograms for the red, green, and blue channels as well.

The *histogram* is a basic bar graph that shows the amount of pixels that fall into each of the 256 shades from pure black to pure white. When you look at the histogram, the far left is black and the far right is white. One thing to remember is that there is no right or wrong histogram; it is just a representation of how the camera captured the scene.

3.9 This photograph of a groom was exposed for the skin tone, causing the dark blue of the tuxedo to be slightly underexposed and appear nearly black.

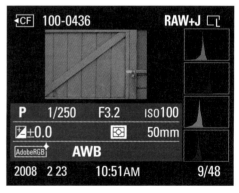

3.10 The photo of the red door does not have a full range of color or tone. The histogram view on the A700 shows a narrow peak in all four of the charts, showing no pure white or pure black.

3.11 The histogram view of this photo shows a large light area, nothing in the midrange, and a small amount of information in the dark range. There is an area of absolute white, which is indicated in the preview as the bright white areas. Because the white is absolute, this area will have no detail.

3.12 The histogram views show that this image has a full range of values from dark to light.

Each of these photos has good exposure, even though the histograms for each one are very different. I use the histogram only to see if there are any areas of absolute black or white. Looking back at figure 3.11, if there had been an area of absolute white, I'd know that the flower would have been too bright and would have lost detail. Had this happened, I would have retaken the photograph with the exposure compensation set to underexpose the image slightly.

Composition Basics

Composition is what goes into, what is left out of, and the placement of the objects within the photograph. With the automatic exposure and the great exposure metering in today's modern cameras, along with the new fast auto focus lenses taking care of keeping the subject in sharp focus, the biggest difference between a good photograph and a great photograph is often the composition.

The first and most important job of the photographer is to decide what the subject of the photograph is. Without knowing what you want to say with the photograph, composing the scene successfully is impossible. Is the subject a group of people at a party or a single wild flower? Only when the subject is known can you decide on the best way to present it.

After deciding what the main subject of your photograph is, you should check the rest of the scene. Are there elements behind or in front of your main subject that will be distracting later? Many photos have been ruined after finding that the tree in the background is sprouting from the top of Aunt Mabel's head. Sometimes a shallow depth of field helps keep the background out of focus, but often just trying to recompose the scene from a slightly different point of view is better. One thing that can help keep the main subject the center of attention is deciding on the orientation of the frame. I always ask myself if the scene I am shooting would

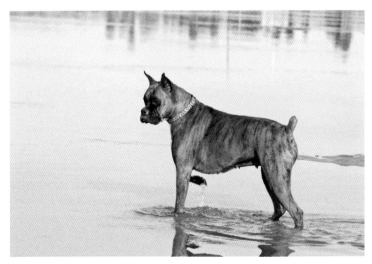

3.13 There is no doubt what the subject of this photo is.

look better in a landscape or portrait orientation. Sometimes the answer is not so obvious, and I end up taking photographs in both orientations. There are also times when the final purpose of the photograph dictates what orientation it needs to be in. For example, shooting for a magazine cover means that the image must be in portrait mode.

As the photographer, it is up to you to choose the viewpoint and angle. Standing under a tree and shooting at an extreme upward angle might be more interesting than shooting that same tree straight on from 15 feet away. When shooting kids playing in a soccer match, I find it more interesting to get down on a knee and shoot the event at the height of the kids, as opposed to shooting down from the height of an adult. Changing the shooting distance and angle brings your unique view to the composition.

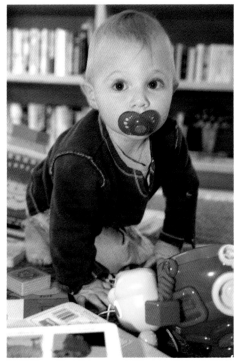

3.14 Photographing at a child's height shows the world from their perspective and not from an adult's.

Composition has some basic rules, but think of these more as guidelines. These rules are to help you compose pleasing-looking photographs, but sometimes breaking the rules is just fine. Once you know what the rules are, you can break them as often as you like.

The Rule of Thirds

The Rule of Thirds is one of the most popular composition rules for photographers. This rule is central to all types of photography. It does not matter if the subject is a landscape or a group portrait. The rule is very simple and can really enhance your composition.

Imagine lines divide the image into thirds both horizontally and vertically. The design is similar to a tic-tac-toe board. The idea is to place important elements of your composition at one of the four points where these lines intersect. It is that simple, and yet this rule can make all the difference between a good photograph and a great photograph.

Tip *Place the horizon line in your photograph one-third of the way from the bottom of the frame or one-third of the way from the top of the frame, depending on the subject.*

Placing elements of your photo a third of the way up, or a third of the way in from the left or right, is a good idea, and with a little practice, it's pretty easy to accomplish.

When you use the Rule of Thirds, it helps to produce nicely balanced photos. It is a great starting point when evaluating a scene to find the best composition.

3.15 The Rule of Thirds grid

3.16 The sunflowers are arranged with the top flower, the main focus, at the top left intersection of the gridlines.

3.17 The photo of a surfer waiting on the beach not only has a clear subject but also exemplifies the Rule of Thirds, creating a balanced image that is pleasing to look at.

Other compositional tips

Here are a few more compositional tips that generally help to produce better photographs. As with all rules in photography, if you feel the urge to break them, there is no punishment; they are meant as helpful guidelines, not absolutes.

✦ **Use the diagonals.** Placing the subject on a diagonal line from one of the corners of your photograph helps draw the eye to the subject.

✦ **Leading lines.** Any lines in the scene that provide a path that leads the viewer's eyes to the subject are used to create a strong composition.

✦ **Look inward.** Subjects should face in toward the center of the frame or toward the camera. This goes for all subjects, but the rule is broken more when it comes to human and animal subjects.

✦ **Human scale.** When shooting very large objects, you can sometimes lose perspective by not including another object in the frame that acts as a point of reference. Including an object whose size is readily identifiable lends scope to the image.

3.18 The hills to the right of the sheep lead the eye from outside of the photo to the subject.

✦ **Frame the image within the image.** To emphasize the main element in the photograph, another element can frame it. This is a great way to add depth to a static scene.

✦ **Use contrast.** A lighter object stands out on a darker background, and a darker object stands out on a lighter background. This seems so simple, yet it can be one of the most technically challenging things to do because of the exposure problems discussed earlier. A large light object against a dark background works only if the subject is exposed correctly.

✦ **Direction of movement.** With subjects that are moving or that can move, you should leave more space in front of the subject than behind. It is better for the subject to be moving into the frame than out of it.

3.19 The trees frame the castle, making it stand out.

3.20 Leaving room in front of the dog gives her space to move.

✦ **Simplify.** One of the key things to remember is to simplify the image. Make sure that you have done everything possible to keep the clutter out of your composition. When composing a photo, ask yourself if there are elements in the frame that distract from the main subject? If so, try to recompose the scene in a way that reduces the amount of distractions.

Break the rules

All the rules above can and should be broken in certain circumstances. Just remember that these rules are more like suggestions, and because the final composition is all about your choices, feel free to do whatever you want. The idea is to start with one of the rules, but if you feel the composition does not work using the rule, it is time to break the rule.

The Rule of Thirds suggests that the subject of your photograph should be placed one-third of the way from the top, bottom, and sides of the photograph. But sometimes placing the main subject in the dead center of the image gives it a punch that it doesn't have when following the rule. This can work well for everything from landscapes to portraits.

At times leaving more space behind a moving object can show where an object has been instead of where it is going. And, having the subject look toward the camera is not always necessary.

Composition is subjective, and no one can tell you what is right or wrong. What I have tried to do is to give you a basic understanding of what seems to work for a majority of situations.

Cross-Reference *Chapter 6 goes into more depth about composition and exposure for a variety of specific situations.*

3.21 This yellow window box is sitting in the middle of the scene, but the impact of the colors still makes it interesting.

All About Light

Cameras work a lot like the human eye: both take the light rays that are reflected from an object and focus those rays into an image. Photography actually records the light that an object reflects. So, without light, there is no photography.

Chapter 3 discusses how to control the amount of light reaching the sensor to create a proper exposure, but light has qualities that go far beyond just illuminating the scene. In this chapter, light is divided into two main categories: natural light and artificial light. Natural light is ambient light — the light that naturally illuminates a scene. It is not there for the purpose of photography. It could be the sun, a streetlamp, a neon sign, or even a bonfire. Artificial light is light that a photographer introduces into the scene for the express purpose of capturing the photograph. This could be a continuous light source or an electronic flash unit. I find that using as much natural light as possible is best, and when using artificial light I try to make the light look natural.

However, before you begin to concern yourself with the types of light, you need to begin to think about the characteristics of all light. As a photographer I am concerned about four characteristics of light: intensity, direction, color, and diffusion.

The Intensity of Light

The intensity or brightness of light depends on how close the subject is to the light source and the size of the light source. The closer the subject is to the light, the brighter or more intense the light is.

Note *When the distance between the light and the subject halves, the intensity increases by 4 times. When you double the distance between the subject and the light source, the intensity drops to one quarter of what it was originally. The only light source not affected by this is the sun. Any distance we move here on earth is so small in relation to the distance between the sun and the earth that the formula doesn't apply.*

It can be very difficult to control the intensity of natural light. When the light doesn't change, it is up to the photographer to adjust the shutter speed, aperture, or ISO to achieve the desired exposure. Gauging the intensity of the light is where I begin my

evaluation of any scene. Is the scene lit by bright lights or by the glow of a single candle? Are you shooting outdoors in the bright sunlight or after sunset when the only light is a glow on the horizon? When the intensity of the light is low, higher ISOs, slower shutter speeds, and a larger aperture are needed. When the intensity of the light is high, you can use faster shutter speeds, smaller apertures, and low ISOs to achieve the best exposure.

Controlling the intensity of artificial light is relatively easy in most cases, and even the built-in flash can be adjusted by using flash compensation. Studio lighting can have multiple lights that are each adjustable, giving the photographer amazing control over the light.

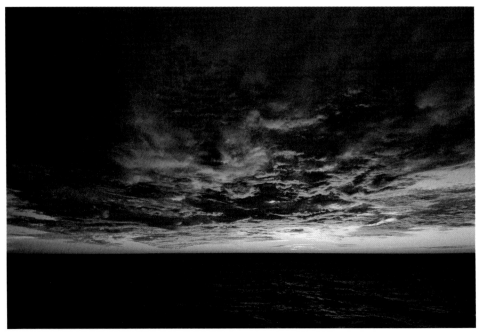

4.1 The intensity and direction of the light brings out the colors and textures in the clouds.

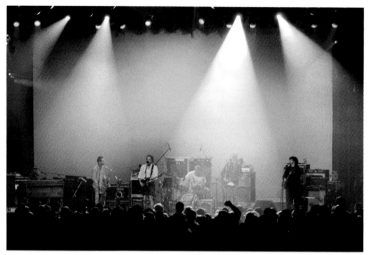

4.2 Stage lights can change direction and intensity at a moment's notice. Waiting until the lights are at their most intense lets me use a lower ISO and higher shutter speed to capture the scene.

The Direction of Light

The direction of the light is important because it determines where shadows fall. The shadows are what create depth in a photo, and if the direction isn't just right, you should either move the subject to change the direction of the light or wait for the light to move. The direction of the light can either bring out the details in your subject or hide them. Light can hit a subject in four distinct directions.

✦ **Front lighting.** Front lighting is one of the most commonly used forms of lighting and one of the most unflattering. This front lighting tends to remove all shadows from the subject, which creates flat, dull images, such as in driver's license and passport photos. If the light is directly behind you and hitting the subject straight on, change your position so that the light strikes the subject at a slightly different angle. This helps create longer shadows and a feeling of depth in your photos.

4.3 Amanda was shot with her face in direct sunlight, which created a flat and dull photograph; and because she had to look at the sun, it was difficult for her to keep her eyes open.

✦ **Overhead lighting.** When the only light source is from directly overhead, as can be the case with landscape photography, the subject can have very little character due to the lack of shadows. Most studio shoots will have a dedicated overhead light, but it is used in combination with other light sources to help create pleasing shadows.

✦ **Side lighting.** When the light hits an object from the side, the shadows that are created emphasize the form and texture of the subject.

✦ **Backlighting.** Although it can create some of the most dramatic photos, backlighting is one of the trickiest forms of lighting. Metering becomes difficult when the scene is lit with a bright light directly behind the subject, and capturing the details in the lightest and darkest areas is impossible. A good example of backlighting is the classic silhouette, where your subject appears as a black shape against a bright background. Sunsets are a great time to take backlit photos.

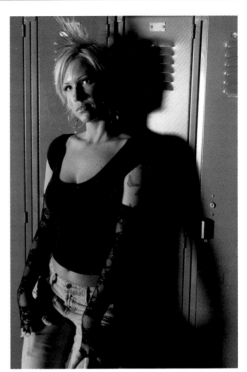

4.4 This model was shot with a strong strobe light from her right side. This light created deep shadows on the left side and helped to create the mood of the photograph.

4.5 The seagull sitting on the wall was backlit by the setting sun. By setting the exposure to properly expose the sunset, the seagull was severely underexposed, creating a silhouette.

The Color of Light

In photography, the light source plays an important part in the color of the photograph, because light emitted by different light sources has different colors. Photographers use *color temperature* to describe the differences in the color of light. The Kelvin scale is used to measure the color temperatures of light sources. The lower the number on the scale, the more orange or red the light is. Light on the higher end of the scale has a blue color to it. The color of the light in your scene also helps contribute to the overall mood of your image. The more the light in a scene goes to blue, the colder the scene will feel, and the more red or orange there is, the warmer the scene will feel. For example, candlelight, which gives an image a warm orange hue, has an approximate color temperature of 1800K whereas shade is usually about 7500K and gives your image a colder blue hue.

The color of light and the white balance setting on the A700 are linked in a very important way. To achieve correct color in your photographs, the white balance setting tells the camera's sensor what the color of the light in the scene is. When the temperature of the light and the white balance are matched, the colors in your photograph will look natural.

 Cross-Reference *Setting the white balance is covered in more detail in Chapter 2.*

4.6 The incandescent lights give this room a warm glow.

The Diffusion of Light

When the light rays are scattered by being reflected or by passing through a translucent material that light is *diffused*. Diffused light provides a more even light and softens shadows in your photograph. You can diffuse artificial light using equipment such as softboxes, umbrellas, diffusers, and reflectors. You can also use diffusers and reflectors to help soften natural light. However, for natural light, the best diffuser is a strong cloud cover, which lessens the intensity of the sunlight as it reaches your subject.

What diffusion does is change the size and intensity of the light source. When shooting outdoors, the sun is a very small, intense light source that creates hard, sharp-edged shadows. When clouds diffuse direct sunlight, the effect is to create a large soft light source. This light has softer shadows and is more evenly dispersed over the area. Cloudy and overcast days are great times to shoot outdoors. People, flowers, buildings all look better when lit with a softer, more even light.

4.7 This statue was photographed during the early afternoon under heavy cloud cover. The diffused sunlight made it possible to get even lighting without any harsh shadows.

Available Light

Available light is any light that exists in the scene naturally. This can be the sun in the sky or a neon sign. Just think of it as light that is already there, that you are not likely to be able to do anything to change.

Daylight

Daylight is the most common form of available light. It is also constantly changing. As the earth rotates around the sun, the available light changes from second to second. Each time of day has a different quality to the light.

Sunrise and sunset

Sunrise and sunset both have unique light properties. Because the sun is lower in the sky, the angle of the light creates long, low shadows that give depth to the scene. More importantly, the color of the light also changes at this time of day. Less white light is allowed to pass through the earth's atmosphere, which gives everything more of a red or yellow hue. Photographers find this light highly desirable.

 You may hear this time of the day referred to as the golden hour or the sweet light.

 Chapter 6 contains more on shooting sunrises and sunsets.

As the sun moves across the sky during the morning hours, the color temperature rises and the shadows get shorter. However, early morning is still a great time for landscape photography. The shadows are still long enough to create interest in your photos and the light is still soft with a yellow cast. The same is true of late afternoon.

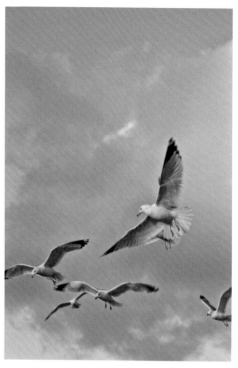

4.8 The light is so good during this golden time that even mundane subjects such as these sea gulls look great when lit at sunset.

Midday

When the sun is at its highest point during the day, the shadows are at their shortest, and any scene will seem flat. This is the worst time to photograph people outdoors. The light causes shadows to fall under the nose and eyes, which is the most unflattering way to photograph people. The light in the midday can be used for shooting, but most professional photographers prefer to shoot during the morning or the evening. If you do need to shoot people in the midday, use diffusers and reflectors to help modify the light.

Shooting landscapes and buildings in the midday sun has the same set of problems. The angle of the sun causes small shadows with little texture. The image is likely to seem flat and dull, and the subject matter is too large to modify using diffusers or reflectors.

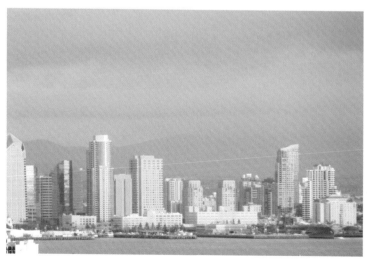

4.9 The San Diego skyline shot during the middle of the day has very little character; the lack of shadows create a flat looking image.

Electrical light

Artificial lighting runs the gamut from neon lights to streetlamps. The intensity of artificial light can vary greatly but doesn't tend to fluctuate as much as daylight. A given type of light usually outputs the same color and amount of light over the life of the light source. Common artificial light types can be broken down into three distinct types: fluorescent, incandescent, and vapor discharge lights.

Fluorescent lights

Fluorescent lights have become the most common lights in workplaces due to their low power consumption. The light emitted from fluorescent bulbs can cause subjects to have a green cast. The A700 white balance can be set to Fluorescent to help counteract this effect.

> **Tip** *When shooting in RAW, you can change and fine-tune the white balance on the computer after the photos have been taken.*

Incandescent lights

Incandescent — or Tungsten — lamps used for photographic purposes have a constant color temperature of 3200 Kelvin, but common bulbs used in everyday lighting situations can vary in color temperature and usually have lower color temperatures, that is, they produce light with a redder color.

To balance out the reddish color of everyday incandescent bulbs, the white balance of the A700 can be set to Incandescent. This tells the sensor that the light in the scene has a red, or warm color cast, and the camera adjusts so that any subject shot under these lighting conditions should look normal.

Vapor discharge lights

Mercury vapor, sodium vapor, and multi-vapor lamps have become very common in the world today and will render a subject a little greener than it should be. The light produced by vapor discharge lights is hard to accurately measure on the Kelvin scale and there is not a preset white balance setting for it.

Because this type of lighting is used in many places, it is likely to end up in your photographs at some point, so the best way to deal with it is to shoot using the RAW image quality. The image can then be adjusted later on the computer. If that is not an option, it is possible to set a custom white balance.

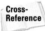 **Cross-Reference** *Setting a custom white balance is covered in detail in Chapter 2.*

Mixed light

Mixed light occurs when a scene is lit by two or more light sources that have different color temperatures. The human eye can deal with mixed lighting automatically, but the camera sensor cannot. The camera needs to have the white balance set so that the colors are reproduced correctly, but what do you do when there are two or more different color temperatures in the scene? For example, if you are shooting an indoor scene that has light from both a window and an indoor lamp, you must choose a white balance carefully. But, how do you know which light source to choose for?

One strategy when shooting in mixed light is to leave the white balance set to AWB (auto white balance) and use the color of

the light to create a mood in the photograph. A second strategy when shooting in mixed light, is to shoot the image as a RAW file and color-correct the file later using software.

Supplemental Light

Supplemental light is light that you bring to the scene. This can range from the small built-in flash on the A700 to a studio full of high-end strobe units. Using supplemental light gives you an amazing amount of control over the photograph. When using supplemental light, you can control the intensity, direction, color, and diffusion of the light. The two main examples of supplemental light are the small dedicated flash units and studio lights.

The built-in flash

The electronic flash was invented in 1931 and changed photography forever. Having an electronic flash built into the camera means that you are never without a light source. However, unless it is used correctly, lighting a scene with it can produce a very unnatural look. The position of the flash directly above the lens aims the light source directly at the subject, which causes a harsh direct light and shadows that are usually inconsistent with any type of natural lighting. It is almost guaranteed to produce red eye as well. The actual flash is small in size, and the smaller the light source, the harsher the light. Using the built-in flash can produce underexposed backgrounds and overexposed foregrounds.

Red eye and Red-eye reduction

Red eye is a phenomenon that has affected every photographer at some time or another. It is the glowing red eyes caused when the light from a flash is reflected off the blood vessels in your subjects' retina. Red eye can ruin even the best photo. The closer the flash is to the lens, the more likely there will be red eye (which is why red eye is a very common problem on point and shoot cameras). As the distance between the flash and the lens increases, the chance of red eye decreases. Note that the red-eye effect (although usually appearing green) also occurs in pet photography.

The Red-eye reduction feature on the A700 tries to negate the red eye by firing a quick burst from the flash prior to taking the photo. This burst of light causes the subject's pupil to contract, allowing less light to reach the retina. This means less light is reflected back. The Red-eye reduction setting is only available when using the built-in flash. To turn on the Red-eye reduction, press the Menu button, and then use the multi-selector to navigate to Custom menu 3. The first choice is to turn the Red-eye reduction on. The default setting is to have the Red-eye reduction turned off. After the Red-eye reduction is turned on, both the Auto Flash mode and the Fill Flash mode will use the Red-eye reduction.

There are a few positives of having a flash built right into the camera. The built-in flash is an integral part of the camera and always available, it is easily programmable, and the camera can automatically adjust the flash.

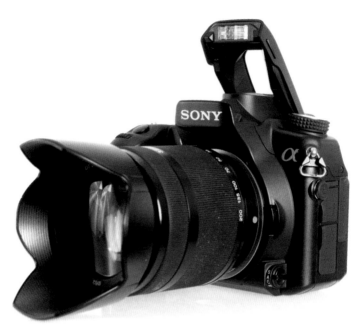

4.10 The built-in flash of the A700

Dedicated flash units

The best thing you can do for your flash photography is to get an external dedicated flash. Sony makes three models for the Alpha series: the HVL-F56AM, the HVL-F42AM, and the HVL-F36AM. All of these flash units are preferable to the built-in flash and can open up a whole new world of flash photography. A dedicated flash has some serious advantages to the built-in flash.

✦ **The flash can be aimed in a different direction to the lens.** The head of the flash unit can be set from 45 to 90 degrees.

✦ **The dedicated flash can be used in a wireless mode.** The flash can be removed from the camera and in this way can be used to direct light.

✦ **The dedicated flash is more powerful than the built-in flash.** It is also easily controlled by the camera, and has its own power, so it doesn't use any of the camera's battery life.

These attributes make the external dedicated flash an absolute necessity in creating professional flash photographs. To get great results from your camera when using a single external flash, there are five things that you can do:

✦ **Diffuse the light.** You can diffuse the light from your flash in three ways. All of these methods work really well in softening the light from the dedicated flash unit.

4.11 A dedicated flash unit can be set at various angles when mounted on the camera.

- **Bounce the light.** To bounce your flash, you aim the flash at the ceiling or a nearby wall, and not at the subject. The light that falls on your subject is not as strong, creating a softer light. Also, light appears to be more natural when it is coming from above or the side. The harsh shadows that are usually behind a flash-lit subject are eliminated when you bounce flash as well. This method works well indoors. One important note is that the color of the surface you are bouncing the light off of affects the color of the light falling on your subject. If the ceiling is red, the light that is bouncing off the ceiling will have a red colorcast, as will the subject being lit.

- **Add a diffusion dome.** This great accessory goes over the end of your flash and acts as a diffuser. The Sony flash units do not come with this standard, but you can buy one for under $20 from companies like Sto-Fen who produce the Omni-Bounce. When the diffusion dome is attached to the flash, angle the flash upward at 45 degrees; the results will amaze you. The light produced by the flash will be diffused and because the flash head is raised, the light will also be bounced to create a softer light falling on the subject.

- **Shoot through a diffuser.** Placing a diffusion panel between the off-camera flash and the subject softens the light with the most control. Place the diffuser as close to the subject as possible and place the flash two feet back from the diffuser. This gives you a nice even light on your subject.

- **Slow down the shutter speed.** When you slow down the shutter speed, you are using more of the available light in the scene, which helps to stop the background from being too dark and your subjects from looking like they have been caught like a deer in headlights. When you use a slower shutter speed, you let more light from the entire scene reach the camera's sensor, and then the flash lights the main subject. Set the Mode dial to Program mode (P) and compose the scene through the viewfinder. Press the Shutter button halfway down until the

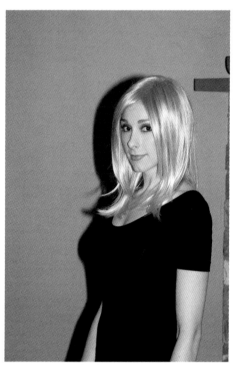

4.12 Here the flash was pointed straight on, casting a strong shadow behind Mia.

4.13 You can see the difference when the flash's light was bounced off the white ceiling—the shadow and overall lighting are softer.

camera has picked a shutter speed and aperture value. Change the Mode dial to Manual mode, set the aperture to the value from the automatic reading, and then set the shutter speed slower than the one the camera set. For example, if the camera set the shutter speed to 1/60 second and the aperture to f/6.3, set the shutter speed to 1/15 second and the aperture to f/6.3. This slower shutter speed allows for more of the ambient light to be in the scene, but the flash still

freezes any motion in your subject. This technique is also called "dragging the shutter."

Tip *It is possible to get the same effect by using the Slow Sync button on the A700 when taking a photo, but it cannot be used in the Shutter Priority mode or in Manual mode. There is no control over the shutter speed when using the Slow Sync button because the camera decides what shutter speed to use, which can give you longer than necessary shutter speeds, causing the image to be blurred.*

4.14 With the flash aimed at the ceiling and covered with a diffusion dome, the light illuminating Mia is soft without any harsh shadows.

4.15 The Breast Cancer 3-Day is a 60-mile walk spread out over three days that takes place in 14 major American cities every year. In the closing ceremony, emotions run high and many walkers hold their shoes in the air. To capture this powerful moment I used a slow shutter speed combined with a diffusion-dome-covered flash. The shutter speed was 1/15 second.

✦ **Use color gels.** Gels are polyester sheets that are a specific color. The name comes from the thin dried sheets of colored gelatin used in the early days of theater lighting. Placing the gel in front of the light source changes the color of the light produced. Matching the light being output from the flash to the color of the ambient light is very important. When shooting inside, other light sources need to be taken into account. When two different types of light are used to light the same scene, problems arise. The camera cannot figure out what the white balance should be. The answer to this is to place a gel in front of the flash so that the color of the light that the flash outputs matches the color of the ambient light in the scene. Yellow gels balance out the light from incandescent lights found in most homes, and green gels balance out fluorescent light.

Tip Lumiquest produces an FX Color Gel pack and holder that you can purchase for under $30.

✦ **Lower the flash output.** The light from the flash can overpower the natural light in the scene, creating harsh flat light and hard flash shadows. One of the simplest ways to fix this is to lower the amount of light the flash produces, the flash output, until it is closer to the natural light. On the A700 this is easily done by adjusting the flash compensation using the Quick Navigation menu. Just press the Function button to bring up the Quick Navigation menu and use the multi-selector to select the

flash compensation setting. The flash can be powered down by a total of 3 stops by using the multi-selector, but I usually start by adjusting the flash down by 1 stop and taking a test photo. I then use the preview on the LCD to decide if I need to adjust the flash power up or down. This technique works better for outdoors than it does indoors.

4.16 Bright sunlight striking the model from the right caused harsh shadows on her face, so I added the external flash and adjusted the flash compensation until I got enough light to offset the shadows on her face.

✦ **Remove the flash from the camera.** This is so easy to do with the A700 that I find myself doing it all the time, just because I can. Removing the flash from the camera means that the flash can be set at a different angle to the camera, creating a more natural light. To set the flash for wireless use, just do the following;

1. **Make sure both the flash and the camera are turned off.**

2. **Attach the flash to the camera's hot shoe and turn both of them on.**

3. **Press the Function button to bring up the Quick Navigation screen or press the Menu button and use the multi-selector to navigate to Recording menu 2.**

4. **Change the Flash mode to Wireless.**

5. **Without turning the camera or the flash off, remove the flash from the camera and raise the built-in flash.** When the Shutter button is pressed, the built-in flash fires a quick burst right before the photo is taken, which triggers the external flash. The built-in flash does not light the scene at all but needs to be in the up position so that it can trigger the external flash.

Flash sync modes

The A700 has four different Flash sync modes. These modes control the way the built-in flash or dedicated flash behaves when the Shutter button is pressed.

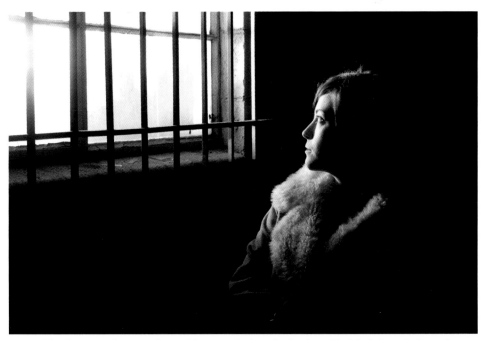

4.17 This photograph was taken with one wireless flash placed behind the window glass and triggered wirelessly. The light it produces coming through the window is diffused by the glass and casts a natural light on the model's face.

✦ **Auto mode.** The Auto mode is accessed by pressing the Function button to bring up the Quick Navigation menu or by pressing the Menu button and using the multi-selector to navigate to Recording Menu 2. The Auto mode is not available when the camera is set to Program Auto, Aperture Priority mode, Shutter Priority mode, or Manual mode. When the Flash sync mode is set to Auto, the flash fires when the camera believes it is necessary. The Auto mode does a great job in most situations and works even better when used with a dedicated flash unit.

✦ **Fill Flash mode.** Access this mode by pressing the Function button to bring up the Quick Navigation menu or by pressing the Menu button and using the multi-selector to navigate to Recording Menu 2. When the camera is in the Fill Flash mode, the flash fires every time the Shutter button is pressed, no matter what the lighting is.

✦ **Rear-sync mode.** This mode is accessed by pressing the Function button to bring up the Quick Navigation menu or by pressing the Menu button and using the multi-selector to navigate to Recording Menu 2. Rear-sync mode makes something that is very difficult to do manually very easy to do automatically. Normally, the flash fires as soon as the shutter is released, no matter how long the shutter is open. This causes the subject to be frozen by the flash at the beginning of the exposure and any movement after the flash fires

is then recorded in front of the image. When the Flash sync mode is set to Rear Sync, the flash fires at the end of the exposure, so the flash freezes the action at the end of the exposure. This causes moving images to be captured in a more realistic way—the movement recorded behind them.

✦ **Slow-sync mode.** Pressing the Slow Sync button on the back of the camera accesses the Slow-sync mode. The Slow-sync mode does not work when the camera is in Manual mode or in Shutter Speed Priority mode. When in the Slow-sync mode, the shutter is opened long enough to allow ambient light to reach the sensor.

✦ **High-speed sync shooting.** Using a Sony dedicated flash unit allows you to take photos at any shutter speed. This means that a dedicated flash can be used all the way up to 1/8000 of a second on the A700.

Flash compensation

There are times when you want to change the amount of light that the flash produces without changing the set exposure. To do this, you must change the light output by changing the flash compensation.

To set the flash compensation, do the following:

1. **Pull up the built-in flash or attach a dedicated flash and turn it on.**

2. **Press the Function button to bring up the Quick Navigation screen.**

3. **Use the multi-selector to select the flash compensation, and press the multi-selector's center button.**

4. **Use the multi-selector to adjust the flash compensation by up to 3 steps.**

5. **Press the multi-selector's center button to set the flash compensation.**

Studio lights

Studio lights come in two flavors: strobe lights and continuous lights. Strobe lights fire an intense short burst of light when triggered, a lot like a camera flash, and continuous lights are either on or off.

Strobe lights

Studio strobe lights come in many different sizes, makes, and models. Multiple strobe lights can be used together to give you complete control over the light. Studio strobe lights must be triggered with a sync cable or a radio slave system that allows the lights to be triggered wirelessly.

 Caution *The hot shoe on the A700 does not work with most hot shoe–triggered radio slave systems. Before making the investment in a wireless system, make sure that it will work with your A700.*

The two types of studio strobe lights are monolights and flash head/power pack systems. A monolight is a self-contained unit that plugs directly into a wall outlet. All the controls are on a single unit. Each monolight can be used as a master or a slave. When the monolight is used as a master, the sync cord plugs from the camera directly

into the monolight. When the master monolight fires, any slave monolights also fire. The output for each of the monolights, master or slave, is controlled independently on the actual light. This allows each of the lights to output different amounts of light. The flash head/power pack studio light system consists of a central power supply with individual flash units attached by their own cables. The sync cable is connected from the camera to the main power supply control unit, and each of the flash heads is adjustable by changing the amount of power going to each of the flash heads.

4.18 These young New York Giants fans were shot in the studio using multiple flash heads attached to a main power supply. This allowed both girls to be evenly lit.

Using a Light Meter

The A700 has a great built-in meter that can handle just about any lighting situation. There are certain situations where the light meter in the camera needs a little help. When using studio flashes with the A700, the amount of light that is produced from the flash is set independently from the camera. When this happens, the camera has no idea how much light is being used to illuminate the scene. So the built-in light meter does not work accurately. In these cases you can shoot a test shot and view the image on the LCD to adjust the exposure or you can use an external light meter.

When using an external light meter the first thing that needs to be done is to set the ISO to the same setting as on the camera. The meter should then be held near the center (chin level in a portrait situation) of the subject with the light-reading dome pointing back toward the camera. The light meter can then be used to trigger the lights in the same way as the camera, with a sync cord. The light meter then records a setting that shows what the aperture and shutter speed for correct exposure should be. These settings can then be entered into the camera. Each time the light or the subject is moved, a new light meter reading is needed.

Continuous lights

Continuous lights are always on, letting you measure the light with the camera's metering system. This means no extra equipment and no need to sync the camera with the lights. Continuous lights used to get a bad rap for being very hot, but this is no longer the case. The new fluorescent bulbs don't produce much heat at all and can be used all day quite comfortably. The continuous light system also has the advantage of being able to use different bulbs if needed. On the downside, because the light output from the continuous lighting setup is not as bright as that from a strobe light, it can't be used to freeze action in the same way.

Accessories to Control Light

Sometimes you can't wait for the perfect light, and the only option is to modify the existing light. There are two great tools that every photographer can use to modify light: reflectors and diffusers.

Reflectors

A *reflector* does exactly what its name implies: It reflects the light onto your subject and fills out the shadows to create a more even light on the subject. The bigger the reflector, the more light is reflected onto the subject. Reflectors work best when the original light source is very strong.

Different reflector surfaces create different light, and using the right reflector for the right job is important. Although very shiny material is highly reflective, it is very hard to control and does not reflect evenly. A plain white reflector has a much softer effect, and the spread of light is more even. When gold is added to the reflector's color, the reflected light is warmer and has the properties more associated with the natural light available during the golden hour. When silver is added to the reflector, the light has a harsher quality.

Reflectors come in a variety of sizes, but what really makes them useful for location work is that most types are collapsible. The reflector material is sewn around a sprung steel hoop, which keeps the reflective material taut, but still allows for the reflector to be folded and stored in a much smaller space. Many reflectors come with multiple covers as well, so that the color can be changed when needed.

To add more light to the shadow portions of the subject, the reflector needs to be positioned directly opposite the main light source and aimed toward the subject. The biggest challenge in using reflectors is positioning them in the right place and still being able to take the photograph. If you have an assistant or just a helpful friend around, this isn't much of a problem because he or she can help to hold the reflector at the correct angle. When you are alone, try to find something to lean the reflector against. You can also hold a small reflector yourself and still try to take the photograph, but this is not an easy thing to do. Some reflectors now come with a handgrip to help keep the reflector

steady. If it isn't going to interfere with the composition, you can even have the subject hold the reflector for you.

One great use for a reflector is to minimize shadows under a subject's eyes. When a person is lit from above by natural or artificial light, shadows can form under the eyes, which is not a very pleasing look. Positioning a white or silver/white reflector in front of the subject, aiming up at the face, reflects some of the light back up at the subject and fills in those shadows.

4.19 The reflector is being used to add light to the right side of the bride and her maid of honor.

4.20 Anna was shot under a tree in some heavy shadows. A small reflector was used to add some light to her face.

Diffusers

Diffusers are light modifiers that go between the light and the subject to soften the light that passes through. Diffusers can be a bit complicated to set up because they must be placed between the light source and the subject of the photo. When used outside in natural light, this usually means that they need to be positioned above the subject so as to diffuse sunlight. Think of a diffuser as an artificial cloud that you have complete control over. Generally, the material of the diffuser should let roughly 50 percent of the light through, but this is a matter of taste.

Because direct sunlight, or any direct light, creates harsh lights for portraits, if you can't avoid taking photos in the midday sun, you should try to use a diffuser of some kind. In a pinch, you can use any light-colored, thin material such as a white bed sheet (obviously you have to have assistance to hold it in place if you are outside). When shooting indoors, the bright sunlight coming through a window can be softened by hanging a white sheet in front of the window. The output from studio lights can be modified using diffusers such as a softbox or umbrella in front of the flash head.

A softbox is a large light diffuser that softens the light of a studio flash, and although these cost more than umbrellas, they do a better job keeping the light exactly where you want it. A softbox connects to a flash head using a speed ring, which is usually sold separately from both the softbox and the strobe. Softboxes come in a variety of sizes and shapes, from a small square to a large octagon.

An umbrella is a light modifier that connects in front of a studio light and looks just like an umbrella that is used to protect you from the rain. The umbrella is positioned so that the light is aimed through the umbrella. The light is then aimed 180 degrees from the subject letting the light reflect back from the inside of the umbrella toward the subject. Although this method is cheaper and easier than having a softbox, it doesn't have the same level of control – but it is still better than nothing at all.

All About Lenses

The versatility of a dSLR system comes from the ability to use a wide variety of lenses with the same camera body. A dSLR camera uses a mirror and a prism so that the view through the viewfinder is the same as the view through the lens. This lets the you see the scene the same way that the camera does, making composition a what-you-see-is-what-you-get exercise. So although the camera is what captures the image, it is the lens that focuses and controls the light reaching the sensor.

The light needs to travel through the actual glass elements inside the lens and be focused correctly onto the sensor for an image to be created. Each of the elements helps to aim the light correctly onto the sensor, and so the higher the quality of the elements inside the lens, the higher the quality of the lens. The simple truth is that the better the lens, the better the final image will be (although it doesn't make up for good composition, correct exposure, and sharp focus).

Many lenses can cost a lot more than the cameras that they are attached to, and while you might replace your camera with a new model, a good lens — or good glass as photographers refer to it — can last forever. I consider high-quality lenses an investment, and with care, a good lens will continue to produce sharp, clear images for a lifetime.

Sony Lens Basics

There are currently 24 Sony-branded lenses and two tele-converters that are available directly from Sony. Sony lenses cover the full focal length range from the super-wide-angle 11mm to the super-telephoto 500mm. Lenses from Sony include four manufactured exclusively for Sony by Carl Zeiss and four lenses in the high-end G-lens series. The A700 mount supports lenses that have built-in focus motors and those that use the camera body focusing motor.

Carl Zeiss Lenses

A world leader in optics, the Carl Zeiss company and Sony partnered up in 2006 to make three Zeiss lenses available with the Sony Alpha lens mount. The three lenses all carry the lens designation of "ZA," standing for Zeiss Lens for Sony Alpha mount. The first three ZA lenses are the Planar T* 1.4/85 ZA, the Sonnar T* 1.8/135 ZA, and the Vario-Sonnar T* DT 3.5-4.5/16-80 ZA. In 2008, Sony released the fourth Carl Zeiss lens, the Vario-Sonnar T* DT 2.8/24-70 ZA, which is a 24-70mm f2.8 zoom lens. These are really great quality camera lenses, and even though the 85mm, 135mm, and 24-70mm lenses cost about as much as the A700 does, they will last for a lifetime if properly cared for.

Compatibility

The A700 utilizes the Sony Alpha lens mount that used to be called the Minolta A-type bayonet mount. This lets the A700 use all the Sony-branded lenses as well as the older Konika Minolta A-type lenses, including the Maxxum and Dynax lenses.

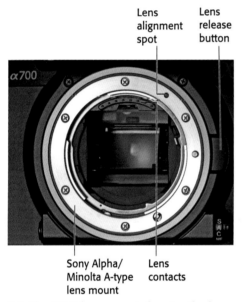

5.1 The A700 lens mount showing the lens contacts, lens alignment spot, and the lens release button.

Maximum aperture and focal length

Each and every lens has two very important qualities: the maximum aperture or the maximum aperture range and focal length or focal length range. These two qualities are used to define the lens, and understanding them is important when choosing which lens to use or which lens to buy for your needs. The SALs (Sony Alpha Lenses) are marked on the lens barrel with the maximum aperture and focal lengths in the following format: 4.5-5.6/11-18 or 2.8/50. The number(s) on the left side of the slash show the maximum aperture value(s), and the numbers to the right show the focal length(s). Other lens manufacturers mark their lenses differently, so it pays to remember that focal lengths are measured in millimeters (mm), and the aperture can be shown as a ratio such as 1:2.8.

✦ **Maximum aperture.** The maximum aperture, or the maximum aperture range, describes the widest opening possible for the lens. The smaller the number, the bigger the opening, and the greater the amount of light that is let through to the lens. If the lens has

a range of focal lengths, it can also have a range of maximum apertures. It is important to know that the maximum aperture can change depending on what focal length is used.

✦ **Focal length.** The focal point of a lens is the point where the rays of light that are passing through a convex lens converge. The focal length of a lens is measured by the distance from the optical center of the lens to its focal point, which is located on the sensor (when the lens is focused at infinity) and is described in millimeters (mm). The focal length determines the angle of view of a lens. The greater the focal length, the narrower the angle of view and the less of the area in front of the camera that will be in the scene. This means that things that are far away, or seem to be taking up very little area in front of the camera, will seem to be closer when viewed through a lens with a long focal length.

5.2 This sequence of photos shows the different focal lengths. The first photo was taken at 18mm (top left), the second at 50mm (bottom left), the third at 100mm (top right), and the fourth at 200mm (bottom right).

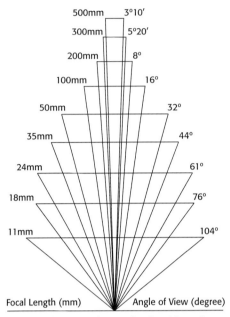

Focal Length (mm)	Angle of View (degree)
500mm	3°10′
300mm	5°20′
200mm	8°
100mm	16°
50mm	32°
35mm	44°
24mm	61°
18mm	76°
11mm	104°

5.3 This diagram shows the focal lengths and the equivalent angle of view for an A700.

Expanding your lens options

Numerous third-party lens manufacturers build quality lenses that use the Sony Alpha mount or the Minolta A-type lens mount. Tamron and Sigma are two of the biggest third-party lens manufacturers, and they both carry a wide variety of lenses that are compatible with the A700. Some of the lenses produced for the A700 from Tamron include a 70-200mm f/2.8 zoom lens, a 10-24mm f/3.5-4.5 ultra-wide-angle lens, and a 17-50mm f/2.8 standard zoom lens. Lenses produced by Sigma for the Sony Alpha mount include the 70mm f/2.8 Macro lens, the 150-500mm f/5-6.3 super-telephoto lens, and the 8mm f/3.5 circular Fisheye lens.

Tip *Another lens available with the Sony Alpha mount, the Lensbaby, has become very popular in creating a selective focus effect. This specialized lens lets the photographer keep one area of the image in sharp focus while the rest of the image becomes increasingly blurry. The Lensbaby allows the area that is in sharp focus to be moved to any part of the photograph by simply bending the lens.*

Understanding the Lens Crop Factor

The A700 uses an APS-sized sensor that is smaller than a 35mm frame of film or a full frame sensor. It's because of this smaller size that lenses appear to produce an image that is magnified compared to the image produced by the same lens on a full frame sensor. What is actually happening is that the smaller APS sensor is only capturing part of the information that a full frame sensor captures.

Lenses are still marked in 35mm focal length numbers, but quickly calculating the equivalent focal length for the A700 is easy. The actual math used to calculate the equivalent focal length is to divide the diagonal of a 35mm frame by the diagonal of the Alpha 700's sensor and then multiply the result by the focal length of the lens. Because the sensor diagonal is 1.5 times smaller than the diagonal of the 35mm frame, the quick way is to increase the focal length by half. For example, a 200mm lens is now equivalent to a 300mm lens, and a 50mm is now equivalent to a 75mm lens.

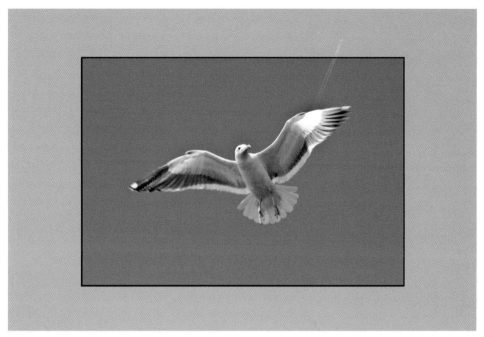

5.4 The outside edge is what you'd see with a 35mm film camera. The inside portion is what you see with the A700. As you can see, the bird doesn't actually get any closer, but it does take up more space.

This is an advantage on the telephoto end of things because your lenses now get you closer to the action than the same lens would on a 35mm camera. The downside occurs when using wide-angle lenses. Because they no longer cover all the area that they would on a full-frame sensor, a 20mm lens now becomes a 30mm lens, and that expensive 16mm now becomes a 24mm lens. To get the same wide-angle view that a 16mm lens offers on a full-frame sensor, the A700 shooter needs to use an 11mm lens.

Sony Lenses

Sony created a series of camera and lens combinations that make it possible to purchase an A700 along with a lens at a discount price compared to buying them separately.

✦ **The A700 and the 18-200mm f/3.5-6.3 lens.** This multipurpose lens covers a wide range of focal lengths, from 18mm all the way to 200mm. The lens has an internal focusing system that keeps the size of the lens compact and the focusing fast. At 2⅞ × 3⅜ inches and 14 ounces, this is a small, lightweight, compact lens that is suitable for a wide variety of applications, from travel to candid photography. The drawback to this lens is that the maximum aperture is f/3.5 at the 18mm focal length, but only f/6.3 at the 200mm focal length, making it difficult to use in low-light situations.

✦ **The A700 and the 18-70mm f/3.5-5.6 lens.** This lens covers a smaller range of focal lengths than the 18-200mm; it covers 18-70mm, with a maximum aperture of f/3.5 at 18mm and f/5.6 at 70mm.

✦ **The A700 with the 16-105mm f/3.5-5.6 lens.** This is a new lens that covers the 16-105mm focal lengths. This lens has a maximum aperture of f/3.5 at 16mm and f/5.6 at 105mm.

Any of these three kits from Sony are a good starting point for any photographer. I would suggest purchasing a prime lens in the 28-50mm focal length range as well. A good prime lens with a maximum aperture of f/2.8 or faster will round out a beginning lens collection nicely.

Choosing Between Prime and Zoom Lenses

Lenses come in two types: prime lenses and zoom lenses. Prime lenses have only one focal length, and are sometimes called fixed focal length lenses. The two names are interchangeable. Prime lenses are easier to make because they have to be sharp only at one focal length, making the optics a whole lot simpler than their zoom counterparts.

Zoom lenses cover a range of focal lengths, giving the photographer more options than a single focal length. There was a time when having a zoom lens meant sacrificing quality for convenience because they had a reputation for not being as sharp as fixed focal length lenses, resulting in poorer image quality. They were also heavier and more

expensive than prime lenses. This is not as true today, with modern manufacturing and lens design, zoom lenses that are as sharp as some fixed focal length lenses are now being produced. Modern zoom lenses are smaller, lighter, and sharper than ever. The Sony line of lenses has 12 prime lenses and 12 zoom lenses.

Prime lenses

Prime lenses have one serious advantage over zoom lenses. Due to the way that lenses are manufactured, prime lenses can

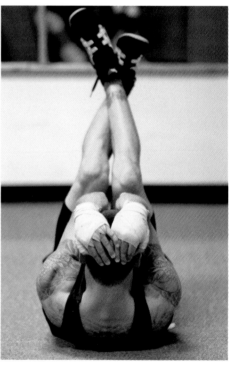

5.5 Taken indoors with available light, this photo would not have been possible with just any lens. The f/1.4 maximum aperture on the 85mm lens allowed me to capture this boxer during his training without the distraction of a flash and to control the depth of field to keep his hands in sharp focus while the legs are pleasantly blurred.

have a greater maximum aperture than zoom lenses, making them much faster than most zoom lenses. Because modern zoom lenses are so much better and affordable than they used to be, many photographers don't use prime lenses very much anymore. This is a real shame. There was a time when the lens that would come with the camera was a prime lens, usually a 50mm lens that offered a normal view. Prime lenses are great tools and should not be dismissed quickly simply because they do not offer a range. One of my favorite "walk around" lenses is the 28mm f/2.8. This prime lens is the smallest and lightest lens that Sony offers, yet it has an f/2.8 maximum aperture for great low-light shooting and amazing control over depth of field.

Zoom lenses

Modern zoom lenses have all but taken over the lens market. Why get a lens that has only one focal length when for a few dollars more (or sometimes less) you can get a single lens that covers a wide range of focal lengths? It is much more economical to purchase a single lens that can do the job of multiple lenses. The ability to cover a wide range of focal lengths makes zoom lenses very useful for today's photographers. Instead of having to carry three or four different lenses, stopping to switch lenses every time you want a different focal length, the single zoom could be your answer. A lens like the 18-250mm f/3.5-6.3 covers focal lengths from 18mm all the way to

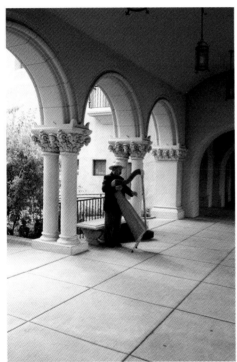

5.6 A great advantage to zoom lenses is the ability to recompose the scene without having to move. I was able to get one shot of this musician playing in San Diego's Balboa Park with his surroundings and one close-up without having to intrude on his playing.

250mm. This makes the lens a wide-angle lens, a normal lens, and a telephoto all at the same time depending on what focal length is used.

One downside is that most zooms have a range of maximum apertures, and none of them are as fast as a good prime lens. Other than the 70-200mm f/2.8 and the 24-70mm, which both have a constant maximum aperture of f/2.8, all the other Sony zoom lenses have a wide range of maximum apertures. This can be a problem especially in low-light situations or when you want a shallow depth of field.

Wide-Angle Lenses

Wide-angle lenses cover an angle of view greater than 60, capturing scenes that are wider than normal. The wide-angle focal lengths also have the ability to expand the space between objects that are in the foreground and those in the background, making the whole scene seem bigger.

Wide-angle lenses can cause perspective distortion. The closer to the camera an object is, the larger it appears in comparison to the rest of the scene. This is important to keep in mind if you are shooting people.

Wide-angle lenses from Sony:

✦ **11-18mm f/4.5-5.6.** This super-wide-angle lens was designed specifically for the APC sensor in the A700 and offers an amazing 104-degree angle of view. This is the widest lens that Sony makes.

✦ **16mm f/2.8 Fisheye.** This lens was designed for the A700 and can focus as close as 8 inches. A unique feature of this lens is the

5.7 Using a 12mm wide-angle lens to create the feeling of space results in the pier seeming to stretch way out into the ocean.

four built-in filters: normal; 056 for improving contrast in black-and-white images; B12, which removes the red tones; and A12, which removes the blue tones. The filters can be selected by simply rotating a dial on the lens.

✦ **16-80mm f/3.5-4.5.** This Carl Zeiss lens was built specifically for Sony. This compact zoom was designed specifically for the APS sensor found in the A700. This lens has an auto clutch that stops the manual focus ring from rotating when in Auto Focus mode.

✦ **16-105mm f/3.5-5.6.** This compact zoom has an internal focusing system that moves elements inside the lens when focusing so the length of the lens doesn't change. This is a great lens for portrait work because it can be used to capture a whole group or a single subject.

✦ **18-70mm f/3.5-5.6.** This wide-angle to mid-telephoto zoom lens was designed for the APS sensor in the A700. This lens uses extra-low dispersion glass to reduce any chromatic aberrations. This is a good budget lens for the amateur photographer.

✦ **20mm f/2.8.** This wide-angle lens has excellent low-light capabilities. This lens utilizes a rear focusing system that moves the rear lens elements when focusing, increasing focusing speed.

✦ **28mm f/2.8.** This medium wide-angle lens has great low-light capabilities. This is the smallest and lightest lens that Sony manufactures, and it spends a large amount of time mounted on my A700. This lens has a unique built-in sliding lens hood that means fewer parts to worry about.

Normal Lenses

A normal lens is any lens where the angle of view is about 50 degrees. This used to be the 50mm lens when on a 35mm camera. With the lens crop factor, this is now closer to the 35mm lens, which is equivalent to a 52.5mm lens when used on the A700. Seven lenses in the Sony family have focal lengths of 35mm. Six of the lenses are zoom lenses and one is a prime lens.

The view through a normal lens is approximately the same as the view through your eyes, which is why it is called a normal view. When a scene is shot using a normal focal length, everything in the photo seems to be in correct perspective. This is a great lens for portraits and group shots because the view is very familiar and can add a real sense of intimacy.

Lenses from Sony that fall into the normal range:

✦ **35mm f/1.4.** This is a super-fast lens with a maximum aperture of f/1.4. This is one of three lenses that are f/1.4, the fastest that Sony makes. The 35mm has the equivalent focal length of 52.5mm when the lens crop factor is taken into account. This makes it the standard in normal lenses. Combined with the Super SteadyShot technology, this lens can be used in very low light.

✦ **50mm f/1.4.** This super-fast, bright prime lens works well for both candid scenes and portraits, even in very low light. This is one of the three fastest lenses made by Sony and its low-light ability is fantastic. If you spend a lot of time shooting indoors or in low light, then this is the lens for you.

5.8 This candid of guitar player Mark Karan getting ready for a show was shot in his living room using a 35mm lens. The choice of this lens lets viewers into the room as if they were standing right next to Mark.

✦ **24-70mm f/2.8.** This Carl Zeiss lens, released in 2008, not only covers the normal focal ranges, but with a constant f/2.8, it is faster than any other normal zoom lens. This lens is equipped with a SSM (Super Sonic wave Motor) that increases focusing speed, and with the Carl Zeiss T* coating, which helps cut down on lens flare, this is one seriously nice piece of glass.

✦ **24-105mm f/3.5-4.5.** This is a standard zoom lens covering the normal lens focal range. This lens includes the auto-clutch feature, which stops the focusing ring from moving when the lens auto focuses.

Telephoto Lenses

Telephoto lenses get you closer to the subject. The longer the telephoto, the closer you can get. This is especially important when there is no other way to get closer to the subject. When you're trying to get a photo of a lion at the zoo, it isn't possible to just walk up closer, so a longer lens is needed. Using telephoto lenses is an absolute necessity when shooting sports, concerts, and wildlife because there is no way to physically get any closer to use normal lenses.

While most people think of telephoto lenses as a way to get closer to the subject, there are some other advantages to using a long lens. Long focal lengths combined with a

5.9 Telephoto lenses let you capture scenes that are too far away to reach any other way. This surfer was close to shore, but I still wasn't able to get this shot without a 300mm lens.

shallow aperture can be used to isolate a subject from the background. Using a 200mm lens and a f/2.8, the background will be pleasantly out of focus, making the subject of your photo stand out.

Because the focal lengths of these lenses are longer than normal, the shutter speed needs to be increased to reduce camera shake.

In addition to the camera shake and shutter speed problems, a form of distortion also occurs when using a long focal length. Because subjects are far away, everything can seem to be compressed. When I was first learning photography, I was shown a photograph of a leopard lying on a tree branch with the setting sun right behind it. It was a stunning shot, with the sun so big, bright, and close to the cat. It turns out that

the sun was a long way away, but because the shot was taken with a very long telephoto lens, the two items seemed to be right on top of each other.

Sony makes a wide variety of telephoto lens. Some of the following lenses fall into more than one category of lens and could be considered wide angle and normal lenses as well.

✦ **85mm f/1.4.** This is a Carl Zeiss Vario-Sonnar lens and one of the fastest lenses Sony makes. The f/1.4 maximum aperture makes this lens fantastic for any lighting condition and a great choice for portraits. This lens is also equipped with a Focus Hold Button and in Auto Focus mode, the focusing ring will not turn.

5.10 This Little League pitcher is in sharp focus, while the cars, fence, and umpire behind him are just a blur, really isolating the pitcher and making him stand out.

✦ **135mm f/1.8.** This is a Carl Zeiss lens and is only marginally slower than the 85mm f/1.4, but it can actually focus closer than the 85mm f/1.4. This lens is great in any lighting condition, and with its internal focusing system, it can focus quickly enough to catch the action.

✦ **135mm f/2.8.** This is a special lens in the Sony lineup. It is the only lens to incorporate Smooth Transition Focus (STF). The STF lets the subject of your photo stay in sharp focus, while the out of focus backgrounds or foregrounds are blurred smoothly and, more importantly, with a gradation that thickens towards the edge of the image. This lens is rated at f/2.8, but because it incorporates a special element that distributes the light in the lens, the transitive brightness can be set from 4.5 to 6.7. A special manual aperture ring controls this transitive brightness. This lens is a manual focusing lens, and it has an extra wide focusing ring.

✦ **300mm f/2.8.** This is the fastest long lens that Sony makes. While there are other lenses that reach the 300mm focal length, none of them have a maximum aperture of f/2.8. That makes this lens the most expensive lens Sony offers. This is the lens for serious wildlife or sports shooters, with a built-in Super Sonic wave Motor to speed up focusing, and it has the ability to work well in low light. This lens is also one of the few that can be used with the Sony tele-converters.

✦ **500mm f/8 Reflex.** This is the only auto focus reflex lens on the market for any camera. The reflex design creates a super-long telephoto lens, but because the maximum aperture is f/8, this is one slow lens, and it needs to be used in bright light. The f/8 aperture is fixed, and the exposure for this lens is controlled by changing the shutter speed and by adding a neutral density filter.

✦ **18-200mm f/3.5-6.3.** This compact zoom lens can be considered a wide-angle, normal, and telephoto lens. It covers a wide range of focal lengths and, because the focusing is done internally, it doesn't change length when focusing, but it does change when zooming.

✦ **18-250mm f/3.5-6.3.** This lens builds on the 18-200mm by increasing the focal length range to 250mm on the telephoto end. Combine the huge focal length range with internal focusing and ED (Extra-low Dispersion) glass, and this makes a great multi-purpose lens.

✦ **55-200mm f/4-5.6.** This is a great starter lens. This lens covers the normal to telephoto focal ranges. Being designed for the APS sensor in the A700 lets this lens be as compact as possible. This lens also lets you get close, with a minimum focusing distance of 3 feet.

✦ **70-200mm f/2.8.** This G series lens is standard for concert shooting with its low-light capabilities and Super Sonic wave Motor (SSM) for faster focusing. This lens is also great for sporting events and wildlife photography. This lens can also be used with the Sony tele-converters, extending its range up to 140-400mm.

✦ **70-300mm f/4.5-5.6.** This lens was released in 2008 and comes with the Super Sonic wave Motor for fast auto focus capabilities, ED glass, Focus Hold button, and a minimum focusing distance of 4 feet.

✦ **75-300mm f/4.5-5.6.** This compact, lightweight zoom lens offers 4x zoom shooting. This is the perfect starter lens for someone interested in shooting outdoor sporting events and wildlife.

Macro Lenses

Macro lenses are specialty lenses that let you create extreme close-ups of your subject. There are two Sony-branded macro lenses:

the 50mm f/2.8 and the 100mm f2.8. Both macro lenses offer 1:1 magnification and f/2.8 maximum aperture. Because of the 1:1 rating, the image on the sensor is the same size as the object being photographed. These lenses demand a premium price for their close focusing ability and 1:1 magnification.

When using macro lenses, the depth of field is severely limited. The closer the subject is to the lens, the smaller the depth of field is, and because the subject in macro photography is only inches away from the front of the lens, the depth of field is very small. To get as much of the image in acceptable focus as possible, using apertures of f/32 is not unheard of.

5.11 The individual wires that make up this computer cable are in sharp focus, while the area that is only 5mm back is blurred. The narrow depth of field was produced by photographing this cable with a 100mm macro lens and an aperture of f/11.

Cross-Reference *For more information about macro photography, see Chapter 6.*

Sony offers two macro lenses, a 50mm and a 100mm.

✦ **50mm f/2.8 Macro.** The 50mm macro lens has a true 1:1 magnification. This lens lets you get in close with a minimum focusing distance of 7.8 inches. The 50mm macro also has a Focus Hold button that can lock auto focusing and a Focus Range Limiter than can speed up auto focusing by limiting the range of distances that are focused on. The limiting range can be set to Close-up Range or Telephoto Range. This lens can also be used as a normal prime lens, and with a fast f/2.8 maximum aperture, it makes a great low-light lens.

✦ **100mm f/2.8 Macro.** The 100mm lens has a true 1:1 magnification. This lens lets you get macro shots without having to get as close as you would with the 50mm macro lens. The 100mm macro utilizes the same Focus Hold button, Focus Range Limiter, and auto clutch as the 50mm macro. Due to the fast f/2.8 maximum aperture, this lens makes for a great telephoto lens that can be used in pretty low lighting with great results.

With two choices for macro lenses, it is important to weigh the pros and cons of the focal length difference. The longer focal length on the 100mm macro lens lets you work farther away and still achieve a true 1:1 representation. This is important if your subject is hard to get close to, like an insect or animal. If you have subjects that can be approached and let you get as close as you

want — flowers, plants, and inanimate objects, for example — then the 50mm macro will suffice.

Tele-Converters

Tele-converters are specialized lenses that go between the camera and the lens that increase the focal length while reducing the maximum aperture of the lens. Tele-converters used to be very popular before zoom lens manufacturing started to produce affordable compact zoom lenses that matched the quality of the prime lenses. Sony understands this, and the tele-converters fit only lenses that have a fast maximum aperture to begin with.

✦ **20TC.** This tele-converter doubles the focal length of the lens it is attached to and only works with the G line of lenses from Sony.

 • **300mm f/2.8 with the 20TC.** The 20TC turns the 300mm f/2.8 lens into a 600mm f/5.6.

 • **70-200mm f/2.7 with the 20TC.** The 20TC turns this lens into a 140-400mm f/5.6

✦ **14TC.** This tele-converter extends the range of the lens it is attached to by 1.4.The 14TC only works with the G line of lenses from Sony.

 • **300mm f/2.8 with the 14TC.** The 14TC turns the 300mm f/2.8 lens into a 420mm F/4.

 • **70-200mm f/2.7 with the 14TC.** The 14TC turns this lens into a 100-320mm f/4.

If you do have the opportunity to shoot with a tele-converter, it is important to remember to either stabilize the lens with a tripod or use a shutter speed faster than the new focal

length of the lens. Note that when you use a tele-converter, your images may not be as sharp as those shot without the converter.

Reducing Vibration

Vibration reduction technology lets you take photos at slower shutter speeds than normally possible while hand-holding the camera. There have been two approaches to vibration reduction in the camera world. One has been to build vibration reduction into the lenses, and the other has been to build the vibration reduction into the camera body itself. Sony has gone with the second method, and in the A700 the vibration reduction technology is called Super SteadyShot. When Super SteadyShot is turned on, the sensor moves in response to camera shake, letting the photographer use slower shutter speeds without any camera blur. The advantage to the Sony system is that the Super SteadyShot can be used with all lenses; there is no need to buy special vibration reduction lenses.

Although the Super SteadyShot technology is great, it won't help in all situations. If the subject is moving, the slower shutter speed does not freeze the action. The main point is to avoid blur when holding the camera. I absolutely love this technology, and I am amazed at how it can save a photo opportunity no matter which lens is on the camera.

5.12 After photographing a fountain in a local park, I noticed that the runoff channel had a couple of leaves stuck to the edge. I took the first photograph with Super SteadyShot turned off and immediately took the second shot with Super SteadyShot turned on. What a difference in the sharpness of the leaf.

Photo Subjects

There are a great many photography opportunities out in the real world; some will be familiar, and some will be new. The purpose of this chapter is to help you get the most out of these opportunities. Each of the following photo subjects includes sample photos with shooting data; ideas to inspire you; a practice image with notes on setup, light, exposure and accessories; and a tips section.

I shoot using the RAW file quality unless otherwise noted. This frees me from having to worry about setting the white balance for every light situation.

Abstract Photography

Photographs capture the world in a realistic way, but sometimes you want a more creative view. These are the times when the composition or the colors are more important than the subject. The basics of good composition — using design elements, selective focus, and leading lines — all come into play in creating a good abstract photograph.

 Cross-Reference *Composition basics are covered in Chapter 3.*

Inspiration

Anything can be used to create an abstract composition. One approach is to look closely at everyday items. In figure 6.1 a mundane box of crayons becomes a study in color. Using a

macro lens and a shallow depth of field, the individual crayons lose their identity and become instead twelve areas of color, and the polished grill of an old car, as seen in figure 6.2, becomes a study of repetitive lines. Looking for opportunities in your everyday environment can open your eyes to a whole new world.

Reflections are also a great source for abstract images. Reflective surfaces are everywhere. Glass, water, metal, and even plastics produce reflections that you can use to create interesting photographs. In figure 6.3, the metal was moving during the exposure, which blurred the edges and the identity of the subject.

After a rain, puddles can also provide surprising abstract reflections of everyday objects, so make good use of the distortion they produce.

6.2 Bright reflective chrome from the grill of a restored car. Taken at ISO 100, f/6.3, 1/160 second.

6.1 The bright yellows, oranges, and reds of a box of crayons shot with a macro lens. Taken at ISO 100, f/22, 1/250 second.

6.3 A sheet of corrugated metal with a bright yellow light reflected at an odd angle makes for a great abstract pattern. Taken at ISO 100, f/4, 1/15 second.

Abstract photography practice

6.4 Nature offers an endless supply of abstract designs.

Table 6.1
Taking Abstract Photographs

Setup	**Practice Picture:** Figure 6.4 shows a macro photo of a spider mum plant. The pattern of the petals looks like a forest of red and yellow, all reaching upward.
	On Your Own: Look closely at the patterns in leaves, plants, and other natural items. The designs that exist in nature make for great abstract photographs.
Lighting	**Practice Picture:** An external flash was aimed down at the center of the flower, and was triggered wirelessly while the camera shot across the flower.
	On Your Own: An off-camera flash is useful in creating better-looking photos. Because the flash can be positioned above the subject, a more natural lighting is created. The flash mimics the sun, and people expect the light source to be above the subject.
Lens	**Practice Picture:** This was taken with a 100mm macro lens.
	On Your Own: A macro lens is great for getting in very close; and most zoom lenses can work for getting a great close-up shot too. Fill the frame with the subject and if necessary, crop the image on the computer in post processing.
Camera Settings	**Practice Picture:** I shot this in Aperture Priority mode so I could get the deep depth of field needed to keep all the petals in focus.
	On Your Own: When shooting close-up or macro photographs, controlling the depth of field is important.
Exposure	**Practice Picture:** ISO 100, f/22, 1/250 second.
	Own Your Own:. The aperture needed to be set to get the whole forest in sharp focus, and I was able to use a fast shutter speed and low ISO due to the close placement of the flash. Abstract photography is one area where anything goes. If you want the image to have some blur, turn off the Super SteadyShot and use a longer shutter speed.
Accessories	A tripod was used to hold the camera steady, and the Remote Commander was used so that the Shutter button did not have to be pressed manually. Remember to set the Drive mode to Remote when using the Remote Commander to take photos.

Abstract photography tips

✦ **Change your perspective.** The most important thing to remember when taking abstract photographs is to try anything. Turn the camera from landscape to portrait orientation and take the photo again. Get down on your knees and look to see if the change in height changes the photograph.

✦ **Use computer software.** Manipulating an image in the computer can produce great abstract images from otherwise ordinary photos.

✦ **Use manual focus.** At times, taking a photograph that is purposely out of focus can produce a great abstract image. With the auto focus system of the A700, it is a good idea to switch to manual focus to make sure that the final image matches your artistic vision.

Architectural Photography

6.5 The church tower seems to be leaning backward the higher it goes. This is an example of converging verticals. Taken at ISO 400, f/4, 1/40 second.

Buildings are built to serve a purpose, but they also make great photo subjects for photographers wanting to improve their skills. Buildings don't have to get up and stretch or take a break to answer the phone, and you can work on the basics of composition without having to feel rushed. Move around the building and check out the different angles and views.

There is a tendency to aim the camera upward when shooting buildings. This is usually the only way to get the whole building in the frame, but it can cause a phenomenon where the building appears to be tilting backward. This distortion is known as *converging verticals*, or *keystoning*. There are only two ways to correct this distortion; move farther back from the building you are photographing and angle the camera so it is even with the horizon, or fix the problem using software in post processing.

Inspiration

Architects and designers spend a lot of time and energy to produce attractive and interesting buildings and structures. Practice and skill with architectural photography can help you to produce better travel and vacation photos. Nothing says travel as much as different and unique architecture. Each culture and generation has a distinct look to its architecture.

6.6 The stained glass and pews immediately identify this interior as a church, and while the bright sunlight is diffused, it still has enough illumination to bring out the details in the wood of the pews. Taken at ISO 100, f/5, 1/100 second.

6.7 The sky scrapers in New York shot at ISO 100, f/10, 1/500 second.

Architectural photography practice

6.8 A series of houses in Ireland all defined by their own color

Table 6.2
Taking Architectural Photographs

Setup	**Practice Picture:** Walking through a small town in Ireland, I was struck by the unique look of these homes in figure 6.8. Each of the homes had its own unique color though the overall style was the same. The curve of the street added to the general composition of the scene.
	On Your Own: Look for the angle that presents the building in the best light. Walk around and check out all the angles. Look to see if the building would look better shot straight on or from the side.
Lighting	**Practice Picture:** This scene was shot in natural light in the early afternoon. This is not the best time to take photos due to the short shadows, which create a lack of depth. Because the sunlight was coming from slightly behind the houses, the walls of the houses were in shadow. The dividing line between the shadow and the sunlight on the street matches the curve of the buildings.
	On Your Own: Photographing buildings means paying attention to constantly changing light. Watch where shadows fall across the building, because without shadows, the building has no depth. Shooting buildings first thing in the morning or late in the afternoon gives the buildings a warmer look and works well for all types of architectural styles.
Lens	**Practice Picture:** I used a zoom lens set at the 24mm focal length to capture the whole length of the building.
	On Your Own: A wide-angle lens is great for architectural photography. Try to keep the lens level with the building because if the lens is tilted either up or down, the building can seem distorted. If you photograph a tall building from the ground in front of the building, the building will appear to be titling backward. This effect can be solved by moving farther away from the building and cropping out the unwanted parts in post processing. The wide range of focal length available by using a zoom lens lets you recompose the scene without having to change your location.
Camera Settings	**Practice Picture:** The photo was taken using the Program Auto mode on the camera. The camera was able to deal with the different colors and the shadow and sunlight all in the same exposure.
	On Your Own: The Program Auto mode works really well. If you are shooting early in the morning or late in the evening, make sure that the Super SteadyShot is turned on; it allows you to take sharp photos at slower shutter speeds. If the shutter speed is still too slow, then either use a tripod or raise the ISO.

continued

Table 6.2 *(continued)*

Exposure	**Practice Picture:** ISO 200, f/5.6, 1/180 second.
	Own Your Own: When shooting large subjects that take up most of the frame, use the multi-segment metering mode. If the building is farther away or there is a bright light source in the scene, the spot metering mode will work best in making sure that the building is correctly exposed.
Accessories	This photo was not shot on a tripod, but a tripod is a very useful accessory for shooting this type of photograph.

Architectural photography tips

✦ **Be careful where you photograph.** Some buildings and areas are off-limits to photographers, and shooting in these areas can even result in your arrest. Airports and government-owned buildings are usually off-limits, and the best policy is to ask permission before shooting. When in doubt, ask first.

✦ **Try to get to a higher vantage point.** Sometimes getting a whole building into a single frame is difficult. One way around this is to shoot from a higher vantage point.

✦ **Use the widest-angle lens you have.** Because most buildings are big, a wide-angle lens is necessary. Ideally, the 11-18mm super-wide-angle lens should be used.

✦ **Check the reflections.** Modern glass and steel buildings tend to be very reflective so it is important to pay attention to the reflections in the windows and other reflective surfaces. Clouds, people, cars, and other buildings can all be reflected in your composition, so make sure they add to the image and don't distract the viewer.

✦ **Watch the light.** Observe how it moves across the building during the day. Usually the best time to photograph a building or structure is in the early morning or late afternoon; bright midday sun can wash the colors out of a building and produce flat, boring photos.

Candid Photography

Candid photography is a lot like taking snapshots. Candid photographs are taken without the subject knowing or caring that they are the focus of your photograph. The subjects of the photo don't pose or act in any way different from the way they normally would. This lets you capture the subjects in the most relaxed and natural way possible. Candid photography is about taking advantage of photographic opportunities as they happen.

Inspiration

Candid photo opportunities are everywhere; it is just a matter of recognizing them and being ready to make the most of them. Concerts, parades, festivals, weddings, and family gatherings all make great candid photo opportunities.

6.9 Neither of the two girls noticed that I was capturing this moment during an afternoon get-together. Shooting from the hip lets me get down to their height without distracting them from their book. Taken at ISO 100, f/2.8, 1/200 second.

6.10 While shooting a wedding on a horse ranch in Arizona, I turned to change lenses and across the way I saw a young wedding guest watching the horses. Taken at ISO 200, f/5.6, 1/125 second.

Candid photography practice

6.11 A rare quiet moment with musician Mark Karan at home.

Table 6.3
Taking Candid Photographs

Setup	
	Practice Picture: I was spending the afternoon with musician Mark Karan at his Northern California home prior to a benefit concert. He was sitting outside enjoying the afternoon and playing one of his acoustic guitars. When he took a break to pay some attention to his canine audience, I captured the moment in figure 6.11 with a 16mm super-wide-angle lens.
	On Your Own: The setup for a candid photograph can be anywhere. Because you never know when a great candid photo opportunity will occur, you should be prepared all the time. There is no harm done if the photo doesn't turn out the way you want, but if you don't have your camera with you and ready to go, you will never even have the opportunity to try.

Lighting	**Practice Picture:** This photo was taken in the late afternoon, and sun was directly on him. This was not the perfect light, and the blown-out highlight of the reflection on the guitar body is a slight distraction, but due to the nature of candid photography, it is unlikely that all the elements will be perfect. **On Your Own:** Lighting in a candid photograph can consist of anything from direct sunlight to the built-in flash on the camera. Practicing taking photographs in a variety of lighting situations will help prepare you in all aspects of photography. Watch where the light falls on your subject, and try to dial in any exposure compensation beforehand.
Lens	**Practice Picture:** This photo was taken at the extreme wide-angle range. The 16mm focal length works here; because the shot was taken on a narrow porch, it was the only way to get both Mark and his surroundings in the frame. In this example, the surroundings determined what focal lengths could be used. **On Your Own:** You can use any lens for candid photography, and usually the situation and surroundings determine what lens works best. A modern zoom lens like the 18-250mm is perfect for this type of photography, letting you frame the image in a variety of ways without disturbing the subject, and letting you shoot at a huge range of focal lengths.
Camera Settings	**Practice Picture:** I shot this on a Program Auto mode. The ability of today's high-end digital cameras to auto-focus and correctly set the exposure is a great advantage for shooting candid photographs. There was no need to ask Mark to sit still or to hold that pose. I was able to quickly frame the shot and capture the moment. **On Your Own:** Use the Program Auto mode and trust that the camera will be able to handle the situation. Shooting candid photographs is not the time to be experimenting with camera settings.
Exposure	**Practice Picture:** ISO 100, f/4.5, 1/30 second. **On Your Own:** Using the Multi-segment metering mode and the Program Auto mode will work in most candid situations. Let the camera do the work while you concentrate on the composition.
Accessories	Extra CompactFlash card. There is nothing as horrible as running out of memory when there are still great photo opportunities around.

Candid photography tips

✦ **Carry a camera at all times.** This one is self-explanatory. If you have a camera with you, you can try to get the shot. If the camera is at home, there is no chance of ever getting the shot. I always have a camera with me, and my friends and family are so used to it that they don't notice when I start to shoot.

✦ **Shoot a lot.** With the high capacity of CompactFlash cards combined with their low price, it pays to shoot as much as possible. Don't wait for the shot to be perfect; shoot anyway. I usually have the camera on burst mode and take three to four photos at a time, which increases my chances of getting the perfect shot.

✦ **Shoot without a flash.** The first time that your flash goes off, your subject knows that you are photographing him or her, killing any chance of future spontaneity. Using a higher ISO or a wider aperture is better than using the flash.

✦ **Use a longer lens.** Being farther away from your subjects increases the chances that they will not notice you photographing them. Give your subjects a little space. This helps them act naturally and not feel like you are invading their personal space.

✦ **Shoot from the hip.** Sometimes bringing your camera up to your face draws attention to you and ruins any chance of capturing the candid moment. I usually zoom out to the widest focal length and shoot from the hip.

✦ **Respect other people and their privacy.** Ask permission when shooting strangers, especially children. Get permission before you take the photograph if you are not sure your subject is willing.

✦ **Carry business cards and model releases.** I always carry business cards and a small pad of model releases. Although capturing a great candid image is fantastic, getting a signed model release helps protect you if you ever want to sell or use the image for publication.

Child Photography

Child photography can be tough. Kids rarely stop moving, and they certainly don't like to spend a lot of time standing still so that you can get a good photograph. Part candid photography, part portrait photography, part action photography, part luck, and part perseverance, child photography can be a challenge, but one that brings a lot of pleasure to family and friends.

> **Cross-Reference** *For more on using a dedicated flash, see Chapter 4.*

Photographing babies is the easiest kind of child photography. Just about everyone thinks that babies are cute, and if the baby is related to you, it must be the cutest baby ever. Babies make great models because until they are able to walk around, they are generally going to stay in one place. Once they start to crawl and move about, all bets are off. Some children like to sit quietly and play in one spot, and others tear around the house, only stopping when they finally run out of energy. So, when photographing children, you need to be prepared for nearly anything!

6.12 The pure joy on a child's face as he crawls toward his favorite toy is captured at his level, bringing the viewer into the child's perspective. Taken at ISO 100, f/4, 1/60 second. A dedicated flash with a diffusion dome was used to get a more even light.

Inspiration

Photographing children in their natural habitat, doing what they love to do, captures the kids at their happiest, and it comes through in the photographs. Let the personality of the child come out in your images. Some children are quiet and serious and enjoy playing alone while others are outgoing and gregarious.

6.13 This little beauty was photographed in the park while she played under a tree. Her mother was standing behind me, and it was Mom whom the little tyke was staring at.

Having your own children or grandchildren is usually inspiration enough. Children grow up very fast, and one of the best reasons to take their photograph is to document a time in their life. If you have no children of your own, look at your nephews, nieces, or children of friends who wouldn't mind being the subject of your photography.

Child photography practice

6.14 These twins pose together, displaying their new smiles.

Table 6.4
Taking Child Photographs

Setup	**Practice Picture:** This photo of two twin sisters, Paige and Olivia, in figure 6.14, was posed in their backyard. Both sisters had recently lost some of their baby teeth and they were eager to show off their new smiles.
	On Your Own: Look for photo opportunities that will capture a moment in the child's life. Children's lives are full of milestones — from taking their first steps to going to their first school dance. These all offer opportunities for treasured memories and treasured photographs. Posing these sisters and taking a few photos took ten minutes and then the girls went off to play.

Lighting

Practice Picture: This photo was taken outside in the late afternoon under cloud cover. The diffused sunlight created a nice even lighting on the girls. I used a dedicated Sony flash unit on the camera to add a little fill light. The flash was set to the High-speed sync mode, which lets the flash fire no matter how high the shutter speed is.

On Your Own: Try to shoot children when they are not in direct harsh sunlight. Because they probably don't care that you are trying to photograph them, they will squint or close their eyes in the sun, and this does not make for a very good shot.

Lens

Practice Picture: I used a 50mm f/1 lens. Using a prime lens for child and candid photography is a challenge. I needed to move close enough to fill the frame with the two girls without the advantage of a zoom lens, but I wanted to blur the background and needed a wide aperture to create a shallow depth of field

On Your Own: Using a prime lens can limit the photo opportunities that are available at any given time, but it does teach you to plan ahead. A zoom lens covering a wider focal range gives you more options to recompose the scene without having to move, but the f1/4 aperture available on the prime lens makes it great for shooting in all kinds of light, even very low light.

Camera Settings

Practice Picture: This photo was taken in Aperture Priority mode with the shutter speed set by the camera using a Center-weighted metering mode. I metered on the faces of the girls and did not want to worry about the dark bushes behind them. I set the aperture to f/2.8 so that the shallow aperture would cause the background to be blurred, making the girls stand out in the photo.

On Your Own: When the subject of the photograph is in different lighting than the background, metering correctly is important. If I had metered on the whole scene, the camera would have over-exposed the subjects due to the large dark area behind them. Remember that children tend to move all the time, and setting a high enough shutter speed is important in capturing sharp photos.

Exposure

Practice Picture: ISO 200, f/2.8, 1/1600 second.

On Your Own: Use Aperture Priority mode to control the depth of field when the background needs to be softened. When kids are playing, consider using Shutter Priority mode so you can freeze the action.

Accessories

I recommend an external flash to help with fill light even when shooting outdoors. The High-speed sync mode available with the Sony brand dedicated flash units let me keep the f/2.8 aperture and use a very high shutter speed.

Child photography tips

✦ **Look to change your angle.** Get down to the level of the child. Taking all the photos looking down doesn't show the child in the best way. Being at your subjects' eye level adds a real look of intimacy.

✦ **Wait until they are used to you.** To capture children in an unposed, natural manner, wait until they are used to you and your camera.

✦ **Be patient.** It may take a lot of photos to get the one that you want. Just stay calm and be patient.

✦ **Be natural.** Try to stay away from unnatural settings or forcing a smile.

✦ **Keep them busy.** When shooting children in a studio setup, have plenty of toys and games around to distract them from what you are doing. This helps in getting a natural look in an unnatural situation.

✦ **Shoot in burst mode.** Children move pretty fast and I usually have the camera set to shoot in burst mode, giving me more than one chance at getting the shot I want.

Concert Photography

Concert photography can be one of the most rewarding and frustrating experiences you can have as a photographer. Just getting a camera into the concert venue is a challenge in itself these days. Most venues do not allow photography during any live performances, and the only people who are allowed to bring cameras are there with the express permission of the venue, the band, or the promoter. Even if you have permission to photograph a concert it is usually only for a very brief period of time, between one minute and three songs. There are exceptions to this rule, but it is better to plan for the worst. Knowing that there is a limited time to shoot, don't waste time by changing lenses or memory cards during the shoot; have your camera set up before the show starts.

At many concert venues you must deal with constantly changing lights and a limited time to shoot, combined with the movement of the musicians and a limited space to photograph from. Ideally, you want to use the lowest ISO you can, while using a fast enough shutter speed to freeze the action.

Tip *Having a portfolio of concert images helps when trying to convince bigger acts that you should be allowed to shoot them. Some of the biggest names in photography have spent many hours shooting live music.*

6.15 Billy Idol photographed from the audience right before the sun went down in a combination of stage and sunlight. Taken at ISO 400, f/2.8, 1/250 second.

6.16 Mark Karan, Bob Weir, and Kenny Brooks at the Sweetwater Saloon shot using stage lighting. Taken at ISO 400, f/2.8 1/60.

Inspiration

Let the music be your inspiration. Musicians put their heart and soul into producing their art and capturing that is the essence of concert photography. The best way to practice is at small local venues that cater to local bands. Local bands are more willing to allow audience members to photograph the show and are easier to contact than major label acts. Another benefit to shooting in local clubs is that, because the lights in these clubs are usually worse than those in bigger stadiums, shooting concerts will actually seem to get easier when you progress to bigger shows.

Shooting concerts works best if it is something you really love. Unlike other photography, there are some downsides to shooting concerts. I have been pushed, pulled, had drinks spilled on me, and once a rowdy fan slammed into my camera snapping the lens off the camera body. Even with all that, I wouldn't pass up an opportunity to shoot a show.

6.17 Bob Weir and RatDog at Golden Gate Park. There are times when a different viewpoint can add a whole new perspective on a concert. By focusing more on the crowd, this photo speaks to the size of the event rather than the actual musicians. Taken at ISO 200, f/5.6, 1/320 of a second.

Concert photography practice

6.18 Bruce Hornsby playing the accordion in concert.

Table 6.5
Taking Concert Photographs

Setup	**Practice Picture:** This photo of Bruce Hornsby in figure 6.18 was taken at a recent show in San Diego. Even though Bruce is known for his piano playing, he usually takes a break from the piano at least once a show to pick up his accordion. **On Your Own:** Find a good angle on the performance. Remember that microphones and microphone stands can cast unwanted shadows, so be aware of their positions. When shooting from the crowd, protect your camera by keeping it close to your body; no one else will care that you are carrying expensive camera equipment.
Lighting	**Practice Picture:** The bright white spotlight on Bruce as he stood playing the accordion enabled me to get this shot. The lights had been very red all night so this was a lucky break. There is still a little red light in the scene, but it added to the image and doesn't distract. **On Your Own:** Concert lighting is one of the hardest things to deal with. The constant changing color and intensity make getting concert shots a real challenge. Shooting in bursts of four or five photos at a time lets you capture a variety of lighting effects and increases your chances for correct exposure.

continued

Table 6.5 *(continued)*

Lens	**Practice Picture:** The 70-200mm f/2.8 lens is my main concert lens. It lets me get in close to the action, and when shooting wide open, the f/2.8 allows me to use faster shutter speeds and lower ISO settings.
	On Your Own: A 70-200mm f/2.8 lens is an absolute must for any serious concert photographer. This lens covers the focal lengths needed to get close to the performers and has a wide enough aperture to be used in low light. For indoor or night concert shooting, any lens with an aperture of f/2.8 or faster is a must.
Camera Settings	**Practice Picture:** I shoot most concerts on Manual, but that is because of the years of practice. I examine the scene and decide what the most important part is.
	On Your Own: I recommend starting in Shutter Priority mode, and setting the shutter speed to the lowest possible setting to freeze the action and avoid camera blur. You also need to consider the ISO because of the potential for digital noise. Start at the lowest possible ISO that still lets you use the exposure settings you want. For indoor concerts, this can range from 200 all the way up to 1600 ISO. I set the metering system to Spot metering because it is usually more accurate to meter for just the main subject than for the whole scene.
Exposure	**Practice Picture:** ISO 500, f/4, 1/80.
	On Your Own: I would usually have shot this at a higher shutter speed and wider aperture, but there are times when the depth of field is important, and I wanted to make sure that the accordion and Bruce were both in focus.

Concert photography tips

✦ **Practice without a flash.** Most bands, venues, and promoters do not allow flash photography to be used, even if you have credentials to shoot the show. It is better to learn how to get the correct exposure without relying on a flash.

✦ **Know your gear and where it is packed.** When shooting in a dark club or arena, it is important to be able to change settings, lenses, and memory cards without fumbling around. Knowing where you put the extra batteries and memory cards in your bag can save you a couple precious minutes.

✦ **Protect your health and hearing.** Shooting loud music close to the stage can result in hearing loss. I keep a set of earplugs in my camera bag for the times when I am close to the stage.

✦ **Go to the venue early.** It is best to get to the venue early enough to secure your credentials if you have any; and if you don't, the earlier you get there, the closer you can get to the stage.

✦ **It pays to be polite.** It is important to remember that people are there to hear the band and enjoy themselves, not watch a photographer. Try not to cause other concertgoers any problems because security will have no problem asking you to leave.

Event Photography

Event photography covers a huge range of subjects and photographic opportunities. Everything from a birthday party to a parade falls under the umbrella of event photography. Some types of specific events, like weddings and concerts, are covered in other sections of this chapter, but the basic idea remains the same. The photos from the event need to tell a story or have a unifying theme. Each photo should be able to stand on its own merits and tell a story or evoke a feeling relating to that type of event.

Planning is very important when shooting events. Knowing what you are going to shoot lets you know what to bring. Are you going to be able to get close to the action, or are you going to be far away? Do you have enough memory cards for the whole event? Is the event inside or outside? The answer to each of these questions determines how you approach the event. If you are able to get close to the event, wide-angle and normal lenses will be more important that a long lens. If the event is going to last a long time, pack extra memory cards, or make sure you don't overshoot the beginning of the event, leaving you without memory at the end. If the event is going to be inside, a flash and faster lenses are needed, which also means extra flash batteries.

Inspiration

Just about every city, every weekend, holds events. Check the local papers and Web sites to find out what is happening around your area. Most events these days have their own Web sites, and there are great resources for photographers. Seeing the photographs from previous years can show you what to expect and give you a sense of the scope of the event.

If the event is based on a person or persons, make sure you capture them in some of the photos. Photos taken at a birthday need to have some with the birthday boy or girl in them, the same way that photos taken at a wedding need a few with the bride or groom. Look for decorations and surroundings that can add to the feel of the overall event.

6.19 A vantage point overlooking a local street fair. At times it is better to step back and look at the overall view of the scene. Because this street fair was located at the bottom of a hill, walking up the hill and using a long zoom lens captures the whole scene. Taken at ISO 100, f/8, 1/250 second.

6.20 Participants line up for their victory lap as they end a 60-mile, three-day walk that raises money to cure breast cancer. Taken at ISO 320, f/4, 1/40 second.

Event photography practice

6.21 A local mariachi singer at a Cinco de Mayo celebration

Table 6.6
Taking Event Photographs

Setup	**Practice Picture:** Cinco de Mayo is celebrated in the United States and other countries as a celebration of Mexican heritage and pride. At a celebration in San Diego, shown in figure 6.21, some great mariachi musicians played all day. This mariachi singer was dressed in the traditional garb of a silver-studded Mexican cowboy outfit with a large-brimmed hat.
	On Your Own: At times one person can sum up a whole event. Try to find a shooting angle that gives you a clean background. Remember you can also take wide-angle shots to get the whole crowd or event.
Lighting	**Practice Picture:** The mariachi was in the shade from the stage overhang. This shade helped to get evenly distributed lighting on the face and the cowboy outfit. The bright silver buckles and buttons weren't in the direct sun, and so they didn't reflect and create bright spots.
	On Your Own: Outdoor event lighting can be bright sunlight, heavy shade, or both. When shooting outdoors, try to use the shade to even out the exposure. A fill flash is great if close enough to be used.
Lens	**Practice Picture:** I used a 70-200mm lens at the 200mm position. This let me get in close on the singer without having to get to the front of the crowd.
	On Your Own: The 18-250mm is a great lens for event photography, especially outdoor events. The compact size and the wide range of focal lengths means that you never have to worry about missing a shot while changing the lens.
Camera Settings	**Practice Picture:** I used Program Auto mode but set the Metering mode to spot metering. The large amount of black in the mariachi singer's outfit would have caused the entire image to be overexposed. I started with the camera set to Multi-segment metering, but after a review of the images on the LCD, I saw that they looked very light. I switched to Spot metering and took another few shots then reviewed the images on the LCD for a second time, and these looked better.
	On Your Own: Using the Program Auto mode lets you shoot a variety of situations without having to worry about missing the shot. If you need to change the shutter speed, just rotate the Front control dial, or change the aperture by rotating the Rear control dial.

continued

Table 6.6 *(continued)*

Exposure	**Practice Picture:** ISO 100, f/5.6, 1/125 second.
	On Your Own: For bright, outdoor events, use ISO 100 or 200. Lower light scenes need higher ISOs; 400, 640, or even 800. For events that start in bright sunlight but end in the evening or night, adjust the ISO as the light starts to fade.
Accessories	A dedicated flash unit that can be angled and diffused for a fill light is very useful for most events. Extra batteries and memory cards can let you keep shooting all day without having to worry about running out of power and memory.

Event photography tips

✦ **Arrive early and do your homework.** Find out if there are going to be any special displays or presentations at the event. If you are shooting a parade, find out where the judges, if any, are going to be and try to set up close to that point. Each float tries to impress the crowd at that location.

✦ **Ask permission.** I carry business cards and photo releases with me when shooting any event. Most people don't mind having their photo taken, but it is best to ask either before or right after taking the photograph if possible. There are times I will shoot first and ask later, but I always ask and if the answer is no,

the image gets deleted immediately. When shooting children, make sure you get the parents' permission before photographing them.

✦ **Plan for the changing light.** Outdoor events take place under the changing sunlight. Be aware of the movement of the sun. A great place to take photos in the morning can change in the afternoon. Be prepared to move around to make the most of the changing light.

✦ **Change angles.** Try to move around and shoot from a variety of positions and angles. Shooting from low angles is great for parades: It makes the whole event seem larger than life.

Flower and Plant Photography

Bright and colorful, flowers and plants make natural photographic subjects. Each and every flower and plant can have a distinct and individual look. Flowers' bright colors, interesting shapes, and unique textures make them great subjects for photography. You can shoot flowers and plants outside in

their natural surroundings, but you can also use them as a subject for still-life photography. Flowers and plants can be posed in any manner; they can be cut, bent, and twisted and will never complain. This makes them great to work with in the studio; just be careful about leaving them under hot lights for too long; they can and will wither and die.

 Cross-Reference *For more on using a dedicated flash, see Chapter 4.*

6.22 These orchids were purchased at the local supermarket as a gift, but they also made a great photograph. Taken at ISO 100, f/6.3, 1/250 second with one dedicated flash unit shot wirelessly placed above and to the right of the flowers.

Inspiration

The best part is that you can find a wide variety of flowers easily. Sometimes I just walk into my backyard and see what's in bloom, or take a quick trip to a botanical or public garden here in town. But great flowers and plants can be everywhere, even in the local supermarket.

Look to combine different flowers and plants together; the combination of colors and textures can lead to pleasing images.

6.23 These bright-colored Plumeria flowers are in bloom close to where I live. I used a large tripod to shoot down on the blooms. The spread of leaves made for a natural background. Taken at ISO 100, f/5.6, 1/8 second.

6.24 At times, focusing on a group of flowers instead of an individual can make for a pleasing photograph. These sunflowers were sitting in a bucket at a flower stand. The umbrella over the flower stand acted as a great diffuser. Taken at ISO 200, f/3.5, 1/80.

Flower and plant photography practice

6.25 This yellow daisy was shot against a white background, outside.

Table 6.7
Taking Flower and Plant Photography

Setup	**Practice Picture:** The yellow daisy in figure 6.25 was purchased at the local flower stand and set up in a vase outside in the late afternoon. I used a white 5 × 6-foot Westcott reversible, collapsible background. This two-sided backdrop has a pure white side and a pure black side and makes for a great quick backdrop whenever needed. The camera was set on a tripod slightly below the height of the flower and angled to have the flower on the left side of the frame using the Rule of Thirds.
	On Your Own: When shooting flowers at a low level, sometimes you need a solid white or black background, and although a professional backdrop is useful, a piece of white foam board works just as well.
Lighting	**Practice Picture:** The photo was shot using sunlight in the late afternoon. The direction of the light can be seen from the shadows cast by the smaller petals on the larger ones below them.
	On Your Own: The best lighting is either in the morning or the afternoon. Cloudy and overcast days let you take great flower and plant photographs. The clouds act like a giant diffuser and create a softer, more even light.
Lens	**Practice Picture:** I used a 100mm macro lens that is my usual choice for this type of photography.
	On Your Own: Any lens can be used for this type of photography, but it is important to frame the flower correctly. The minimum focusing distance can play a key roll in this decision. For example, the 18-250mm has a minimum focusing distance of 1.6 inches and the 50mm f/2.8 has a minimum focusing distance of 7.8 inches.
Camera Settings	**Practice Picture:** I set the camera to Shutter Priority. I was shooting outside and there was a very slight breeze, so I needed to be sure that there would be no blur. With the shutter speed of 1/125 and an ISO of 100 there was enough light for an f-stop of f/9, creating a nice deep depth of field.
	On Your Own: Using the full auto settings of the camera is a great starting point for these types of photos. After you are comfortable with the setup and the composition, you can experiment with the depth of field and shutter speed. Just remember that with macro lenses, you can have a depth of field so narrow that petals in the front of the photo will be in focus but the petals on the back of the flower will be out of focus.

continued

Table 6.7 *(continued)*

Exposure	**Practice Picture:** ISO 100, f/9, 1/125 second.
	On Your Own: When shooting large areas with many plants and flowers, use a deeper depth of field to keep all the flowers and plants in sharp focus. To make a single flower stand out against a background, use a shallow depth of field.
Accessories	A tripod is the most useful piece of equipment for this type of photography. Being able to set the camera in one position and fine-tune exposure and focus are key to getting great flower and plant photographs.

Flower and plant photography tips

✦ **Change your point of view.** Shoot from a low angle across the flower or plant instead of down at it. This results in flower or plant photographs that stand out from the crowd.

✦ **Fill the frame with the subject.** Using a macro lens helps in this, but even if you don't have a macro lens, try to either move closer to the flower or plant or zoom in as tight as possible. Filling the frame with the subject and keeping the background simple makes the flower or plant the center of attention.

✦ **Use colors to your advantage.** A single white rose in a bunch of red roses makes for a striking photograph. The contrast between the colors makes the single white rose stand out.

✦ **Block the wind.** When shooting outdoors, placing yourself between the flower and the breeze can block a slight breeze. This will cut down on any movement caused by the wind.

✦ **Bring your own rain.** Having a small spray bottle of water lets you create fake rain or dewdrops on your flowers and plants. A little bit of water goes a long way, so be careful not to drench the flower, and remember to keep your camera dry.

Group Portrait Photography

A group portrait can have two, three, thirty, or three hundred people. Having to light and arrange a couple, or a couple of hundred people, keeping everyone's attention focused on you, and still getting them all to smile on command can be a daunting task. The more people involved, the bigger the challenge. While this section can't cover every group situation — there are just too many — the following information can help with the basics. Group portraits use the same basic rules as individual portraits: great use of light and well-posed subjects.

Considering lighting and location

As with every photograph, the most important element is the light. Light is needed to illuminate the scene and getting the right amount of light onto multiple people is a real challenge. For example, shadows that one person casts can hide a second person. In figure 6.26 I positioned the people so that the sun was behind and to the right of the group. I then set the camera's exposure to capture the kids in the middle and didn't worry about overexposing the sky or the ground. Because this photo was taken during a scheduled activity, I had no control over the time of day the shot was taken. Watch the ground in front of the portrait and try to make sure your shadow doesn't end up in the photograph.

If you know that you are going to be shooting group portraits, try to scout out a good location beforehand. Find a location where the whole group will fit. A cramped group of people leads to a cramped-looking photograph. Find a location that does not distract from the group. Try to keep the background as neutral as possible to keep the focus on the group.

Working with people

Getting everyone to look at you and smile at the same time is the biggest problem with group photography. As a photographer, you need to take firm control over the group and keep everyone's attention on you. This is a balancing act between firm and fun: too firm and the group starts to get turned off to the whole photograph, too fun and the group stops paying attention. I talk to the group the whole way through the process to keep the attention on me. The more direction that is given to a group, the better the results will be.

6.26 A very large group portrait never gets every single person looking at the camera. This was the third shot out of six that I took in burst mode. Taken at ISO 100, f/5.6, 1/350 second.

Posing a group of people is more difficult than posing just one person. Some basic guidelines when posing a group:

◆ **Stagger the heads.** When setting people up, do not put the head of the people in the second row straight above the person in the first row.

◆ **Light the whole group as evenly as possible**. If one part of the group is in deep shadow and the other is in bright sunlight, achieving proper exposure is very difficult.

Cross-Reference *Studio lights are discussed in Chapter 4.*

◆ **Group people around a center point.** Instead of putting the group in a straight line, have them gather around something or someone. For example, if you are shooting a family portrait, have the mother sit in the middle and then have the rest of the family gather around her. This will add a feeling of togetherness that a family standing in a straight line doesn't.

◆ **Keep the main subjects the center of attention.** When shooting a group photo at a wedding, birthday, or a special event for one or two people, make sure that the main subjects are the center of attention. Place the very important person(s) in the middle of the group and build the group around them.

Inspiration

Group portraits can run the gamut from an informal gathering of friends to a formally posed wedding photo. Group portraits all capture a moment in time when a specific group of people is gathered for a specific purpose. These images can become treasured mementos for years to come, passed down from generation to generation. Looking back at group portraits is a true trip down memory lane, so never hesitate when a group of friends are together to gather them into a group and take a group portrait; I guarantee you won't regret it.

6.27 Even in a formal portrait setting, keeping the attention of all the subjects is important. Taken at ISO 100, f/5.6, 1/200 second. A studio monolight with a large softbox was used to light the family.

Group portrait photography practice

6.28 A group of friends gathering at a wedding celebration

Table 6.8
Taking Group Portraits

Setup	**Practice Picture:** The photo in figure 6.28 was taken immediately following a wedding ceremony. Everybody was gathered together with minimal direction and asked to smile. The setting wasn't ideal, and some of the subjects didn't speak English and couldn't understand a word I was saying, but it captured a group of people in a time and place that made a memory that will always be treasured. I used hand gestures to gather the people around the bride and groom in the center.
	On Your Own: Any time there are two or more people together, it's a good time to take a photograph. Small groups can be posed just about anywhere, but larger groups need a little more planning. Use larger areas that the whole group will fit into without looking cramped or unnatural.

continued

Table 6.8 *(continued)*

Lighting	**Practice Picture:** Because this photograph was taken outside at night, I used a dedicated flash unit. The flash unit was placed just to my right, clipped onto a portable light stand. I had the shutter open for 1/8 of a second, which would have caused a blurred image if not for the flash.
	On Your Own: The key to a great group photograph is in the lighting. When shooting using available light outdoors, position the group so that the light falls evenly on the group. When shooting indoors, lighting a group becomes a little more difficult. Use a dedicated flash unit to bounce the light off the wall or ceiling to spread the light out and have it light the group more evenly.
Lens	**Practice Picture:** I used a 35mm lens for this photograph.
	On Your Own: A zoom lens lets you adjust the focal length between shots quickly and easily. When using a wide angle, keep the lens pointed straight at the group and avoid any tilting up or down. This minimizes any distortion that can occur using a wide angle lens.
Camera Settings	**Practice Picture:** I had the camera set on Manual mode to use a slow shutter speed with the external flash unit. I also pushed the ISO to 400 because I had run out of available light. When the group first gathered, there was plenty of light, but by the time people were ready for the photo, the sun had set completely and I needed to use a flash. I could have set the aperture to f/2.8, but that would have caused a very shallow depth of field and the people in the back row would have been blurred.
	On Your Own: For most group portraits, it is important to make sure there is enough depth of field to have all the people in focus. Shoot using the Aperture Priority mode to make sure you keep control over the aperture.
Exposure	**Practice Picture:** ISO 400, f/5.0, 1/8 of a second.
	On Your Own: If your subjects are young and have a hard time sitting or standing still, make sure you use a shutter speed high enough to freeze their motion.
Accessories	A tripod and a light stand, along with an external flash unit, were used to get this shot. I try to use a tripod whenever possible. Setting the camera on a tripod frees you up to direct the people in the photograph.

Group portrait photography tips

✦ **Shoot multiple shots.** Take as many shots as possible in as short amount of time as possible. People seem to relax right after the first shot is taken, resulting in photo two or three being a better photo.

✦ **Have a posing plan.** Look at magazines, books, the Internet, and see what group poses appeal to you. Keep these in mind for the next time you need to pose a group.

✦ **If they can't see you, you can't see them.** Ask the folks if they can see you before you take the photo. If they are having a problem seeing you, then chances are their face will not be in the image.

✦ **Get in close.** Unless the background is an important part of the photograph, fill the frame with your subjects. I cropped the image in figure 6.28 using Adobe Photoshop CS3 to remove the unwanted black area above the group.

✦ **Try a different angle.** A great way to photograph a very large group is to shoot from a higher vantage point down at the group. A ladder comes in very handy for this type of photograph.

Indoor Portraits

Great portraits depend on two things: a well-posed model and proper use of light. Shooting portraits indoors give you much greater control over the light than is otherwise possible. When discussing portraits the word *key* is often used. The key light in a portrait is just another way of saying the main light. The three different types of portraits are high key, mid-key, and low key portraits. A *high key* portrait is an image with a light tone overall. One main aspect of a high key photo is a clean background that is lighter than the subject. Figure 6.32 is an example of a high key portrait. A *low key* portrait has a darker tone overall. The light is carefully controlled to draw your attention to the subject. Figure 6.30 is an example of low key lighting. A mid-key portrait isn't overly dark or light; the overall tonality is a mid-tone. The background of a mid-key portrait is usually a neutral tone.

Knowing that the light will be consistent lets you focus on posing your subject. Getting the best results from your subjects requires getting them to relax and look natural. Many people tense up when they are in front of the camera, resulting in stiff unnatural poses and expressions. I find that explaining what I am doing as I have the subjects turn or pose helps them understand the portrait process and gets them to relax. It lets the subject become part of the process. Here are some tips to help with some common problems when posing your subjects.

✦ **Bald is beautiful, but it can cause problems.** Bald heads can cause unwanted reflections. Make sure that no lights are aimed directly at a bald head. Use a softbox to soften the light hitting the problem area.

✦ **Glasses are not bad, but reflections are.** Glass reflects light, and eyeglasses can cause lots of problems in portraits. Moving the arms of eyeglasses up slightly higher than normal changes the angle of the glasses and reduces reflections. Try to reposition the main light a little higher than normal to minimize the reflections even more.

✦ **A little weight reduction.** To reduce a double chin, have the subject look slightly up and shoot down from a higher angle. Place the main light slightly higher than the camera and aim the light slightly downward, creating more of a shadow under the chin. Turning slightly toward the camera and having one side closer to the camera than the other is another great way for a subject to look slimmer. Profile poses are not a good idea because they tend to exaggerate body size.

✦ **A little more weight reduction.** Using a low key lighting style with lots of shadow area helps hide problem areas. Move the light in a little closer to the subject and change the angle to create more shadows on problem areas.

✦ **Working with hands.** Hands can be very expressive and add character to a portrait, but a badly placed hand can just as easily ruin an otherwise great portrait. Don't let the hand appear to be too large. This is more important when the hands are close to the subject's face. To reduce the size of the hands, turn them so that the side of the hand is facing the camera and not the back or palm

6.29 David Baron, a famed comic book colorist, needed a new photo for his portfolio and wanted something a little different. He was shot surrounded by comics on the floor of his studio using one strobe off to the left, which created hard shadows across his face. Taken at ISO 100, f/9, 1/250 second.

6.30 A single softbox on a studio flash placed close to the model on the left side created the soft light and set the mood for the photo. This low key portrait has a darker tone overall. Taken at ISO 100, f/7.1, 1/250.

Inspiration

Capturing the personality and character of your portrait subject is important. Lighting, backgrounds, even props don't matter if the subject's character doesn't shine through in the portrait. Establishing a good rapport with your subject can turn a simple portrait shoot into a great experience for both the subject and you.

6.31 John Ginty, a musician, photographed in the dressing room of a concert venue. This was the first time I had met John, and we talked about music and travel as I set up one off-camera dedicated flash unit. Even with limited time, establishing a rapport was important. Shot at ISO 250, f/4.5, 1/60 second.

Indoor portrait practice

6.32 A high key portrait of a model for her portfolio

Table 6.9
Taking Indoor Portraits

Setup	**Practice Picture:** Figure 6.32 was shot as part of a set for the model's personal portfolio. The model and I met to discuss what she wanted from the shoot and what clothes she would be wearing. The photo shoot was set up as a four-light shoot against a seamless white backdrop. The backdrop was held in place with a portable backdrop support system that can be purchased at any good camera store or online.
	On Your Own: Seamless paper backgrounds are great portrait backdrops and come in a wide variety of colors. The drawback to using paper is that it is easy damaged and can't be used more than a few times. A viable alternative are cloth backdrops; they are available in a huge variety of colors and patterns and are easy to transport and store.
Lighting	**Practice Picture:** I used a four-light setup. Two of the lights were aimed at the white backdrop to make the background nice and white. One light was set up with a softbox and placed behind and to the left of the camera. The forth light was placed to the left of the model to add the bright highlight on the side of her face.
	On Your Own: Studio lights can be a very expensive. Some lighting companies offer starter kits at fairly reasonable prices. Being able to control the amount and direction of the light gives you complete control over the entire photographic process.

Lens	**Practice Picture:** I used the 85mm focal length on a 70-200mm lens.
	On Your Own: You can use most lenses to create great portraits. It is best to start in the 35-85mm range and work from there. The 50mm f/1.4 lens is a great portrait lens, and with an f-stop of f/1.4, this lens is great in all kinds of light.
Camera Settings	**Practice Picture:** I metered the scene with a Sekonic light meter and used those settings on the camera in Manual mode.
	On Your Own: When using external strobes, setting the camera on Manual mode is important. The camera will not be able to readjust in the middle of the exposure.
Exposure	**Practice Picture:** ISO 200, f/8, 1/200 second.
	On Your Own: Focus on your subject's eyes and set the aperture to at least f/5.6 or higher to start and the whole face will be in focus.
Accessories	I use a variety of studio lights, but the one piece of equipment that is crucial is a separate light meter. I use a Sekonic light meter with a built-in wireless trigger for the lights. I can trigger the strobes with the light meter and get an accurate exposure reading. I then enter those settings into the camera in Manual mode and use the review screen to double-check the exposure settings after every couple of shots.

Indoor portrait tips

✦ **Meet beforehand if possible.** Although it isn't always possible, meeting with the subjects before a portrait session lets you know what they expect to get from you and, just as importantly, what you will receive from them.

✦ **Be prepared.** Nothing can make a portrait shoot go bad faster than a bored subject. Don't make them wait for you to get ready or set up your equipment. Have a game plan ready before you even start. This makes the whole process go by faster and creates a positive experience for both you and the subject.

✦ **Talk to your subjects.** Talking to your subjects not only keeps them at ease and makes for a more relaxed atmosphere, but it also lets you direct the poses without sounding like you are ordering them around.

✦ **It's all in the eyes.** Focus on the eyes. If the eyes are out of focus, the rest of the portrait won't matter. If one eye is closer to the camera, focus on that eye.

✦ **Shoot multiple photographs.** In this digital age, there is no reason not to take multiple frames of the same pose. Sometimes a slight difference in expression is the difference between a good portrait and a great portrait.

✦ **Follow simple clothing rules.**
Vertical stripes add length, giving
the subject the illusion of being
taller and therefore slimmer.
Horizontal stripes have the oppo-
site effect and should be avoided.
Logos on clothing should be
avoided unless they are needed as
part of the portrait.

✦ **Makeup is key.** Do not underesti-
mate the usefulness of a profes-
sional makeup artist. The portrait
photograph is capturing a moment
in time, and looking your best is
important. A good makeup artist
can do wonders, and proper use
of makeup can accentuate the
positive and hide the negative.

Landscape and Nature Photography

Landscape photography has long been a
favorite of photographers. Landscape can be
taken in any environment, from the moun-
tains and deserts to forests, lakes, beaches,
and any place in between.

Inspiration

Wide open spaces and ever-changing light
offer the photographer a great opportunity.
Look at the clouds and decide if including
more or less of the sky will enhance or
detract from your image. A clear sky usually
detracts from an image; if there is nothing in
the sky, there is nothing for the viewer to
look at. Clouds on the other hand can add
much needed texture and color.

Sweeping vistas and mountain ranges make
for breathtaking images. From before the
sun rises to after the sun sets, landscapes
offer an ever-changing view. Take a land-
scape image one day and the next day it will
be different. The light is never exactly the
same twice.

6.33 A Sedona, Arizona, landscape. Shot at ISO 100, f/7.1, 1/320 second.

6.34 The snow-covered mountain tops on the way over the Continental Divide in Colorado. Shot at ISO 100, f/9, 1/320 second.

Landscape and nature photography practice

6.35 The Irish White House

Table 6.10
Taking Landscape and Nature Photographs

Setup	**Practice Picture:** The Irish White House or Aras an Uachtarain shown in figure 6.35 is the official residence of the Irish President and is nestled on 1,752 acres on the outskirts of Dublin. The green grass leading up to the building draws your eye right into the frame
	On Your Own: When looking to set up for a landscape image, pay close attention to all the areas of the photograph. Because the foreground, middle ground, and background are all important elements in a landscape image, elements that don't belong, such as power lines, can distract the viewer's eye from where you want it to go. Careful composition minimizes these distractions and produces better looking images. Also, try placing the horizon line one third of the way from the bottom or the top to create a more balanced imaged.
Lighting	**Practice Picture:** This photo was taken during the middle of the day, as the shadows from the trees show. Usually not the best time to photograph landscapes, but the cloud cover above the building diffused the light enough and added character to what would have been a dull sky.
	On Your Own: Watch the light as it moves. Because landscape photography uses available light, the light changes constantly. Traditionally, the best light for landscape photography is in the early morning or late afternoon when the shadows are at their longest and the color of the light is warmer.
Lens	**Practice Picture:** The 18-200mm f/3.5-6.3 lens is a great travel lens and here it did a fantastic job getting the whole scene in frame. I started out at the 18mm point and zoomed in slightly to 24mm so the trees on either edge of the frame were exactly where I wanted them.
	On Your Own: Both wide-angle and telephoto lens are good for landscape photography. Having a large focal range on one lens lets you experiment with your composition without having to move very far.
Camera Settings	**Practice Picture:** I set the camera to Aperture Priority to make sure that I had enough depth of field to get the whole scene in focus. I used Spot metering on the gray area above the house. This made it possible to get an even exposure on both the house and the sky.
	On Your Own: The Multi-segment metering mode on the A700 works well for most landscapes, but if you need to make sure that your subject has correct exposure, use Spot metering.
Exposure	**Practice Picture:** ISO 200, f/16, 1/250.
	On Your Own: It is important to control the depth of field, but a landscape also needs to be as sharp as possible. If you have no tripod, use higher ISO values to make sure there is no camera shake and turn on Super SteadyShot.
Accessories	A tripod is a must for shooting during the morning light when longer shutter speeds are needed.

Landscape and nature photography tips

✦ **Identify your subject.** Find the most interesting feature in the landscape and make sure that it does not have to compete for the viewer's attention.

✦ **Use different focal lengths.** This is easy to do with lenses like the 18-200mm f/3.5-6.3. Just zoom in a little closer to see what happens. The telephoto focal lengths cause elements in the background to appear closer to elements in the foreground, while the wide-angle focal length causes elements in the background to be much farther away than elements in the foreground.

> **Cross-Reference** *For more on focal length distortions, see Chapter 5.*

✦ **Add a person.** Including a person in the image adds a sense of scale and perspective. It is sometime hard to determine the true size of a landscape without an easily recognizable object to give a scale of reference.

✦ **Protect yourself and your gear in bad weather**. When shooting outdoors, be careful about protecting yourself and your gear from the elements.

✦ **Adjust your exposure when shooting snow.** Huge areas of bright white can cause the metering system in the camera to underexpose the rest of the scene, so it is important to adjust accordingly.

✦ **Watch the light.** As the sun moves across the sky, the light will change constantly. Watch where the shadows fall and how different areas are lit over time. The same landscape photo taken at dawn will look very different even one hour later.

Light Trail Photography

Light is essential to creating a photograph, but with light trail photography, the subject of the photograph is the light. If your subject or your camera moves during an exposure, the photo looks blurry or streaky. This effect can be used to your advantage, and with some creative vision and control, the results can be stunning.

You can get light trails in two ways: the first is to have the camera steady and the lights move, and the second is to have the lights be steady and the camera move. The key to both techniques is longer-than-usual shutter speeds.

Using your camera to create light trails is surprisingly easy. Just zoom in or out when the shutter is open. Having the camera on a tripod helps during the long shutter speeds. Figure 6.37 is an example of this type of light trail.

6.36 The light trails add a sense of movement to the scene. As the cars speed past, the lights help to draw the eye to the palm grove and the Ocean Beach sign. Taken at ISO 100, f/22, 6 seconds.

Inspiration

Because photographing with light as the subject requires the rest of the scene to be rather dark, the best time to look for light trail subjects is after dark. Look for viewpoints where you can see movement. A busy road during the day takes on a whole new personality at night. The multi-colored cars are reduced to streaks of red and white.

6.37 With the camera firmly mounted on a tripod and zoomed in close on the San Diego skyline, I used a long shutter speed, and while the shutter was open, I rotated the zoom ring causing the focal length to change from 200mm to 18mm. Taken at ISO 100, f/9, 6 seconds.

Light trail photography practice

6.38 Light trails leading to the city

Table 6.11
Taking Light Trail Photographs

Setup	**Practice Picture:** The Cabrillo Bridge has a great view of the 163 freeway as it heads toward downtown San Diego. Photographed forty minutes after sunset, figure 6.38 shows the light trails from the cars heading down the freeway, which lead your eye right into downtown. **On Your Own:** Look for places where the light trails will help move the viewer's eyes into the scene. The difficult part about shooting traffic is that it is never the same twice.

continued

Table 6.11 *(continued)*

Lighting	**Practice Picture:** This photo was taken forty minutes after sunset. The sky was starting to turn dark blue, and the lights in the buildings were all visible. The lights from the cars traveling on the road merge into a constant stream of light.
	On Your Own: To get the light trails to stand out, look to shoot after sunset. The light needs to be low enough that the shutter can be left open long enough to turn the individual car lights into a solid stream of light.
Lens	**Practice Picture:** I used an 18-200mm zoom lens with the focal length set to 35mm. The use of the zoom made life easier to adjust the focal length when at the bridge. Because there is a high guard fence on the bridge, the zoom made it easier to shoot bars.
	On Your Own: Any lens will work for this type of photography.
Camera Settings	**Practice Picture:** I set the camera to manual mode and the shutter speed to 10 seconds. I then set the aperture to f/5.6 and took the first exposure. After checking the exposure on the LCD, and seeing that the scene still looked a little too light, I adjusted the f-stop to f/8 and took another exposure. This one was a little better, but the sky still looked a little too light, so I moved the aperture to f/11. After checking the third shot, I was happier with the exposure. Because the light was starting to fade even faster, I took another 18 exposures, adjusting the shutter speed slightly each time; but in the end, it was the third exposure that looked the best.
	On Your Own: The most important part is to shoot multiple exposures of the scene. While the LCD is great for previewing the image, the light sets pretty fast, and studying each image for too long results in less time to actually shoot. It is better to shoot first and study later. Use the screen to make quick adjustments to the exposure and keep shooting.
Exposure	**Practice Picture:** ISO 100, f/11, 10 second exposure.
	On Your Own: To get the whole scene in focus, an aperture of f/11 was used. If the background doesn't need to be in focus, a wider aperture can be used, but that could cause a shorter shutter speed, which might not let enough light into the scene to get the trail effect.
Accessories	A tripod was a necessary accessory. There was no way to handhold a camera steady for 10 seconds.

Light trail photography tips

✦ **Use a tripod.** Light trail exposures need long shutter speeds, and the best way to keep the camera steady is by using a tripod.

✦ **Use the review on the camera to adjust the exposure.** One of the biggest advantages of digital photography is the ability to review the photograph that you just took to make adjustments before the next photograph.

Fireworks

The most important part of shooting fireworks is to use a tripod. Setting the camera on a tripod keeps the camera steady during the long exposure needed to capture the falling light trails. Use Manual Focus mode to preset the focus to infinity, so the camera doesn't have to try to focus on distant bright lights that might give the camera problems. Set the camera to Manual mode, the ISO to 200, and the aperture to f/11. The only setting to change at this point is the shutter speed. I start at 2 seconds and work up or down from there. For photos of just the fireworks, use as long a lens as possible to fill the frame with the fireworks. If the photo you want to capture is a fireworks display over a city skyline, a wider-angle lens is necessary. A fireworks display gives you multiple chances to shoot the fireworks; use these chances to correct the exposure and framing between photos. The Remote Commander or an optional Sony cable release is useful in this situation, because it reduces camera movement and lets you watch the fireworks so that you can trigger the shutter release when the rocket is at its apex. This lets the shutter stay open while the light trails are visible and helps in getting a bright, sharp photo of the firework.

After the first photo, check the exposure by looking at the picture on the LCD. If it looks underexposed, increase the shutter speed to 3 seconds and try again. If the scene looks overexposed, decrease the shutter speed to 1 second. Because the Sony has a Bulb setting, you can also manually keep the shutter open while the fireworks are visible. Just set the shutter speed to B for bulb, hold the shutter down when the rocket bursts, and release the shutter when the light trails start to fade.

Macro Photography

Macro photography is about getting in really close to your subject. A macro lens is a specialized lens that gives you a 1:1 view of your subject, but you don't need a special lens to get close to your subject. You can also use a special close-up filter that turns any zoom into a macro lens, and the best part is that these filters are less expensive than buying a specialized macro lens. Sony does make two specialized macro lenses: a 100mm f/2.8 macro lens, and a 50mm f/2.8 macro lens.

 Cross-Reference *For more information on specialized lenses, see Chapter 5.*

Because macro lenses are usually used very close to the subject, they have a very shallow depth of field. It is critical to keep the camera from moving, and using a tripod is the best way to do this. When you are focused really closely on a subject, any bit of movement can shift the focus off of what you want it to be focused on.

 Note *A 1:1 view means that the image is the same size as the area being photographed.*

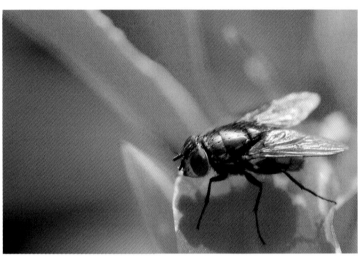

6.39 When I was setting up a macro shot outside, a fly landed on the flower that I was planning to photograph, so I started to shoot. This shot is handheld because I didn't have time to get the tripod into position. ISO 200, f/8.0, 1/250 second.

Inspiration

Almost any subject is suitable for close-up photography. Shooting close-ups of everyday subjects can reveal textures, patterns, and shapes that you wouldn't normally notice.

One of the best places to look for macro subjects is outside in nature: the design on a leaf or the spines on a cactus, for example. Insects also make great subjects and can be found just about anywhere. Going to a park presents you with a great deal of macro subjects, from flowers and plants to the insects that live in and on them.

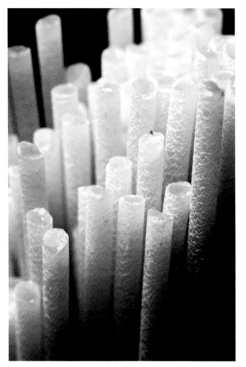

6.40 Strands of uncooked pasta shot with a 100mm macro lens. On a black background using Aperture Priority mode with natural sunlight from a nearby window. Taken at ISO 200, f/16, 1/15 second.

6.41 The detailed parts of an orchid make a great subject for macro photography. Taken at ISO 100, f/18, 1/160 second.

Macro photography practice

6.42 Macro photo of a Passionflower on the vine

Table 6.12
Taking Macro Photographs

Setup	**Practice Picture:** I have a Passionflower vine growing in my back-yard. The first time I saw the flowers, I was amazed by the design. The shot in figure 6.42 has extremely narrow depth of field and was very difficult to obtain while the flower was still moving slightly. I had to wait until the flower was completely still to take the shot.
	On Your Own: Look for the patterns in your subject and experiment with different angles and different depths of field. Because you are shooting a very small area, even a little adjustment will result in a very different photo.
Lighting	**Practice Picture:** This shot was taken using natural light, when the sunlight was direct and very harsh. The vine acted as a natural diffuser and softened the light on the purple and white parts while still adding bright highlights to the top of the stamen.
	On Your Own: Watch the angle of the light play across the subject. It doesn't take a big change in the light source to make a big difference in the composition of your photograph.
Lens	**Practice Picture:** I used the 100mm macro lens.
	On Your Own: Sony makes two dedicated Sony-branded macro lenses: the 100mm f/2.8 macro lens that has a 1:1 magnification and a minimum focusing distance of 1 foot 2.4 inches and the 50mm f/2.8 macro lens with a 1:1 magnification and a 7.8-inch minimum focusing distance.
Camera Settings	**Practice Picture:** I had the camera set on Aperture Priority because I wanted to get that shallow depth of field and keep the background out of focus.
	On Your Own: If you are shooting with a constant light and a tripod, it would be best to set the camera to Aperture Priority mode and concentrate on achieving the desired depth of field.
Exposure	**Practice Picture:** ISO 200, f/3.5, 1/50 second.
	On Your Own: Make sure that you use a depth of field deep enough to get the whole area you want in focus. If you need to shoot without a tripod, make sure the Super SteadyShot is turned on.
Accessories	A tripod and the Remote Commander are recommended when shooting macro photography.

Macro photography tips

✦ **Use a tripod and cable release.** I know I have mentioned this before, but using a tripod is a must for getting the sharpest macro photographs possible.

✦ **Super SteadyShot.** If you can't use a tripod, turn the Super SteadyShot on and use the vibration reduction that is built into the A700.

✦ **Change your viewpoint.** Try different angles and distances. After you have the camera and tripod set up for the shot, it isn't hard to experiment a little. Move the camera to the right or left and shoot a different angle of the same subject.

✦ **Move the camera to focus.** Set the auto focus to manual and set the lens for the closest focus point. Then move the camera and lens forward or backward to change the focus. This results in the maximum magnification of that lens.

Night and Low Light Photography

Night offers a great many photographic opportunities. Even after the sun goes down, a great deal of light remains, especially in the city. Buildings that are lit up at night, streetlights casting their glow, and even neon signs are all great light sources for night and low light photography. The same city street shot during the day has a completely different look to it when shot at night. Under the bright direct sunlight of midday, a street might look washed out and dull. That same street lit by the glow of streetlamps can look warm and inviting.

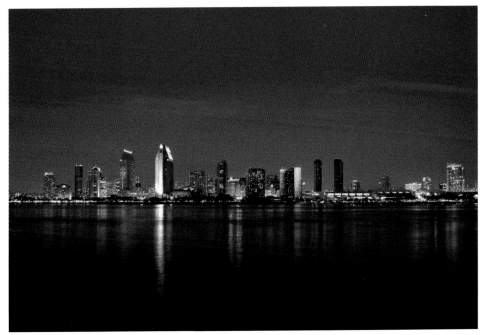

6.43 The San Diego skyline taken from Coronado Island. Shot at ISO 100, f/10, 10 seconds.

Inspiration

The best time to take night shots is right after sunset and before complete darkness, when the sky takes on a very deep blue hue. Because this time does not last very long, it is important to plan your shots in advance so that you are ready to take the shot at the best possible time.

As the sun sets, notice how many other lights start to come on. Busy streets and downtown areas light up from shops, restaurants, and theaters, and these all make great night scenes. People coming and going shot with a slow shutter speed keep the buildings in focus but add a sense of movement to the photograph.

Night and low light photography practice

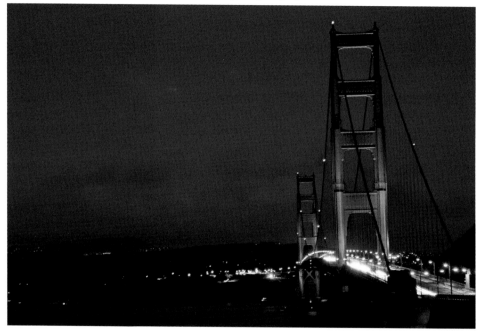

6.44 The Golden Gate Bridge from the north side of the bay.

Table 6.13
Taking Night and Low Light Photographs

Setup	**Practice Picture:** I waited until twilight to capture the image in figure 6.44. Using a tripod, the camera was set up facing south with the bridge off to the right. One of the hardest parts of this shot was keeping the camera steady during the three seconds that the shutter was open even using a tripod because the winds picked up. I used my body to try to block the wind and pushed down on the tripod legs while the shutter was open. **On Your Own:** Buildings and other structures don't move and make for great night and low light photograph models.

Lighting	**Practice Picture:** There are three sources of light in this exposure: the lights from the cars moving across the bridge, the bridge lights, and the ambient light in the sky. The shutter was kept open long enough to make the car lights blend together into a stream of white light.
	On Your Own: When shooting at night, there are usually a variety of light sources and you should take them all into consideration.
Lens	**Practice Picture:** I used the 55mm focal length on a 70-200mm f/2.8 lens. This focal length let the bridge uprights fill the height of the frame without too much space above or below.
	On Your Own: Any lens can be used for night photography. Many lenses change the maximum f-stop as they zoom out. When using these lenses, be careful that if you change the f-stop, you also change either the shutter speed or the ISO to get an equivalent exposure.
Camera Settings	**Practice Picture:** I shot with the camera on Manual mode, and after a test shot at 2 seconds I set the shutter speed to 3 seconds and bracketed the exposure.
	On Your Own: Use the screen on the back of the camera to check the first exposure as a basis for the following exposures. I also recommend bracketing the exposures and shooting as many shots as possible when the twilight is just right.
Exposure	**Practice Picture:** ISO 200, f/5.6, 3 seconds.
	On Your Own: Shooting static subjects while using a tripod allows for sharp images using long shutter speeds. It is also possible to raise the ISO to capture the same image using shorter shutter speeds. Using the lowest ISO possible results in photos that have less digital noise and look better when enlarged, especially for printing. Checking the histogram view helps to avoid having areas that are too bright, but remember the histogram for a low light photo has more information on the left side.
Accessories	A tripod and cable release or Remote Commander is useful when shooting long exposures.

Night and low light photography tips

✦ **Bracket your shots.** The time period between sunset and complete darkness doesn't last very long. Bracketing your shots is a good way to make sure you get the exposure you want.

✦ **Using a tripod.** Many night and evening photos require longer shutter speeds that need a tripod to keep the camera steady.

Note It is not possible to use the supplied Remote Commander and bracketing at the same time. The Drive mode needs to be set for either the Remote commander mode or for a Bracketing mode.

Online Auction Photography

Online auctions are big business, and nothing helps sell like photographs. Internet auction sites such as those hosted by eBay, uBid, and Yahoo let you sell everything from an automobile to a zoot suit, and getting good photographs of the items you want to sell helps you get higher bids and more sales.

The best part of photographing most items for online auctions is that it needs very little extra equipment; the built-in flash and most lenses work just fine with some advance planning. Online auction photographs have a very specific purpose: to make your items more appealing to prospective buyers. There is no reason to try to create fine art or spend a lot of time on each photo. Because the only place these photos will be viewed is on the Internet, their size will be smaller than needed for prints, so consider choosing JPEG for the format in which your camera records.

6.45 Setting up a simple black cloth backdrop, the camera on a tripod, and a single overhead light source created a good basic auction photograph of this vase. Taken at ISO 100, f/7.1, 1/125 second.

Inspiration

The best advice for online auction photos is to shoot them on a clean background. By making the subject of the photo the only thing in the photograph, nothing can distract the prospective buyer. There are many specialized products to help create a clean background, but a white sheet works very well and costs very little. The idea is to set up a location where you can easily shoot a variety of objects in a short amount of time.

6.46 This David Bowie record and jacket were shot on a white sheet. The image was lit by an open door to the right and was taken standing over the record and shooting straight down. Because the light was not overhead, my body did not cast any shadows. Taken at ISO 250, f/4.0, 1/25 second with Super SteadyShot turned on.

Online auction photography practice

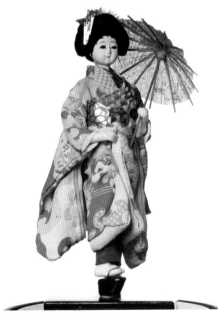

6.47 This Oriental statuette was purchased many years ago and was recently photographed to be sold online.

6.48 Especially with delicate items, it is important to show all sides. Here is the statue's back.

Table 6.14
Taking Online Auction Photographs

Setup

Practice Picture: The photos in figures 6.47 and 6.48 show both sides of a statuette. The statuette was placed against a white background with a single strobe light. The camera was set on a tripod and focused on the statuette. After the first shot, all that was needed was to rotate the statuette and take the second shot. This setup made it possible to create the matching photos in a matter of seconds.

On Your Own: Remember that the purpose of these photos is to sell your items online and not to create fine works of art. After the setup and exposure are complete, it is just a matter of putting the objects to be photographed in the right spot and taking the required shots.

Lighting

Practice Picture: The lighting for the statuettes was a single strobe slightly above and behind the camera. Using a strobe lets the light remain constant and speeds up the process.

On Your Own: If you plan on photographing a lot of items for online auctions, it pays to buy a strobe light with a small softbox to evenly light the auction items.

Lens

Practice Picture: I used a 100mm macro lens. This is a great lens to use for small items, and due to the shallow depth of field, the background is out of focus and doesn't distract from the items being sold.

On Your Own: Make sure that the items being photographed fill the frame. Any lens can do this, and so there is no need to buy any special lenses.

Camera Settings

Practice Picture: I set the camera on Full Auto mode and took an exposure reading of a gray card (cardboard that is colored a neutral 18% gray) in the place of the items to be photographed. I then set the camera to Manual mode and entered the shutter speed and f-stop from the earlier exposure reading. This keeps the camera from changing any of the settings and keeps the exposure constant from item to item. This is even more important when shooting the same object from different sides and angles.

On Your Own: Setting the camera on Manual mode keeps all of your settings consistent. A clean look and uniformity in the exposures present the items in a more professional way. Set the white balance using the Custom White balance discussed in Chapter 2. This will give you most uniform results.

Exposure

Practice Picture: ISO 100, f/7, 1/250 second.

On Your Own: If the object you are shooting is thinner or thicker, adjust the aperture so that you have enough depth of field to keep the whole object in focus.

Online auction photography tips

✦ **Honesty is the best policy.** It is easy to remove dents, scratches, or other imperfections using today's photo-editing software. This is one time that I recommend not correcting the imperfections. You should be honest about what you are selling instead of making the object flawless.

✦ **Zoom in close.** You will only have a second or two to make an impact when your potential buyer is looking through the auction listings. Use all the space in the photo for the item. Since the A700 does not have any crop functions, it is important to fill the frame when photographing the object.

✦ **Take multiple photos from various angles.** Buyers like to see multiple angles of whatever they are buying. It pays to have multiple shots of the same product, and using the method outlined earlier, taking multiple shots is a snap.

Outdoor Portrait Photography

Portraiture is one of the most common forms of photography. Many people buy cameras to take photos of friends and family. Portraits can include only the head of the subject, the shoulders and head, the upper torso, or the entire figure. Portraits can either be posed or candid, and although portraits can be shot anywhere, this section deals with shooting outdoors.

Shooting portraits outdoors usually means using natural light and incorporating some elements of the background or foreground into the photograph.

You can shoot outdoors at night, but with the absence of sunlight, you usually have to add light to the scene. This might be as simple as the on-camera flash, but for more versatile shooting, at least one portable light source is needed.

6.49 Positioning the model in the doorway cut down on the direct light and made for a more pleasing photograph. A reflector was used to redirect part of the sunlight inside to light the model indirectly. Taken at ISO 100, f/8, 1/250 second.

together. I have found that the best outdoor portraits happen when the subject is comfortable in his or her surroundings. However, be careful not to let the surroundings overpower the subject.

6.50 Shooting outdoors at night is possible, but to get this shot, a set of portable strobe units were brought in to light the model and the lockers. Taken at ISO 100, f/5.6, 1/200 second.

Inspiration

Capturing the character of your subject is key to a great portrait. The greatest background and the greatest model might not make the greatest photo if the two don't seem to go

6.51 While shooting on location at an outdoor music event, I came across this young fan backstage. I had her stop for a moment and took a quick series of photos. Taken at ISO 200, f/8, 1/250 second.

Outdoor Portrait Photography

6.52 This runner was waiting for his race to be called.

Table 6.15
Taking Outdoor Portraits

Setup	**Practice Picture:** This runner in figure 6.52 was waiting for his race to be called when I posed him in profile with the racetrack reflected in his glasses. The serious expression on his face set the mood for the image. This is a serious athlete waiting for his chance to go to work.
	On Your Own: When shooting outdoors, pay attention to the background. Try to use an aperture that keeps the subject in sharp focus while softening the background.
Lighting	**Practice Picture:** This was shot in the early afternoon sun. I needed to position the runner so that the track was reflected in his glasses, which placed the sun above his head and caused some very bright areas on his head. I would have preferred to shoot this later in the day, but it needed to be done when the track was empty between races.
	On Your Own: The best times to shoot are early in the morning or late in the afternoon. The light is not quite as harsh during these times, and the shadows are not so hard. If the shadows are too severe, you can use a fill flash to bring out details in the shadow areas.

continued

Table 6.15 *(continued)*

Lens	**Practice Picture:** I used a 70-300mm f/4.5-5.6 lens at the 300mm focal length. Due to the location, shooting at an active track and field event, I needed to stay farther back that I would have preferred, but the 70-300mm let me zoom in close enough to fill the frame with the athletes head. **On Your Own:** If the world were a perfect place, I would use a 50mm or higher focal length lens for all portraits. The85mm f/1.4 makes a fantastic portrait lens. The 85mm focal length and the f/1.4 maximum aperture makes this lens a great choice for portraits.
Camera Settings	**Practice Picture:** I shot this on Aperture Priority to try to keep the background as out of focus as possible. I set the aperture to f/5.6, which was the widest aperture at the 300mm focal length. Because of the bright sunlight available, the shutter speed was high enough that camera shake wasn't an issue even with ISO of 100. **On Your Own:** Shooting in Aperture Priority mode gives you a greater amount of control over the background. Shooting outdoors means that the light can change from minute to minute due to the movement of the sun. Having the subjects hold their position while you shoot lets you not worry as much about shutter speed. Start with an aperture that gives you the look you want for the portrait, and then increase the ISO if needed.
Exposure	**Practice Picture:** ISO 100, f/5.6.0, 1/800 second. **On Your Own:** Using Aperture Priority mode you can set the depth of field and let the camera set the shutter speed. This allows you to control how blurred the background will be. Because the subject of your image is posing for you, they don't need to be frozen by a fast shutter speed.
Accessories	A tripod is useful for holding the camera steady while adjusting the model.

Outdoor portrait photography tips

✦ **Watch the light.** Sunlight constantly changes as the sun moves through the sky. A stray cloud can change the lighting dramatically, and it is up to you to adjust accordingly.

✦ **An assistant is useful.** At times shooting outdoors requires the use of reflectors and diffusers, and using these correctly while taking the photograph can be nearly impossible.

✦ **Pay attention to the background.** The background can change during a shoot, and it is easy to forget to continuously check to make sure the background is clear of distractions. After completing a recent on-location shoot, I found that during the shoot a stranger had wandered into the frame and was in the background of a handful of shots, effectively ruining the photographs.

Panoramic Photography

Panoramic photographs convey a sense of space that makes them a great choice for sweeping landscapes. Panoramic photography used to take specialized pieces of equipment or cameras. With digital photography and advances in software, panoramic photography has become much easier for everyone.

Stitching three, four, or more photos together as in the image below, has become much easier. You can shoot panoramic photos in two ways: The first is to shoot multiple exposures, panning the camera to capture a large area and then merging the photos together into a single image using third-party software, such as Adobe Photoshop CS3. The second method is to crop a single photo to create a panoramic effect. Cropping one image actually removes information making a smaller file with fewer pixels, while combining two or more images creates a much larger image.

The key to shooting good panoramic photos is to set up the shot correctly before making a single exposure. Although you can shoot a series of photos to create a panoramic print without a tripod, I always recommend using a tripod. This keeps the camera on the same level throughout the process.

Sports Photography

A great sports photo is all about capturing the action. At times, freezing the action is the most important thing; at other times, it's showing the motion. To freeze a fast moving action, a shutter speed of 1/250 of a second is the absolute minimum that should be used, and I recommend 1/500 or faster. In practical terms this means that either there needs to be a lot of light or you need to use a fast lens, one with a maximum aperture of f/2.8.

6.53 A pickup basketball game at the local recreation center was a great place to use the A700's Sports mode. Taken at ISO 200, f/3.2, 1/3200 second.

To show the motion in a sporting event, a technique called *panning* is used. Panning uses a slower shutter speed while you pan or move the camera in the same direction that the subject is moving. When the camera moves at the same speed as the subject, the subject stays in reasonable focus while the background blurs. To get the best results, keep your feet still and rotate the top half of your body, tracking the subject at the same time. The shutter speed needs to be set to keep the shutter open through the panning movement. This can be 1/15 of a second or 1/40 of a second, depending on the speed of your subject.

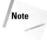

> **Note** *Professional sports photography requires super-fast, super-long telephoto lenses, making shooting pro sport events a very expensive pastime that is not for everyone. For example, the Sony 300mm f/2.8 lens costs more than $5,000.*

When shooting sports and action photographs, timing is very important. Each sport has predictable movements, and knowing these helps you get the shot. When shooting the surfer in Figure 6.54, I knew which direction he was going to be traveling on the wave. It was then easier to keep him in focus as I tracked him from right to left, shooting the whole time. You need to anticipate the action — if you can see the action, it is too late to photograph it. For example, when I watched the basketball game in figure 6.53, I started to shoot as soon as I saw the player break for the basket. This was the fifth image in the sequence.

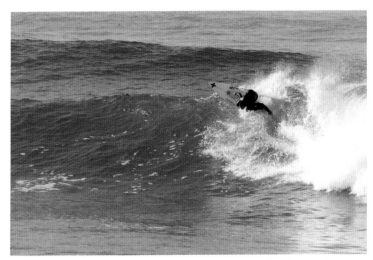

6.54 I used a shutter speed of 1/2000 of a second to freeze the surfer and the water at the crest of the wave. Taken at ISO 400, f/5.6, 1/2000 second.

Inspiration

Sporting events range from horse racing to surfing and everything in between. Sports are exciting; otherwise people wouldn't play them or watch them. Capturing that excitement makes for great sports photos. The split second as the baseball hits a bat, or the moment the soccer ball soars into the goal are great photo opportunities, but also look to the players as they experience victory or defeat. The emotional impact of those moments can make a fantastic sports image.

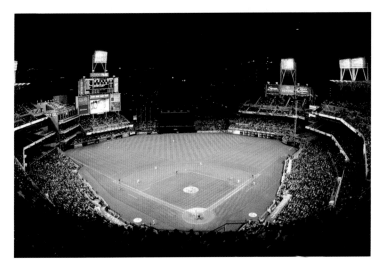

6.55 For this baseball game I went to the top of the park and photographed the entire scene with a super-wide-angle lens. This shows a whole different perspective on the game. Taken at ISO 250, f/3.5, 1/80 second.

Sports photography practice

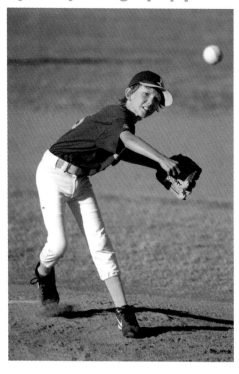

6.56 A Little League pitcher in action.

Table 6.17
Taking Sports Photographs

Setup	
	Practice Picture: The Little League pitcher, shown in figure 6.56, was caught just after he released the ball. I stood just to the side of the protective cage and shot as straight on at the pitcher as possible. I kept the focus on the face and shot in Burst mode from the end of the windup to after the pitch. I did this for multiple pitches and didn't worry about editing until after the game was over.
	On Your Own: Plan ahead for the shot. Try to position yourself in the best location to achieve it; this is where knowing the sport is helpful. Watch the event for a few minutes before picking up your camera to get an idea of the game play and the best angles.

Lighting	**Practice Picture:** This All-Star Little League game was played late in the afternoon and the sun was lighting the scene from the left. This gave nice even lighting on the left side of the player, and with the shadows going off to the right, there was little to distract from the moment. **On Your Own:** The more light that is present when you shoot, the easier it is to use a higher shutter speed and a low ISO. Pay attention to any hats or other headgear that can cause shadows to fall across the players' faces. Watch how the shadows change during the game: Places that started out in bright sunlight could end up in heavy shadows.
Lens	**Practice Picture:** To get this close to the pitcher, I used a 300mm lens. This let me frame the player and still capture the ball in the air. **On Your Own:** Because many sporting events happen quite far away from the spectators, using a lens that reaches the action is very important.
Camera Settings	**Practice Picture:** The camera was set on Shutter Priority mode with a shutter speed at 1/2000 of a second. This froze the action of the pitcher. Even in Little League, the pitcher is moving really fast. I shot in Burst mode to capture the entire pitch; if I had waited to see the release, it would have been too late to capture both the pitcher and the ball. **On Your Own:** Set the camera to Shutter Priority mode and set the shutter speed high enough to freeze the action, at least 1/500 of a second. Use the LCD review to see if the shutter speed really is getting you the sharpness you want, and adjust the shutter speed if necessary.
Exposure	**Practice Picture:** ISO 250, f/4.0, 1/2000 second. **On Your Own:** Shooting in Shutter Priority mode with a shutter speed fast enough to freeze the action may require you to increase the ISO to get a properly exposed image.
Accessories	A monopod is a useful addition when shooting sports. Hold a long lens for any extended period of time, and you will understand how helpful a monopod can be.

Sports photography tips

✦ **Shoot in burst mode.** By shooting multiple exposures during the action, you are more likely to capture the best action shot.

✦ **Carry a lot of memory cards.** Shooting in Burst mode results in a great many photos, and because there is not enough time to edit them during the event, make sure you have enough memory cards to last.

✦ **Shoot using the widest aperture possible.** Shooting with the widest possible aperture lets you use the highest possible shutter speed, which helps freeze the action. It also blurs the background, which helps keep the focus on the main subject.

✦ **Look to use different angles.** At times it is better to kneel down and shoot from a lower angle, especially when shooting a field game like kids' soccer. Other times it pays to go a little higher in the bleachers and shoot down.

✦ **Ask permission when shooting kids.** This is a good basic tip for any event. Parents are highly protective of their children, and asking them before aiming your long lens at their children helps avoid any misunderstandings. If the parents are not present, talk to a coach or game official.

Still Life Photography

Shooting still life photographs in a studio setting gives you complete control over the lighting and viewpoint of your photographs. When setting up a still life studio, you don't need a whole lot of room or much special equipment to start. A table to hold your subject or subjects, a camera, a tripod, and a light source are the basics needed for still life photographs.

Taking your background into consideration is important because the right background makes your photos stand out. Keep the background clean and uncluttered. Using a tripod lets you set the camera up and make minute adjustments without having to deal with holding the camera. Keeping the camera rock steady also lets you use a lower shutter speed without having to worry about blur.

The last part of a still life setup is the light. This can be anything from daylight streaming through a window to a studio full of lights. The built-in flash is not the best light for this type of photography because the location and size of the flash in relation to the lens makes for a flat light. An external flash that can be moved off camera is a much better way to light a still life.

6.57 The simple layout of the sushi with even overhead lighting creates a balanced display of edible art.

Inspiration

One of the great things about still life photography is the wide variety of subject matter. Any item can be used as a subject for a still life photograph. Avoid the temptation of cluttering the scene; start with a single item and build the scene carefully. Watch how each item changes the light and shadows falling onto the other items.

Any item can be made the subject of a still life photograph: flowers, jewelry, a favorite vase or piece of clothing. Also, cooked or raw food makes great subject matter for still life photography.

6.58 This fairy statue lives on a high self, but for this picture, it was placed outside in the early morning sun so that the background could look natural. The shallow depth of field kept the background blurred so that the delicate features of the statue would stand out. Taken at ISO 100, f/6.3, 1/1250 second.

6.59 A simple black background lets the white popcorn really stand out.

Still life photography practice

6.60 These three peppers and a chef's knife make for a simple yet powerful still life.

Table 6.18
Taking Still Life Photographs

Setup	**Practice Picture:** In figure 6.60, I set three bell peppers on a big bamboo cutting board and added a large chef's knife at a diagonal from the bottom right corner. I wanted the hard bright steel to be a counterpoint to the soft round shapes of the peppers. I originally set this shot up to be photographed at a 45-degree angle, but after looking through the viewfinder I decided that an overhead view with light coming from the right side would make a better composition. Using a tripod that allows the center column to be removed and placed horizontally so that the camera can be aimed straight down let me place the cutting board on the floor. I shot straight down at the board using a cable release so as to not move the camera at all.
	On Your Own: When setting up a still life photograph, look at the scene from different angles. You might see something that would make a better photograph.

Lighting	**Practice Picture:** I used one off-camera flash slightly below and to the right of the camera. The bright highlights on the red bell pepper and the knife blade show the direction of the light.
	On Your Own: An external light source is a big plus when shooting still-life photos. Positioning the light source at a different angle than the camera helps create scenes that don't look flat.
Lens	**Practice Picture:** I wanted a wider view and was limited in the height of the tripod because I was shooting straight down. I used a Sony 50mm f/1.4 to capture this photograph.
	On Your Own: Any lens can be used for still life photography. Use a focal length that lets you frame the subject.
Camera Settings	**Practice Picture:** I shot the peppers on Manual mode. I wanted a very deep depth of field so that the textures and cut marks on the cutting board were in focus along with the peppers and knife.
	On Your Own: Being able to control the depth of field is a good starting point for still life photography. Using Aperture Priority mode gives you that control without having to worry about shutter speed, and because the camera is on a tripod, a low shutter speed doesn't matter.
Exposure	**Practice Picture:** ISO 100, f/20, 1/50 second.
	On Your Own: Since your still life is not moving, use the aperture to set the depth of field you want. Apertures of f/5.6 or wider will cause the backgrounds to blur, making your subject really stand out.
Accessories	A tripod and the Remote Commander were both needed for the setup of this photograph.

Still life photography tips

✦ **Use a tripod.** Using a tripod keeps the camera steady, and more importantly, in the same exact position, so that you can arrange and rearrange the subject of your photograph. Keeping the camera steady on a tripod also produces the sharpest photographs possible by eliminating any movement even during long exposures.

✦ **Use the best looking items.** This is especially true when shooting food. Use the freshest, most appealing food and clean off any dirt and grime to get it as clean as possible.

✦ **Watch for dust.** When shooting anything that has a reflective surface, dust carefully. I use a can of compressed air to blow the dust off any reflective surface between shots. Just remember not to aim the compressed air back toward the camera.

✦ **Change the background.** Shooting in front of a different background can change the entire tone of the photograph. If you were shooting against a light color, try using a darker background.

Street Life Photography

There are times when the people around you can be inspiration enough for a photograph.

It could be a man hurrying to work or a street musician setting up for the day. It might just be a couple of men feeding the birds. Every city and town has a wide variety of people that can be great subjects for street life photography.

6.61 Feeding the birds in Bath, England. This man spent hours sitting on the bench feeding the birds. I walked by him at least three times before stopping to take the photo. Taken at ISO 100, f/5.6, 1/100 second.

Inspiration

I like to sit and watch the world go by. Pick a spot and just watch what happens around you. People will come and go, offering you a wide variety of photo subjects.

If you would rather be the one moving, go for a walk in any tourist area of town. The street venders, musicians and tourists all become great subject matter. Have your camera ready, because there is always change happening in street photography. People are moving about and a shot that is available one minute could be gone the next.

6.62 A young street musician sits after a long afternoon of trying to earn a living. Taken at ISO 100, f/6.3, 1/125 second.

Street life photography practice

6.63 A painter sets up at a local beach.

Table 6.19
Taking Street Life Photographs

Setup	**Practice Picture:** The young painter in figure 6.63 makes his living selling his paintings to the tourists that frequent the shops nearby. He sets up early in a spot that has a lot of foot traffic between the beach and the local shops.
	On Your Own: Look for areas where there is a lot of foot traffic. The more people that walk on by, the more chances there will be to get a good subject for your photograph.
Lighting	**Practice Picture:** This photo was taken in the late afternoon; the painter had nearly finished his work. There was a heavy cloud layer that diffused the light causing very soft shadows — very good light to photograph and paint in.
	On Your Own: When shooting around buildings and streets, watch for sharp shadows. One minute your subject could be in deep shadows, and the next, blazing sunlight. Overcast and cloudy days are great times for this type of photography.
Lens	**Practice Picture:** I used the 18-200mm f/3.5-6.3 lens. This gave me a large range of focal lengths to use. I could zoom in on an individual, or zoom out to capture more of the overall scene.
	On Your Own: Any lens can work for this type of photography. A normal lens is very commonly used for street life photography because it gives you a truer view of the scene.
Camera Settings	**Practice Picture:** I set the camera on Program Auto mode and Multi-Segment metering. The day was bright enough that I didn't have to worry about camera shake and slower shutter speeds.
	On Your Own: To freeze fast moving people, use a high shutter speed, but sometimes it is good to experiment. Slower shutter speeds can give your image a sense of movement.
Exposure	**Practice Picture:** ISO 100, f/9, 1/160.
	On Your Own: In mixed light, where you have areas of bright light and dark shadow, use the spot metering on you subject and experiment with setting the ISO to Auto. Review your images on the LCD and if needed and possible, shoot again.
Accessories	Use a waist pack to carry an extra lens or flash along with extra memory cards and a battery. The LowePro Orion Mini is a good example of a walk-around bag.

Street life photography tips

✦ **Be ready to photograph.** Keep your camera ready to go. By the time you take your camera from its camera bag, attach a lens, and turn it on, remove the lens cap, the photo opportunity is lost. I carry my camera around my neck, or over my shoulder with the lens cap removed, and the lens hood attached.

✦ **Carry extra memory.** You never know how many images you will take and what you might come across, so carry a couple of extra memory cards so you don't have to stop shooting.

✦ **Pay your way.** Street artists and musicians are great subject matter, but they are trying to earn a living so offer to contribute before taking their photo.

✦ **Shoot from the hip.** Changing the perspective can add a whole new dimension to the photograph, especially when using a wide-angle lens.

Sunrise and Sunset Photography

Sunrise and sunset are two times of the day when it is nearly impossible to mess up the lighting and the photograph. Because of this, everybody takes sunrise and especially sunset photos, and even though they may seem cliché, sunrises and sunsets are great photographic opportunities. The light changes rapidly during these times, and this means that you must be ready to take the shot before it happens.

Inspiration

There is a great sunrise and sunset every day. Whether it is the sun setting over a city skyline or rising over a mountain range, the warm colors during the sunrise and sunset make for great photographs.

Having an identifiable object in the photo helps create a sense of size and location. For example, the pier in figure 6.66 helps draw the eye into the sunset and gives the entire scene a sense of space.

6.64 The sun setting over the mountains in Sedona, Arizona, makes for a great sunset photo, and more importantly, shows that a sunset can be taken in a portrait position.

6.65 During the wildfires that raged through Southern California in 2007, the particles in the air made for a very colorful sunrise.

Sunrise and sunset photography practice

6.66 Ocean Beach Pier in San Diego, California

Table 6.20
Taking Sunrise and Sunset Photographs

Setup	**Practice Picture:** This shot in figure 6.66 was the final exposure of the sunset that evening. I set up a tripod with a super-wide-angle lens and a cable release to capture the sun setting behind the pier. Shooting sunsets on the West Coast of the United States means that the sun sets over the ocean, and although that in itself can make a great photograph, a pier or other structure can add to the composition of the scene. The Ocean Beach Pier is the longest pier in San Diego County and stretches 1,950 feet out over the water.
	On Your Own: Sunsets change every night, and no two are ever the same. When you find a spot that has a good sunset view, visit often; you will be surprised at the wide variety of sunsets that you can photograph at the same location.
Lighting	**Practice Picture:** Shooting a sunset is all about shooting the light. The sun had just set moments before, and the pier lights had just come on. Reflections of the pier lights are visible in the water.
	On Your Own: Use the LCD screen on the back of the camera to check for blown highlights, and shoot every minute or so as the sun goes down. The differences in the light are noticeable from moment to moment.
Lens	**Practice Picture:** I used an 11-18mm super-wide-angle zoom lens set to 12mm to capture as much of the scene as possible. Sunset photographs are usually taken with the wide-angle lenses used in landscape photography. Sunsets are a specialized part of landscape photography.
	On Your Own: Go as wide as you can. Using a wide-angle lens helps in framing the whole vista. I find the 11-18mm a great lens for this. The focal ranges of 11-18mm cover the super-wide angles very nicely.
Camera Settings	**Practice Picture:** I shot this on Manual mode. First I set the ISO to 100 to get the least amount of digital noise possible. I then set the aperture to f/13 to get the deepest depth of field, and finally I set the shutter speed. Because the camera was mounted on a tripod, I was able to experiment using long exposure to capture not only the last light of the sunset, but also the lights on the pier reflected in the water.
	On Your Own: I always recommend using a tripod for these types of photographs, but at times it isn't possible. When that happens, start by opening up the aperture and increasing the ISO; make sure that the Super SteadyShot is turned on. This lets you raise the shutter speed enough to hand-hold the camera and still get a good exposure.

continued

Table 6.20 *(continued)*

Exposure	**Practice Picture:** ISO 100, f/13, 3 seconds.
	On Your Own: The light changes very rapidly as the sun is setting. Use the LCD to review the image and adjust the settings according to what you see. I only adjust the shutter speed, leaving the aperture and ISO alone. To get the correct exposure, use the Spot-metering mode to meter on the sky above the sun. Make sure that none of the actual sun is in the metering spot.
Accessories	A tripod and Remote Commander are really important in getting decent sunset photos. Being able to hold the camera steady for long periods of time lets you get very sharp photos long after the sun has dropped below the horizon.

Sunrise and sunset photography tips

✦ **Use the Internet to find out sunrise and sunset times.** You can use Internet search engines like www.google.com or sites like www.sunrisesunset.com and www.timeanddate.com to find sunrise and sunset times for most areas around the world.

✦ **Arrive early.** To shoot a sunrise, arrive before the sun has started to rise and get set up. Once the sun has started to light the sky there is not much time to get the shot.

✦ **Bracket your exposures.** The light at these two times of the day changes very quickly. Bracketing your exposures helps you get the exposure you want.

Travel Photography

Planning ahead helps to create successful travel photographs because knowing what to expect at your destination improves your odds of capturing a great travel photo. For example, find out if there is a big festival or parade in the area you will be visiting. Nothing is more frustrating that arriving a day late or having to leave a day early and miss a big local event.

Another part of being prepared is making sure that you have the right gear and that all of your equipment is in good working order.

Make sure that all of your lenses are clean and that you have enough memory cards and batteries. Running out of power or memory on a trip is avoidable.

Look for landmarks that identify your travels, but try to find a different perspective than the standard postcards. Make the image your own by using your viewpoint. This will not only make for a more personal image, but one that you will have an emotional tie as well. The story on how you got the image will be part of the memory always associated with that trip.

6.67 Big Ben, arguably the world's most recognizable clock tower, is an integral part of London. The photo also has a part of the London Eye in the background, showing the old and the new. Shot at ISO 100, f/9, 1/400 second.

6.68 Traveling through Ireland, I came across this small cemetery and this stone Celtic cross. Even without an identifiable landmark, the cross speaks volumes about the location and I will never forget that small cemetery south or Cork. Taken at ISO 200, f/5.6, 1/320 second.

Inspiration

Traveling photography is a way to share your adventures with others. Look for unique clothes, people, architecture, events, and any other scenes that will transport you back when you see the images. Look for street posters, soft drink cans, even street signs that while familiar in form and use, are unique to your location.

Respect the culture of the country you are visiting. There are people and places where photography is frowned upon. There are many cultures that frown upon taking photographs of people, especially women. Be polite and ask permission before photographing people.

6.69 Mexican blankets hanging up for sale at a street bazaar in La Paz. Taken at ISO 200, f/5.6, 1/180 second.

Travel photography practice

6.70 The Empire State Building is one of the most recognizable buildings in the world.

Table 6.21
Taking Travel Photographs

Setup	**Practice Picture:** Walking through New York City, the entire city seems to be built of skyscrapers, but one building stands out above the others: the Empire State Building shown in figure 6.70. From King Kong battling the planes for his lady on the top of the building, to Tom Hanks and Meg Ryan meeting on the observatory deck in *Sleepless in Seattle*, the Empire State Building has been filmed and photographed since its construction started in 1930. I chose a location that showed the building towering into a gray winter sky.
	On Your Own: Unless you are on a specific photo vacation, there are times that you need to make the most of a situation. It would be great to be able to come back in good light or on a sunny day, but that is not always possible. Try to change your viewpoint or angle to change the way the light hits your subject. Preplanning comes in handy: Do some research on your travel location, and make a list of places you want to see and photograph.
Lighting	**Practice Picture:** This photograph was taken during the middle of the day. This was more due to the limited time I had in New York City than any other consideration. There was a lot of cloud cover that day, and that diffused the bright sunlight.
	On Your Own: The best lighting is just after sunrise and just before sunset, but to be out photographing at these times when traveling is not always possible. If there is a special landmark or area that is important for you to photograph, try to plan on being there either first thing in the morning or last thing in the afternoon.
Lens	**Practice Picture:** I used the 28mm focal length on a zoom lens. This was wide enough to get not only the Empire State Building but the buildings to my right as well. This balanced out the composition and also helped block the harsh midday sun.
	On Your Own: Travel photography can encompass a wide range of subjects at a wide range of distances. A compact zoom, like the 18-250mm, provides a wide range of focal lengths from a wide 18mm all the way to a 250mm telephoto.
Camera Settings	**Practice Picture:** I used Spot metering to make sure the building was properly exposed, and the Aperture Priority mode to make sure that there was a sufficiently deep depth of field to keep the whole scene in focus. There was plenty of sun out, so I had no worries about the shutter speed being too slow.
	On Your Own: Shooting in Program Auto mode will yield the best results in most situations with ample light. For shooting indoors, use Aperture Priority to use all the possible light. If the shutter speed is still too low to get a sharp image, increase the ISO and make sure the Super SteadyShot is turned on. For situations where the exposure of a certain element of your scene is critical, switch to Spot metering and take a second or third photograph.

continued

Table 6.21 *(continued)*

Exposure	**Practice Picture:** ISO 200, f/10, 1/400 second.
	On Your Own: When shooting people, use a wide aperture, such as f/4.5 or f/5.6 to slightly blur the backgrounds, making the people stand out. When shooting buildings and other large scenes, use apertures that will keep the whole scene in focus, such as f/9 or f/10.
Accessories	I recommend using a tripod most of the time; however, keep in mind that many places do not allow tripods to be used.

Travel photography tips

✦ **Practice at home.** It is easy to forget that the place where you live has attractions that visiting photographers would love to shoot. Think about the unique places close to home and practice your travel photography in your hometown or nearby countryside.

✦ **Protect your gear and yourself.** As a photographer, you can make an easy target for thieves because you carry your expensive camera gear around in the open all day. Use some common sense and keep your gear close to you at all times. Pay attention to your surroundings; exploring new places is great, but don't put your safety in jeopardy. Don't take more than you need when travelling.

✦ **Know your gear.** Traveling in new and exciting locations will offer countless photo opportunities. Being familiar with your camera will let you get the shot without having to think about all the settings and maybe miss the shot altogether.

✦ **Plan your day.** Shooting landmarks and other scenic areas on your travels is best done in the early morning or late afternoon; use the midday to shoot interiors and for planning the afternoon shoots. Keep shooting after the sun goes down because many cities take on a whole new life at night.

✦ **Take one more shot.** It is not often that we get to travel to the same places over and over again, so chances are that whatever photographic opportunity you have while traveling will be a once in a lifetime chance. If you have taken your photographs and are ready to move on, take one more look and one more photo. Change the orientation from portrait to landscape or visa versa.

✦ **Ask permission.** Always ask permission to photograph people, especially children. Even if the people don't speak your language, try to communicate your intentions and get a confirmation that photographing them is allowed.

✦ **Take a tour.** No matter how well you think you know a place, a trained guide can show you the best places to photograph and the best times to do it. Many specialized photography-based vacations and travel workshops are available for the novice and the professional photographer.

Wedding Photography

A wedding is one of the most important days in a couple's life and you just can't stop the ceremony to have the bride and groom move into better light or have the maid of honor move just a little to the left. A great many books have been written about being a wedding photographer, and more actual wedding photographers exist than any other type out there. So why include a section on wedding photography here? Because sooner or later, as the owner of a high-end DSLR, you will be asked to shoot a wedding. There is just no getting around it.

Inspiration

No matter what you are told, the wedding day is all about the bride, so start with her. She spent long hours picking out that perfect wedding dress; make sure you spend some time photographing it.

6.71 Every wedding ceremony should end with a kiss. A long lens made this shot possible without any disruptions.

6.72 Using a long lens with a 200mm focal length, I was able to capture this moment without being obtrusive.

It is a special day for the groom as well, and although it is not as important to show the groom getting dressed, a photo of the best man helping the groom with his boutonniere is a must. Right after the ceremony is a great time to get the formal portrait shots of the wedding couple, their wedding party, and family.

Tip *The Alpha 700 lets you push the ISO all the way up to 6400, but setting the ISO at 800 or 1600 should let you use a fast enough shutter speed to avoid camera shake and freeze the action.*

Wedding photography practice

6.73 The happy couple posing in a nearby park

Table 6.23
Taking Wedding Photographs

Setup	**Practice Picture:** The couple in figure 6.73 had their formal portraits taken at a public area close to the ceremony site, and in this particular shot I turned the camera slightly to make for a more interesting composition. The angle also was needed to crop out an unwanted piece of the background. I had the bride and groom look at each other and not at me; this day is about them and the love they have for each other.
	On Your Own: Every bride and groom have their own ideas about what they want from their wedding photographer. It is important to find out what they want before the actual wedding day because there will be little time then.
Lighting	**Practice Picture:** This shot was in direct sunlight in the late afternoon. The photos were taken about an hour prior to sunset, and the light had started to take on a golden hue.
	On Your Own: This is not always under your control because the photographs are shot around the time of the wedding, but try to use natural light as much as possible, and use a fill flash if necessary. Each part of the wedding can have different lighting. A ceremony shot in a church, followed by a dinner in a ballroom with the dance floor set up with its own light means that you need to adjust for each type of light. Shooting in RAW lets you adjust the white balance later and not while shooting.
Lens	**Practice Picture:** This photo was taken with a 35mm f/1.4 prime lens. I really like this focal length for full portraits. The speed of the lens also makes it a great choice for low-light situations that can occur at weddings.
	On Your Own: Weddings can take a variety of lenses: the wide-angle for interior and exterior location shots, and for activities like the garter and bouquet toss; the telephoto lens to capture the ceremony and other wedding events like the cake cutting, without disrupting the couple or their family and friends. A wedding photographer needs to have a full arsenal of lenses to be able to cover any situation that might arise.
Camera Settings	**Practice Picture:** The camera was set to Program Auto mode. I had the camera use the Multi-segment metering mode so it would meter the full scene. The black tuxedo balances out the white dress, and the metering system handled the whole scene with ease.
	On Your Own: When shooting a bride alone, remember that the camera tends to underexpose to compensate for the large area of bright white, and when shooting a groom in a dark tuxedo the camera tends to overexpose. Each of these situations can be handled by dialing in the correct exposure compensation.

continued

Table 6.23 *(continued)*

Exposure	**Practice Picture:** ISO 200, f/5, 1/320 second.
	On Your Own: Each part of the wedding can have their own lighting but that lighting tends to stay the same. The light in a church won't change much during the wedding ceremony, so setting the camera at the beginning of the shoot lets you shoot without having to worry about the settings until you change location.
Accessories	Have a tripod, flash, and plenty of memory cards with you when shooting a wedding. A reflector and diffuser can be helpful for modifying the natural light if necessary.

Wedding photography tips

✦ **Shoot in RAW.** With the sheer amount of photos taken in different light, shooting in RAW is easier than having to set the white balance for each JPEG shot. The ability to set the white balance during post processing leaves you with more time to shoot.

✦ **Carry lots of memory cards.** Shoot as much as possible. Don't take the time to edit on the camera. Weddings move much faster than you realize, so shoot everything and carry as much memory as you can. I have shot over 1,000 images at a single wedding before!

✦ **Follow the bride.** Nothing at a wedding happens without the bride. No toasts, no cake cutting, no first dance. To make sure you get the important moments of the wedding, follow the bride.

✦ **Plan ahead.** Knowing the order of the events in the wedding will allow you to plan ahead and make sure you are in position for the important moments, like the first dance and bouquet toss.

✦ **Build the group portraits.** Put the bride and groom in the center, and then add people around them.

This keeps the couple as the center of attention for all the portraits.

✦ **Shoot the tables.** Nothing is worse than going through the photos after the wedding and realizing that you missed getting a shot with some of the guests. One quick tip to get around this takes a little help from the bride and groom: A great time for the newlywed couple to make the rounds is during the meal. After they have had a bite to eat, going from table to table to greet all the guests is a great time to get photos of the bride and groom with each table.

✦ **Soften the light.** Using a flash indoors creates flat, unflattering light with harsh shadows. The last thing you want at a wedding is unflattering light, and so this is a great time to use a diffuser either on the built-in flash or on an external flash unit.

✦ **Use your flash outside for fill light.** Using the flash outdoors helps reduce harsh shadows and creates a more even, pleasing light. I usually set the flash compensation to -1 or -2 so that the light from the flash isn't very bright and does not overpower the natural light.

Wildlife Photography

When it comes to animal photography, the same rules for photographing people apply: The eyes are the key to a great photograph. It makes no difference if the rest of the animal is in focus if the eyes are out of focus.

Shooting wild animals in their natural habitat takes lots of planning, equipment, and expense. Not many people get to go shoot animals on safari, but luckily there are alternatives. Modern zoos offer excellent opportunities to get close-up photos of wild animals in very convincing surroundings. Although it may take days or weeks to spot a particular animal in the wild, zoos offer you a variety of wildlife to choose from, so plan ahead and take your time. There is no need to rush; the animals and the zoo aren't going anywhere, and you can always revisit a display or come back at a later date.

Animals by nature avoid human contact in the wild, and even when they are in a zoo they tend to stay away from us. A key piece of equipment is a telephoto lens to let you get close to the animal without intruding on its space. And although a telephoto lens helps you get in close, there are still some barriers to capturing great animal photos in zoos, and those are literally the bars, glass, and physical barriers between the zoo animals and you.

6.74 This Malaysian tiger looks out from behind a tree at the San Diego Zoo. Taken at ISO 400, f/3.2, 1/125 second.

6.75 This Persian leopard was shot through a metal fence. By using a 200mm lens and an f/4 aperture, the fence disappears. Taken at ISO 400, f/4, 1/125 second.

One solution to shooting through bars and fencing is to use a lens with a focal length of at least 100mm, and shoot with the aperture wide open as close to the barrier as possible. When you focus on the animal, the shallow depth of field usually makes the barrier disappear.

Inspiration

Modern zoos and wildlife reserves let you travel the world in a single day, or even a single morning. From the plains of Africa where you can see the majestic elephants to the jungles of India where tigers roam, there is a wide variety of photographic subjects in a relatively small area.

There are also numerous photo safari trips where professional photographers and wildlife guides take you out and let you to shoot the animals in their natural environment. Programs like Moose Peterson's Wildlife Base Camp take photographers to locations around the United States shooting a variety of wildlife.

6.76 These elephants were photographed using a 300mm lens to fill the frame with just the gray hide and yellow tusks. Taken at ISO 100, f/3.2, 1/320 second.

Wildlife photography practice

6.77 A giant panda

Table 6.24
Taking Wildlife Photographs

Setup	**Practice Picture:** A giant panda hanging out at the top of her tree looking down at her visitors is shown in figure 6.77. I spent close to an hour waiting for her to roll off her back and look down. The hardest part was staying alert during the wait.
	On Your Own: Zoos have a wealth of photo opportunities, and planning ahead is important. If there is a special animal that you want to capture, go there first and find out the best times to photograph.
Lighting	**Practice Picture:** This photo was shot late in the morning. The panda had climbed to the top of a tree in the enclosure, and the angle of the shot was from below the tree shooting nearly straight up. Half of the panda's face was still in shadows, and the bright spots behind her made metering difficult.
	On Your Own: The advantages of shooting at a zoo are that the animals are easy to find, and as the sun moves across the sky, the lighting changes in the separate enclosures. Most animals spend the midday hours asleep, so chances are you will be shooting into shadows. Shooting in RAW mode lets you adjust the white balance after shooting.
Lens	**Practice Picture:** This shot was taken with a 70-200mm lens at the 200mm focal length. Being able to zoom in close to the panda's face was important because the rest of the bear was behind a tree trunk.
	On Your Own: The Sony 70-200mm f/2.8 G is the perfect lens for this type of photography, but any of the Sony zoom lens that can zoom out to 200mm, 250mm, or even 300mm will let you get in close.
Camera Settings	**Practice Picture:** Because the giant panda is black and white, I set the camera on Spot metering and took a reading on the area between the eyes. I used Spot metering to avoid using the bright areas behind the panda. I used the Aperture Priority mode, with the aperture set to f/2.8. This made for a shallow depth of field that kept the panda in focus but caused the branches in front of the bear to be nicely blurred. I set the ISO to 400 so that I could use a fast shutter speed to eliminate camera shake.
	On Your Own: Shooting at a zoo is a true balancing act between ISO, shutter speed, and f-stop. The light is out of your control, and because using a long lens requires a fast shutter speed, you must push the ISO and use as wide an aperture as possible. If you are shooting through a fence, use Aperture Priority mode to make sure that the fence disappears.

Exposure	**Practice Picture:** ISO 400, f/2.8, 1/1000 second.
	On Your Own: The shallow depth of field that an aperture of f/2.8 creates is very useful in removing unwanted elements from fences, cages, and other enclosures.
Accessories	A good pair of shoes and comfortable clothing are necessities for visiting the zoo because you want to be comfortable when spending a day walking around. A monopod is a great accessory to hold a long lens steady for extended periods of time, but check to make sure that the zoo allows their use.

Wildlife photography tips

✦ **Leave some space in front of the subject.** When framing an image, leave some space in front of the subject so that it looks like there is space for the animal to go. If the photo is cropped too close, the animal will seem to be trapped in the photograph, making for an awkward composition.

✦ **Use a large aperture to limit the depth of field to keep the focus on the animal.** The subject of your photograph needs to stand out from the background, and using a shallow depth of field helps with this.

✦ **Go early or late to the zoo.** Animals are more active in the early morning or late afternoon, and the crowds are usually smaller than during the middle of the day.

✦ **Check for special events or feeding times.** Check the schedule at the zoo for any special events and feeding times; these times make great photo opportunities.

✦ **Don't harass, tease, or torment the animals.** This holds true for pets, animals in the zoo, or any other animal at any time.

✦ **Check the Internet for information on the zoo before leaving home.** Modern zoos take advantage of the World Wide Web by posting their hours and exhibit details on the Internet. Use this information to help plan a successful trip to the zoo.

Pet Photography

Pet photography is a huge business, and photographers everywhere are starting to specialize in shooting pets, both on location and in the studio. Many people consider their pets as important members of the family. Shooting pets is very similar to shooting children, and some of the same techniques apply. The following list of helpful hints will make pet photography a little easier.

continued

continued

✦ **Think about personality.** Every pet, like every person, has a unique personality. A pet's personality is reflected in the behaviors and expressions of that animal. If the pet is yours, you already know the behaviors to watch for, but if you are photographing someone else's pet, ask them what separates their pet from all others.

✦ **Location, location, location.** At times it is easier to shoot a pet at their location. They are more likely to act in a natural way if in familiar surroundings.

✦ **Use a long lens.** Animals, just like humans, can react if their space is intruded upon. Using a longer lens helps you fill the frame with the pet, as it did with this cat.

✦ **Try a wide angle.** Shooting close with a wide-angle lens can add a slight amount of distortion to the photograph, and although this is not a good thing to try with humans, it can add to a pet photograph.

✦ **Get down to the pet's level.** Shooting at the pet's eye level lets you see the world from its perspective and produces better photographs.

✦ **Capture the action.** Using a fast shutter speed helps freeze the action of a dog or cat running or playing.

✦ **Shoot one shot with the owners.** Because pets are considered part of the family for most people, I usually try to get the owners to pose with the pet for a couple of photographs. Try to have the owners get down to the pet's level; this is a good time to shoot in Burst mode. The expressions on both the owner and the pet can change very quickly, and because there is no way to ask a dog or cat to smile for the camera, shooting four or five shots in a row is a good idea.

Viewing, Downloading, and Printing Your Photos

You have been out photographing all day, the memory card is nearly full, and you know you have captured some fantastic images. Now what? Having all of your images in the camera is one thing, but now it is time to do something with them.

One of the great advantages to digital photography is that images no longer need to be processed or printed before they can be viewed. Aside from viewing your images on the camera's 3-inch LCD screen, you can also look at your photos on a television or on a computer. You can also print photos directly from the camera or from the memory card. Using the PictBridge printer technology, images can be printed right from the camera when attached to a compatible printer.

Viewing Your Images on a Television

The A700 is manufactured by Sony, a leader in home electronics and televisions, and so it is no surprise that the A700 can easily connect to a television directly from the camera. The A700 not only connects to a regular television, but also to the newer HDTV sets.

Connecting to a regular television

The A700 connects to a regular television through the supplied mini USB-to-video-out cable.

1. **Make sure the camera is turned off.**

2. **Open the rubber cover on the left side of the camera that covers the HDMI Type C mini socket and mini USB port.**

3. **Insert the mini USB-to-video cable into the mini USB port.**

4. **Plug the yellow video RCA cable into a video-in jack on your television.**

5. **Turn the camera on.**

6. **Turn the television on and select the video input that matched the location where you plugged in the camera cable.** If needed, refer to your television manual on how to do this.

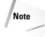Note *The camera cannot be plugged into a computer or printer and a regular television at the same time.*

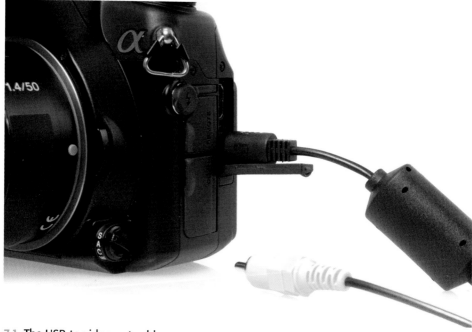

7.1 The USB-to-video-out cable

Pressing the Function button when there is an image on the television opens the rotate image screen. Pressing the multi-selector's center button rotates the image counterclockwise. The multi-selector or the Front or Rear control dials can be used to navigate through your images.

Connecting to an HDTV

High-definition television, or HDTV, is a digital television system with greater resolution than standard television. The HDTV standard aspect ratio is 16:9 and, not surprisingly, the A700 can be set to shoot in a 16:9 aspect ratio by using the aspect ratio menu. To connect your A700 to an HDTV, you need either the VMC-30MHD 10-foot HDMI mini cable or the VMC-15MHD 5-foot HDMI mini cable. Neither of these cables are supplied with the A700; they have to be purchased separately.

 Cross-Reference *For more information on setting the aspect ratio, see Chapter 2.*

1. **Make sure the camera is turned off.**

2. **Open the rubber cover on the left side of the camera that covers the HDMI Type C mini socket and mini USB port.**

3. **Insert the mini HDMI cable into the HDMI socket.**

4. **Plug the HDMI cable into an HDMI jack on your HDTV television.**

5. **Turn the camera on.**

6. **Turn the television on and select the video input that matches the HDMI location where you plugged in the camera cable.** If needed, refer to your television manual on how to do this.

Note *The A700 is the first camera to support Sony's new PhotoTV HD viewing standard. This standard is used when connecting the A700 to the Sony Bravia HDTV line of televisions. The latest generation of Sony Bravia televisions has specially optimized display modes that, according to Sony, "bring out every image detail and color gradation in high definition" when the A700 is connected.*

Viewing the images on a television

Once the camera is connected to a television, the LCD no longer displays any images or menus. Instead, all the information that would be displayed on the LCD is now displayed on the television.

Using the camera to display images

The controls on the camera that are used to review images on the LCD are the same controls that are used to review the images when connected to a television. Pressing the Playback button opens the last image taken. Once an image is on the screen, you have many options:

✦ **You can use the multi-selector or either of the control dials to navigate through your images.**

✦ **You can press the Display button to switch among the three view modes: Display with information, Display without information, and Display with the 5-image thumbnail.** Each time you press the Display button, the display cycles to the next display mode.

- **Display with information.** The image is overlaid with the file-name, file type, file size, shutter speed, aperture, ISO, date and time the image was recorded, and the image number / total images that are on the card. The type of storage, Compact Flash or Memory stick, is also displayed on the top-left corner of the image. The Front or Rear control dial or the multi-selector can be used to cycle through the images on the memory card.

- **Display without information.** In this mode, the image is displayed without any information at all. The Front or Rear control dial or the multi-selector can be used to cycle through the images on the memory card.

- **Display with 5-image thumb-nails.** In this mode, the display is broken into two parts: the thumbnail strip along the top and the main image on the bottom. Shutter speed, aperture, ISO, the date and time the image was taken, and the image number / total images taken are all displayed over the bottom of the main image. The Front or Rear control dial or the multi-selector can be used to cycle through the images on the memory card. The selected image will have a red line under it on the thumbnail strip.

✦ **You can press the Custom button to open the histogram view; pressing it again reverts back to the previous view.**

✦ **You can zoom in on any photo using the AM/MF button.** When in the Zoom mode, the Front control dial scrolls from one photo to the next, and the Rear control dial changes the percentage of the zoom. Pressing the multi-selector moves the zoomed image around within the LCD screen. Pressing the multi-selector's center button changes the display by showing the entire image with a red box located in the middle of the image. This red box is the area of the image that will be displayed when the multi-selector's center button is pressed a second time. The red box can be moved around the image by using the multi-selector to select the area of the image you want to look at closer. While in this mode, the Rear control dial changes the amount of zoom and graphi-cally shows this change by making the red box bigger or smaller. The Front control dial changes from one image to the next. Pressing the AM/MF button returns the view to the previous mode.

✦ **Pressing the Index button opens a thumbnail index screen.** This screen shows three columns of three images per screen. It is a fast and easy way to navigate through your images. You can use the multi-selector to navigate through the images and the multi-selector center button to select the high-lighted image. The Front control dial navigates among images, and the Rear control dial navigates by screen. You can also change which folder on the memory card is being viewed. When the folder icon on the left side of the screen is selected and the multi-selector

center button is pressed, you can change the folder using the multi-selector.

✦ **Pressing the Function button, when there is an image on the television, opens the rotate image screen.** Pressing the multi-selector's center button rotates the image counterclockwise. The multi-selector or either of the control dials can be used to navigate through your images.

✦ **The Delete button deletes the image that is on the screen.** After the Delete button has been pressed, a confirmation screen asks if the image should be deleted or if you want to cancel this action. After an image has been deleted, there is no way to get the image back. Making this action is something to seriously consider before executing.

Using the Remote Commander to display images

When the A700 is connected to a television, the included Remote Commander can control the playback. All of the functions available for image review and playback on the camera are available on the Remote Commander. There are separate buttons for all of the following functions:

✦ **Playback.** This button puts the camera into Playback mode and displays the last image taken.

✦ **Display.** Rotates through the three display modes.

 ● **Display with information.** Shows the image with shooting data.

 ● **Display without information.** Shows the image without shooting data.

 ● **Display with 5-image thumbnail.** Shows the image with a reduced set of shooting data but with a strip of thumbnails across the top. The thumbnails show the selected image plus the images on either side of it.

✦ **Selector.** These five buttons are used the same way as the multi-selector on the back of the camera.

✦ **Histogram.** Changes the display to the histogram view.

✦ **Index.** Changes the display to the index view.

✦ **Rotate.** Opens the rotate screen, which allows the user to rotate the image using the selector on the Remote Commander.

✦ **Zoom in / out.** Pressing the Zoom In button immediately displays a zoomed portion of the current image. The Zoom In / Out buttons can then be used to zoom in or out of the current image. The Playback button closes the Zoom mode and returns the display back to the last mode used.

✦ **Delete.** The Display button brings up the delete image screen.

Remote Commander has a Playback mode that is not available when using the camera.

✦ **Slide show.** The Slide show button starts an automatic slide show of the images stored on the memory card in the camera. Pressing the Display button during the slide show superimposes the date and time the image was taken and the number of the image / total images taken across the bottom of the display. The slide show automatically ends when all images have been viewed.

When the A700 is connected to an HDTV, it can simultaneously be connected to a printer using the USB connector. When this is the case, it is possible to print images while viewing them on the television. The Remote Commander has a Print button for this function.

 Note *It is important to remember that the remote sensor is on the front of the camera, and so the remote must face the front of the camera.*

Connecting to a Computer

You can get your images from the camera to the computer using two methods. The first is to connect the camera directly to the computer with the supplied USB cable. The second is to remove the memory card from the computer and use a separate card reader to transfer the images to the computer. Both methods allow you to copy the images stored on the CompactFlash card or Memory Stick Duo to the computer, and each have their own pros and cons.

Using the USB cable

Attaching the camera to a computer is as easy as plugging one end of the supplied USB cable into the camera and the other into the computer.

1. **Turn the camera on.**

2. **Press the Menu button.** Use the multi-selector to navigate to Setup menu 2.

3. **Select USB connection and press the multi-selector's center button, and make sure that the USB connection is set to Mass Storage.**

4. **Turn the camera off.**

5. **Open the rubber cover on the left side of the camera that covers the mini USB port and plug one end of the supplied USB cable into the camera.**

6. **Plug the standard USB plug into your computer.**

7. **If your computer is not on, turn it on, and then turn the camera on.**

7.2 The USB cable being used to connect the A700 to a computer

The camera is now connected to the computer and will be recognized as an external device. Use the computer's operating system to copy the image files from the camera to the computer. Some words of caution when using this method: Make sure the camera's battery is fully charged. If the battery runs out of power during the transfer, the photographs could be corrupted.

Using a card reader

The other method of transferring your image files to your computer is using a card reader.

1. **Turn off the camera.**

2. **Open the memory card cover by sliding it straight back towards the back of the camera.**

3. **Remove the CompactFlash card by pressing the CompactFlash card eject lever, or remove the Memory Stick Duo by pressing down on the actual Memory Stick Duo; this ejects the Memory Stick Duo.**

4. **Plug the card reader into the computer using the directions that came with the card reader.**

5. **Insert the memory card into the reader until it is firmly seated.**

With the card reader connected to the computer, the memory card is recognized as an external device. Use the computer's operating system to copy the image files from the camera to the computer. There are a variety of card readers on the market — in all shapes, sizes, and prices.

7.3 A Lexar Professional UDMA FireWire card reader connected to a laptop

Connecting to a Printer

The A700 uses the PictBridge technology to enable printing directly from the camera. PictBridge is a standard technology that is used by many of today's printer and camera companies.

To print directly from the camera, follow these steps:

1. **Turn the camera on.**

2. **Press the Menu button.** Use the multi-selector to navigate to Setup menu 2.

3. **Select the USB connection and press the multi-selector's center button, and make sure that the USB connection is set to PTP mode.**

4. **Turn the camera off.**

5. **Open the rubber cover on the left side of the camera that covers the mini USB port and plug one end of the supplied USB cable into the camera.**

6. **Plug the standard USB plug into your PictBridge-enabled printer.**

7. **If your printer is not on, turn it on, and then turn the camera on.**

When the camera is connected to a PictBridge printer, the LCD shows the last photo taken. You can use the multi-selector to navigate through the images stored on the memory card. Pressing the multi-selector center button marks an image for printing. Pressing the Menu button opens the Print menu.

Remember that RAW images cannot be printed using PictBridge printing. If you plan on printing directly from the A700, make sure you are shooting in JPEG or in RAW & JPEG mode.

Print menu 1

Pressing the Menu button when the camera is connected to a printer brings up the Print menu 1.

✦ **Print.** This prints the selected images.

✦ **Set Print Quantity.** You can print up to 20 copies of each image.

✦ **Paper size.** This is dependant on the printer connected. The A700 can print images from 3.5 × 5 inches up to 11.7 × 16.5 inches as long as the printer supports the paper size.

✦ **Layout.** The layout default is Auto, but it can be set for any of the following:

• **Auto.** This uses the printer setup to determine the layout.

• **1-up / Borderless.** Borderless, 1 image per sheet.

• **1-up.** 1 image per sheet.

• **2-up.** 2 images per sheet.

• **3-up.** 3 images per sheet.

• **4-up.** 4 images per sheet.

• **8-up.** 8 images per sheet.

• **Index.** This prints all the selected images and an index print using the setup from the printer.

✦ **Date Imprint.** The date and time of the photo can be attached to the image. Make sure to turn this off if you don't want the date and time printed.

Print menu 2

Pressing the Menu button when the camera is connected to a printer brings up the Print menu 1. Use the Multi-selector to navigate to Print menu 2. Pressing the multi-selector's center button selects Print menu 2.

✦ **Unmark All.** This menu choice clears all selected images.

✦ **Folder Print.** This prints all the images in a selected folder.

Appendixes

Camera Care

Your camera is a tool and is meant to be used. However, like all well-loved tools, it gets dirty with use. So, good cleaning habits help keep your camera and lenses in good working order for many years and let you get the most out of your investment.

Today's cameras are built tough, and the Sony Alpha A700 is no exception. The body is a combination of an aluminum chassis and a magnesium body, and the buttons and levers are sealed to protect against dust and moisture.

Dust is one thing that can cause a great photo to be unusable. The A700 has both a static-free anti-dust coating on the sensor and an anti-dust vibration system that automatically vibrates the sensor to dislodge any dust every time the camera is turned off. But even with these new advances, dust can still get into the camera and on the sensor while you are shooting. The two places that dust can settle that will cause you the most problems are on the lens and on the sensor. Back in the days of shooting with film, cleaning lenses was the most important thing because each photograph was a brand new piece of film being moved through the camera. This meant that even if dust got into the camera, it would only affect one frame. In digital cameras, the sensor doesn't change, so any dust that gets on the sensor affects every photograph taken after that point.

AA.1 The red circles mark where dust and dirt in the camera have made their way onto the final image.

Preventing Dust from Entering the Camera Body

Dust enters the camera body when the lens has been removed and the camera body is open to the elements. The most important thing you can do as a photographer is to be careful when you change lenses.

Camera manufacturers recommend never changing the lenses when dust is present. This is not always possible, and so there are a few techniques that can help reduce the amount of dust and dirt that enters the camera body.

✦ **Point the camera down.** When changing the lens, hold the camera pointed towards the ground to cut down on the amount of dust that can enter the camera body.

✦ **Use your body.** Keep the camera close to your body when changing lenses to help block any wind from blowing dust and dirt into the camera body.

✦ **Check the lens.** Make sure that there is no dirt, dust, or anything else on the lens, especially the rear part that attaches to the camera.

✦ **Use your car or an inside location.** When shooting in a dusty or sandy location, make a trip back to your car or inside a building before changing lenses. It is still important to point the camera body down to keep it as dust free as possible.

cards and the photo files are being downloaded, I make it a point to take that time to wipe off the camera and any lenses that I used. I use a soft cloth to remove the surface dirt and grime so that over time it does not build up and work its way into the camera body.

AA.2 Keep the camera pointed down when changing lenses.

Cleaning the Lenses

The first thing I do when I get a new lens is purchase a new filter for the front element. Sony sells a line of filters made especially for this purpose: the Multicoat Protector line of filters. Local camera stores also carry a range of filters that can be used. These filters help protect the front element from dirt, scratches, and dust; and because they can be replaced when damaged, they help prolong the life of the lens.

The basic lens-cleaning tools are a hand blower, lens-cleaning solution, a microfiber cloth, and canned air if necessary.

Cleaning Your Gear after Shooting

Part of my post-shooting workflow is to clean off the camera and lenses that I just used. This keeps the gear nice and clean so that the next time I grab the camera and lenses, they are ready to use. While the computer is reading the CompactFlash

AA.3 The Sony Multicoat Protector line of filters is manufactured by Carl Zeiss for optimum image quality while they protect the front of the lens. Here one is attached to the Sony 55mm f/1.4 lens.

Caution *When using the canned air to blow dust from a lens, never blow directly at the glass elements, but instead blow across the glass. The high pressure of the compressed air can damage the glass.*

The first step is to dislodge any surface dust and dirt. I use a hand blower on both the front and back elements of the lens. This should dislodge dust and dirt that is on the lens; if the hand blower doesn't seem to have enough power, use the canned air carefully. Fingerprints and basic smudges can be removed by using a microfiber cloth to wipe the dirt away in a circular motion.

If the lens is still dirty after this, special lens-cleaning solutions can help get rid of the stubborn dirt problems. I use a Zeiss lens-cleaner solution, but there are plenty of good products available in any good camera store. Spray the solution onto a clean cloth, and then use the cloth to wipe the lens element clean.

Caution *Never apply any liquid cleaners directly to your lenses or camera.*

Cleaning the Mirror

This is something everyone wants to do, but usually for the wrong reasons. Any dirt and dust on the mirror does not end up in the photograph; the mirror is moved up and out of the way before the shutter is opened. The only reason to clean the mirror is to keep the dust and dirt from moving off the mirror and onto the sensor. Remember that it is

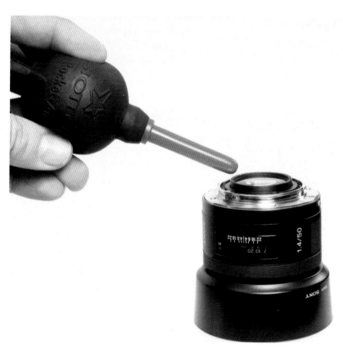

AA.4 Giotto's Rocket Air Blaster is a great tool for removing dust and dirt from the lens. Here one is being used to gently blow the dust and dirt from the rear element of a lens.

not necessary to clean the mirror, and more importantly, the mirror is a delicate part of the camera that can be damaged if treated incorrectly. The only tool I ever use to clean off the mirror is a hand blower to gently blow the dust and dirt off of it.

Hold the camera upside down and look up into the body. Be careful not to touch the mirror with the end of the blower, and gently blow the dust off the mirror. By holding the camera upside down, the dust that is blown loose falls out of the camera and does not end up back in the camera on the sensor.

Cleaning the Sensor

The sensor on the A700 is covered by a static-free anti-dust filter that was made to repel dust and keep the sensor clean. Sony has also equipped the A700 with an anti-dust mechanism that vibrates the sensor to dislodge dust every time the camera is turned off. These two safeguards help keep the A700 free of dust on the sensor, but no system is perfect, and there may come a time when you need to clean the sensor.

If dust and dirt does happen to get onto the sensor, you can clean the sensor in the following manner.

1. **Make sure the battery is fully charged.** It is important that the camera does not lose power during the cleaning. Make sure that the battery shows at least three stripes on the battery display. If the battery does not have enough power, the camera will not go into the Cleaning mode. If you have the optional AC adaptor, use that instead.

2. **Select Cleaning mode.** Press the menu button and then use the multi-selector to navigate to Setup menu 3. Then use the multi-selector to navigate to the Cleaning mode. Press the multi-selector center button to start the Cleaning mode.

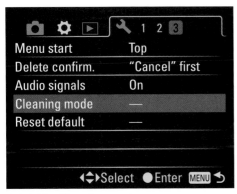
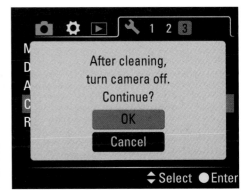

AA.5 The Cleaning mode menu

3. **Start the Cleaning mode.** When the camera displays "After cleaning, turn camera off. Continue?" use the multi-selector to choose between the default OK or Cancel. The image sensor vibrates for a short time to dislodge any loose dust on the sensor, and then the mirror is lifted out of the way.

4. **Remove the lens.** Carefully remove the lens while keeping the camera body pointed towards the ground.

5. **Making sure not to touch the sensor, clean off the sensor and the surrounding areas using a hand blower.** This part needs to be done as quickly and carefully as possible.

Caution *Do not use compressed air or a spray blower to clean inside the camera because both of these can introduce vapor into the camera body. Do not insert a hand blower (or any blower) into the camera body past the lens mount. There is no reason to get that close to the sensor.*

6. **Once you are done cleaning, simply reattach the lens and turn the camera off.** This is all there is to cleaning the A700.

If after doing all the cleanings there is still dirt and dust in the camera, it is time to send the camera off to Sony to have it professionally cleaned and serviced.

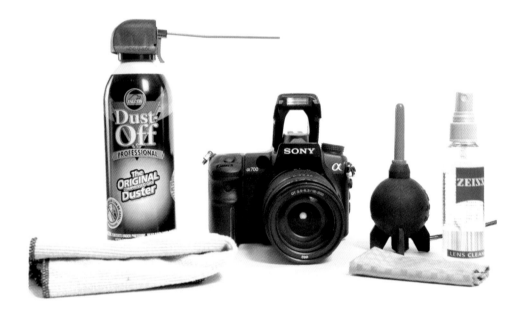

AA.6 The A700 with the basic cleaning tools: Compressed air, a Giotto's Rocket Air Blaster, Zeiss lens-cleaner solution, a microfiber cleaning cloth, and a lint-free cleaning cloth.

Editing Software Options

In this age of digital photography, taking the photo is only part of the process. Once you take the photos, you have to decide what to do with them — will you print them straight from the camera, take the memory card to a professional for printing, or download the images to your computer for reviewing and editing before you print them? If you intend to download them, you have many choices when it comes to the software that you can use to review and edit your photos.

Sony Software

The A700 comes with three software programs for both Apple- and Windows-based computers. The three programs are Image Data Lightbox SR, Image Data Converter SR ver2, and Remote Camera Control. The following sections take a brief look at each of these and their uses.

Image Data Lightbox SR

The Sony Image Data Lightbox SR software is used to view, compare, sort, label, and rate images on your computer. You can compare images to each other and rank each photo with a 5-star rating system. If you need to edit individual files, you can do this with Image Data Converter SR, and when you save your changes, they are automatically updated in the Image Data Lightbox SR software.

Although this program is not as complete or as powerful as Adobe Photoshop Lightroom or Apple Aperture, it is free, and you can use it to launch both the Image Data Converter SR and the Remote Camera Control software.

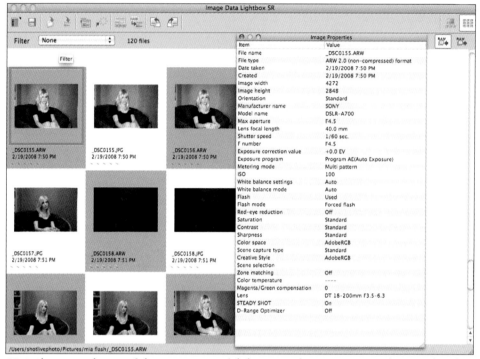

AB.1 The screen layout of the Image Data Lightbox SR software program, showing the file information panel

The Image Data Lightbox SR software does not have any way to transfer images from the memory card to the computer.

Image Data Converter SR

Sony developed the Image Data Converter SR software for photographers who shoot and save their images using the Sony RAW format. The Image Data Converter SR or IDC SR software has some advantages over any other RAW conversion software because it gives a complete set of image controls that match the settings of the camera.

The real power comes in from the three adjustment palettes.

Adjustment 1

The first palette (Adjustment 1) lets you adjust the white balance, hue, and saturation.

You can set the white balance either with the value that the camera records at the time the photograph is taken – Camera setting – or by changing it to a preset value that matches those available in the camera – Preset. You can also set the white balance by setting a specific color temperature by either using a slider or by entering a value directly. If those three methods weren't enough, it is also possible to set the white balance by specifying a gray point in the image and having the software calculate the white balance. The gray point can either be selected with an Eyedropper tool to choose

a specific point or with a selection box that uses a user-defined area. After the white balance has been set, the overall color can be adjusted using the color correction slider. Using the slider, the color can be adjusted by either adding green by moving the slider to the left, or by adding magenta by moving the slider to the right.

The hue of the image can be adjusted using the slider or by entering a value between -100 and +100 directly. Changing the hue shifts all the colors in the image towards red when moved to the left and towards green when moved to the right. Clicking the

camera setting button returns the value to the one set in the camera when the image was taken.

The saturation of the image can be adjusted by entering a value between -100 and +100 or by moving the sliders. Moving the slider all the way to the left, or entering -100, removes all the color from an image, creating a black-and-white image. Moving the slider to the right adds saturation and causes the image to appear more vivid. Clicking the camera setting button returns the value to the one set in the camera when the image was taken.

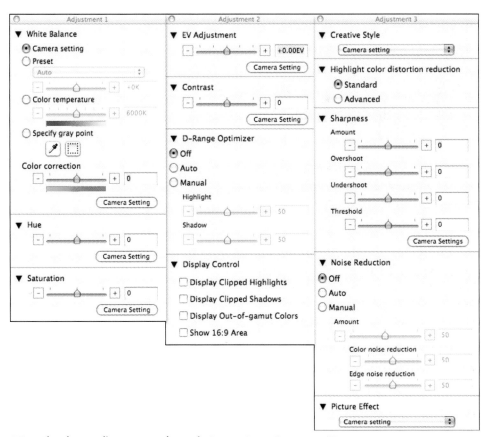

AB.2 The three adjustment palettes in Image Data Converter SR

Adjustment 2

The second adjustment palette (Adjustment 2) enables you to adjust the exposure value (EV Adjustment) and Contrast. You can set the D-Range Optimizer to Off, Auto, or Manual. The Manual option then allows you to adjust the highlights and shadows.

You can also use this palette to set the display to control aspects of what is displayed. You can choose

✦ **Display Clipped Highlights.** Areas in your photo that are pure white will show up in magenta. This is helpful when trying to avoid bright spots in your photo.

✦ **Display Clipped Shadows.** Areas in your photo that are pure black will show up in yellow. This is helpful when trying to find areas that are too dark.

✦ **Display Out-of-gamut Colors.** Areas in your photo that have colors that cannot be displayed correctly will show up in gray.

✦ **Show 16:9 Area.** When selected, the display will superimpose bars on the top and bottom of the image to display the image as if it had been taken using the 16:9 aspect ratio.

Adjustment 3

The third adjustment palette (Adjustment 3) holds the Creative Style menu that lets you assign any of the Creative Styles to the image. These are the same 11 Creative Styles that are available in the camera, but changing the Creative Style resets all of the settings to the camera default except the tone curve. The Highlight color distortion reduction setting is set to Standard by default but can be changed to Advanced,

which helps to reproduce highlights in your photo with a more natural color. Adjusting the sharpness is done with four separate sliders.

✦ **Amount.** Dragging the slider to the right increases the overall sharpness of the image, while dragging it to the left reduces the sharpening.

✦ **Overshoot.** Adjusts the amount of sharpening in the overshoot direction.

✦ **Undershoot.** Adjusts the amount of sharpening in the undershoot direction.

✦ **Threshold.** Sets the amount of difference that needs to occur between two colors before the sharpening amount will be applied.

Noise reduction can be applied to the image automatically or by manually setting the amount of Color noise reduction and Edge noise reduction.

 Caution

Applying noise reduction to an image can cause deterioration of the overall image quality.

You can assign one of four different Picture Effects: Sepia, B&W, Solarize, or Negative.

Other features

In addition to the three adjustment palettes, there are also palettes that show a navigator for navigating around the image and a Histogram palette that shows histogram data for an image. One of the really nice features is the Image Properties palette. This shows all the shooting data for the selected image, from the name and time the image was created to whether or not the flash was used and what other settings were applied to the image at the time it was taken. This

information is key in the learning process; knowing what settings produced an image makes it easier to produce that image or type of image again.

Edited images can be saved as JPEG, TIFF, or ARW (the Sony RAW file type) files. This is important because Web browsers, e-mail clients, and many print order companies need the photograph files to be in the JPEG file format.

Remote Camera Control

The Remote Camera Control software allows you to connect the camera to a computer with the included USB cable.

To attach the camera to the computer, set the USB connection type in the Setup menu 2 to Remote PC mode. Then plug the included USB cable into the camera and into a USB port on the computer. After the camera is attached, the Remote Camera Control can be started.

You can use the remote software to shift the camera controls from the camera to the computer. The software allows you to change any of the following:

✦ **Drive mode.** You can select a drive mode from the drop-down list. Each of the camera's drive modes, including the bracketing modes, is available in this list.

✦ **White balance.** The drop-down list of white balance presets matches the settings in the camera's White Balance menu. The menu has the following choices:

 • Auto WB

 • Daylight

 • Fluorescent

 • Tungsten

 • Flash

 • Cloudy

 • Shade

 • Color Temperature

 • Custom 1 – 3

✦ **Color temperature.** When the white balance is set to Color Temperature, the actual temperature can be set manually from 2500K to 9900K.

✦ **Color filter.** When the white balance is set to Color Temperature, you can set a color filter from M9 to G9.

✦ **D-Range Optimizer.** You can set the D-Range Optimizer to the camera-supported modes here.

✦ **Quality.** You can select the desired file format from the drop-down list. The file formats match the capabilities of the camera.

✦ **Image size.** When the Image quality is set to the JPEG file type, you can set the size of the file to L, M, or S here.

✦ **Aspect ratio.** You can select supported camera aspect ratios here.

✦ **Save location.** This is the location to which the computer saves the files while it controls the camera. This does not use the memory card in the camera.

✦ **Open in Image Data Lightbox.** After the image has been taken, you can open it and edit it using the Sony Data Lightbox software.

When the Shutter button on the screen is clicked, the camera takes a photo and the image file is saved to the computer.

Other Software Options

Many great software programs are available for sorting, editing, and viewing digital photographs. Adobe has long been considered the leader in photo-editing software, and their flagship photo-editing software, Adobe Photoshop, is the most widely used software for photo editing and correcting. Adobe also produces two other programs for photographers: Adobe Photoshop Lightroom and Adobe Photoshop Elements.

Adobe Photoshop

There are hundreds of books, videos, and online training programs that explore every aspect of Adobe Photoshop. Adobe Photoshop is actually made up of three parts: Bridge, Adobe Camera Raw, and Photoshop. The three programs work together as a complete editing suite. Adobe Photoshop CS3 is available as a free 30-day demo at www.adobe.com.

Bridge

Bridge works in the same way as the Sony Image Data Lightbox software and acts as a great starting point for editing your photographs. One great thing about Bridge is the Get Photos from Camera import feature. You can set this photo importer to launch any time a camera is connected to the computer, making the transfer of your photos from the camera to the computer very easy.

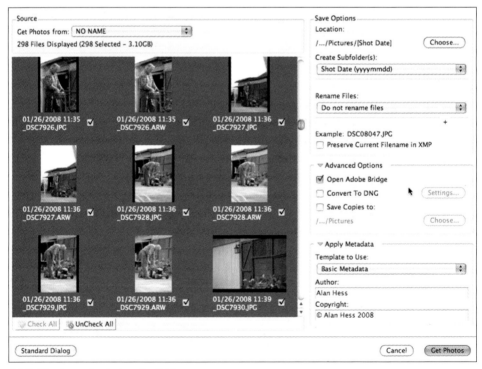

AB.3 The Import window in Bridge

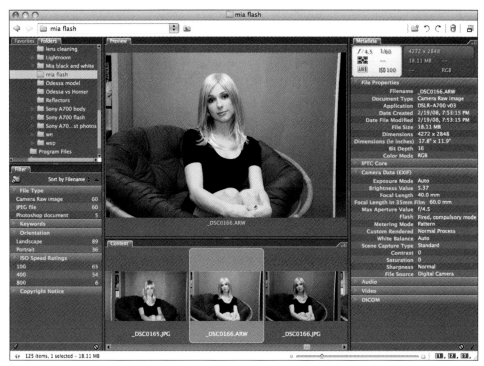

AB.4 The main Bridge display

After the images have been imported from the camera to the computer, Bridge functions as a file browser that also lets you sort, rate, organize, and label your images. You can select and open images (even JPEG images) in Adobe Camera Raw from Bridge.

Each image can be rated with a star system, color-coded, and sorted by a variety of criteria including image orientation, ISO, and more.

Adobe Camera Raw

Adobe Camera Raw or ACR is the software that converts raw images into a format that Adobe Photoshop can use. The A700 uses a RAW format that needs ACR 4.3.1 or later.

Because ACR works with all image files from all camera manufacturers, some of the features available in the Sony Image Data Converter SR are missing. ACR has no D-Range Optimizer and does not have the ability to change the aspect ratio after the image has been taken. A real bonus to using ACR, however, is the ability to adjust the white balance not only of RAW files but also of JPEG files. This makes it possible to save images that previously would have taken hours to fix in Photoshop.

After any adjustments have been made to the photo in ACR, the file can then be opened in Adobe Photoshop.

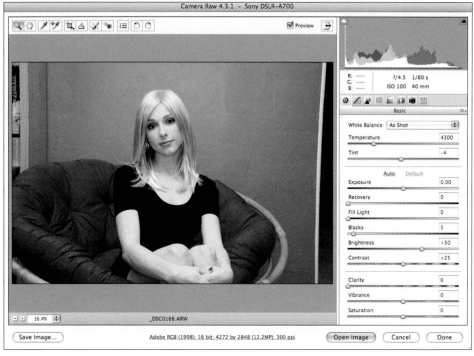

AB.5 The Adobe Camera Raw work space

Photoshop

When it comes to photo editing, Photoshop can do it all. If you are going to do any serious photo editing, this is the program to use. Photoshop can make the smallest color adjustments or completely change the image. Due to the huge number of powerful tools and image-processing power in Photoshop, the learning curve is quite steep. However, many books and tutorials are available to help even true beginners find their way around.

Adobe has also created a scaled-down and much less expensive version of Photoshop called Adobe Photoshop Elements.

Adobe Photoshop Elements

Photoshop Elements lets you download your images from the camera and view them in a media browser. The images can be tagged with custom keywords, ratings, and labels for easier searching and retrieval of your images.

Photoshop Elements has a new Stacks feature, letting you keep images shot of the same scene together, or you can reject images to hide them from view. Photoshop Elements has a set of 1-click fixes that perform common image fixes quickly and easily.

AB.6 Photoshop CS3 work space

Elements also lets you present your images in many ways. Producing photo books, scrapbook pages, online albums, cards, and CD/DVD labels is simple. Customized layouts and colors can be used along with text and text effects like drop shadows.

Adobe Photoshop Lightroom

Adobe Photoshop Lightroom, or Lightroom for short, is a relatively new program. It was released as a free beta program for Apple Macintosh computers in January of 2006. It was the first Adobe product released to the general public during development. The final product was released in February 2007.

The feedback from actual working photographers during the development created a program that could be a complete digital darkroom solution.

Lightroom is divided into five modules: Library, Develop, Slideshow, Print, and Web. Lightroom also has a complete Import feature that copies the images from your camera or memory card to your computer. Lightroom lets photographers import, sort, organize, edit, and output professional results all from one program.

The Library module is where the sorting and organizing of your photos takes place. You can associate keywords with images, add color labels, rate images with 1 to 5 stars,

and flag an image as a keeper or reject it. Images can also be sorted into collections, and the same image can actually be sorted into numerous collections; an image of a tiger can be sorted into a wildlife collection and a San Diego Zoo collection. This is a very powerful tool that makes finding photos later much easier than trying to remember when or where the image was taken.

Making adjustments to your photographs in Lightroom is similar to using Adobe Camera Raw because Lightroom uses the same Adobe Camera Raw processing engine that Photoshop has. Adjustments are made in the Develop module, and as with processing any RAW image, the changes are not made to the actual image file but are a set of instructions on how to treat the image written to a separate file. What this means in practical terms is that the original file can be used to create different images with different settings without doing any damage to the RAW file.

The Slideshow, Print, and Web modules all create different output from your images. The professional Web galleries, print packages, and slide shows are all customizable to a high degree, and there is a huge number of free templates on the Internet.

Adobe Photoshop Lightroom is available as a free 30-day demo at www.adobe.com.

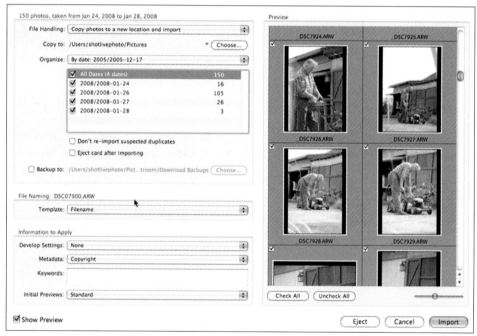

AB.7 Adobe Photoshop Lightroom photo import window

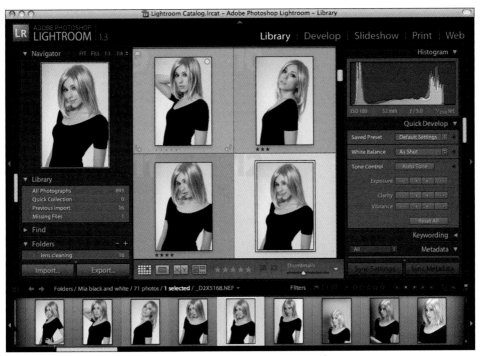

AB.8 Adobe Photoshop Lightroom main work space module

Apple Aperture

Aperture 2.0 is the professional photography post-production tool from Apple. Aperture lets you import, manage, edit, catalog, organize, publish, and save your images. Aperture works only on Apple computer systems. Aperture 2.0 or higher along with Mac OS Tiger v10.4.11 or Mac OS Leopard v10.5.2 or later is needed to process A700 files. When your camera is attached to the computer or a memory card is inserted into a connected card reader, Aperture automatically brings up an import window that lets you decide not only the location to save the image files, but it also lets you add copyright info, keywords, and other metadata.

Aperture 2.0 has an all-new image-processing engine that offers a complete set of RAW adjustments. You can recover details in both the shadows and highlights; remove small blemishes; and adjust the color, white balance, and exposure. As when working with any RAW file, the original image is not harmed by any of the adjustments.

Where Aperture really shines is in the features not found in other products. One of those features gives you the ability to sort your images like you would on an old-fashioned light table. The Light Table view lets you add, resize, and sort your images as if you were working on a light table, and no light table would be complete without a loupe. Aperture has a great loupe that can

AB.9 Aperture work space showing the loupe feature to get a 100% preview of the model's eye

AB.10 Aperture's Light Table mode

be used at any time to get a 100% view of any image on the screen. This lets you check the sharpness of the image at any time, a great feature for quickly deciding whether or not the image is a keeper. Aperture also has the built-in ability to use two monitors, with the second monitor showing a 100% preview of any selected image.

Aperture 2.0 is available as a free demo from Apple at www.apple.com.

iPhoto

Apple's iPhoto is part of the iLife product line and is free on every new Apple computer. With iPhoto '08 and Mac OSX Leopard 10.5.2, iPhoto has the ability to process not only JPEG images, but Sony RAW images as well. iPhoto imports and sorts images automatically and allows you to sort photos into user-defined albums. Apple iPhoto has one feature that none of the other programs have and that is the ability to not only order prints directly from Apple, but to order a variety of products including calendars, cards, and photo books. iPhoto also makes it easy for users to select photos to automatically attach to e-mails or upload to .Mac galleries. Ordering products; printing, editing, and attaching photos to an e-mail; and uploading photos to a Web gallery are all easily done by clicking the dedicated button on the bottom of the user interface.

Images that are part of the iPhoto library can also be used system-wide on the Apple computer as screen savers, backgrounds, and slide shows. The new Apple TV product also displays images from the iPhoto library on any television that the Apple TV is connected to.

AB.11 The iPhoto user interface

Photo Mechanic

Photo Mechanic software is produced by Camera Bits and is used to import images from a camera or memory card reader to the computer. Because the Sony software that comes with the camera does not have any way to automatically import photos, you can use this program instead.

The import function lets you copy the images to two separate locations at the same time; rename the photos on import; and apply keywords, copyright, shooting data, and captions when the images are imported.

The Photo Mechanic software shows the images in a Contact Sheet view, which allows you to sort the images, and if a RAW image needs to be edited, Photo Mechanic launches the Sony Image Data Converter SR automatically.

Photo Mechanic is available as a free demo that you can try before you buy at www.camerabits.com

Glossary

Adobe RGB A color space created by Adobe to more closely match the output of inkjet printing devices. Also see *color space* and *sRGB*.

AE lock Pressing the camera's AE lock button locks the current exposure and lets you recompose the scene without changing the exposure.

AF (auto focus) lock The focus can be locked by either pressing the Shutter button halfway down or by setting the AF/MF button to act as a AF lock button in Custom menu 1. When the focus is locked, the camera can be moved but the focus will not. The focus stays locked until the shutter is released or the Shutter button is released. This allows the scene to be recomposed without changing the focus.

ambient light The natural light in the scene, also referred to as available light.

angle of view The amount of the scene in front of the camera that a specific lens sees.

aperture The lens opening that the light passes through before reaching the sensor in the camera. The aperture can be adjusted by controlling the diaphragm by changing the f-stop. This is expressed as f/number—for example, f/5.6.

Aperture Priority mode In this mode the photographer sets the aperture and the camera sets the shutter speed.

artificial light Any light that the photographer introduces into a scene.

aspect ratio The proportions of the image captured by the camera, calculated by dividing the width of the image by the image height. The A700 can save images in the standard 3:2 aspect ratio and in the HDTV aspect ratio of 16:9.

Auto adjustment mode In this mode the camera sets the shutter speed, aperture, and ISO to achieve the correct exposure.

auto focus The camera automatically adjusts the focus depending on which focus sensor is selected. The auto focus on the A700 can be started by either the Eye-Start sensor or by pressing the Shutter button halfway down.

auto focus illuminator A built-in red light that illuminates the scene, helping the camera achieve focus when there is not enough ambient light present.

backlighting A method of lighting where the main light is placed behind the subject. Also see *silhouette*.

barrel distortion An effect that causes straight lines to bow outward, especially at the outer edges of the frame. This effect is more pronounced when using wide-angle lenses.

bounce light Light that is bounced off a surface before hitting the subject to create a more flattering light source. This is used mainly with a dedicated flash unit that can be aimed at a wall or ceiling.

bracketing A method in which multiple exposures are taken, some below and some above the recommended exposure. The A700 can also bracket the white balance and the D-Range Optimizer settings.

buffer The camera's built-in memory that is used as a temporary storage before the image data is written to the memory card.

bulb A shutter speed setting that keeps the shutter open as long as the Shutter button is held down.

camera shake The small movements of the camera that can cause blurring, especially when the camera is being hand-held. Slower shutter speeds and long focal lengths can contribute to the problem.

Center-weighted metering The entire scene is metered, but a greater emphasis is placed on the center area.

CMOS Complementary Metal Oxide Semiconductor. The type of image sensor in the A700.

color cast An overall look or predominant color that affects the whole image. Color casts are usually brought about by an incorrectly set white balance. Also see *cool* and *warm*.

color space A description of the range of colors that can be displayed accurately by the current device. See also *Adobe RGB* and *sRGB*.

color temperature A description of color using the Kelvin scale. See also *Kelvin*.

colored gel filters Colored light modifiers that when placed between the light source and the subject change the color of the light hitting the subject.

compression Reducing image file size by either removing information (lossy compression) or writing the information in a form that can be re-created without any quality loss (lossless compression).

Continuous Auto Focus mode A mode in which the camera continues to refocus while the Shutter button is held halfway down. This is the best Focus mode for moving subjects.

contrast The difference between the highlights and the shadows of a scene.

cool A descriptive term for an image or scene that has a bluish cast.

crop To cut off or trim one or more of an image's edges. When the A700 is set to the 16:9 aspect ratio, the image is being cropped by removing data from the top and bottom of the scene.

dedicated flash A flash unit that works with the A700.

depth of field (DOF) The area of acceptably sharp focus in front of and behind the focus point.

diaphragm An adjustable opening in the lens that controls the amount of light reaching the sensor. Opening and closing the diaphragm changes the aperture.

diffused lighting Light that has been scattered and spread out by being bounced off a wall or ceiling or shot through a semiopaque material, creating a softer, more even light. Diffused lighting can also be sunlight shining through the clouds.

digital noise See *noise*.

diopter A unit of measurement used in the making of corrective lenses. The A700 has a diopter adjustment so that people who need corrective glasses can use the viewfinder without glasses.

exposure The amount of light that reaches the sensor.

exposure compensation A method of adjusting the exposure so that it differs with the metered reading.

exposure metering Using the light meter built into the camera to determine the proper exposure. See also *Metering modes*.

fast A description referring to the maximum aperture of a lens. Lenses with apertures of f/2.8 and higher are considered fast lenses. See also *slow*.

fill flash A method where the flash is used to reveal details in shadow areas that would usually be lost.

filter A glass or plastic cover that goes in front of the lens. Filters can be used to alter the color and intensity of light, add special effects like soft focus, and protect the front elements of the lens.

flash A device that produces a short bright burst of artificial light. The word *flash* can be used to describe the unit producing the light or the light itself.

flash compensation An adjustment that changes the amount of light produced by a flash independently of the exposure settings.

flash sync The method by which the flash is fired at the moment the camera shutter is opened.

flat A description of an image or scene that has very little difference between the light values and the dark values. An image or scene with low contrast.

focal length The distance from the optical center of the lens when it is focused at infinity to its focal plane (sensor), described in millimeters (mm).

focal plane The area in the camera where the light passing through the lens is focused. In the A700 this is the digital sensor.

focus The adjustment of the lens to create a distinct and clear image.

focus lock The focus is set and does not change even if the scene is recomposed.

front lighting A method of lighting where the main light is placed directly in front of the subject.

f-stop A measure of the opening in the diaphragm that controls the amount of light traveling through the lens. See also *diaphragm*.

gigabyte A unit of measurement equaling 1 billion bytes. Used in describing the capacity of the memory cards used in digital photography.

high contrast A description of an image or scene where the highlights and shadows are at the extreme differences in density.

high key A description of a photograph with a light tone overall.

histogram A basic bar graph that shows the amount of pixels that fall into each of the 256 shades from pure black to pure white. The histogram view on the A700 also shows the values of the red, green, and blue color channels.

hot shoe The camera mount on top of the viewfinder that accepts Sony flash accessories. The hot shoe on the A700 is a proprietary design and does not accept standard hot shoe accessories designed for other manufacturers.

image rotation The ability of the camera to recognize the orientation in which the photo was taken and to display the image in the correct orientation when viewing it on the LCD.

ISO International Organization for Standardization. An international body that set standards for film speeds. The standard is also known as ISO 5800:1987 and is a mathematical representation for measuring film speeds.

ISO sensitivity The light sensitivity of image sensors in digital cameras are rated using the standards set for film. Each doubling of the ISO makes the sensor twice as sensitive to light, meaning that in practical purposes, an ISO rating of 200 needs twice as much light as an ISO of 400.

JPEG Joint Photographic Experts Group. The most commonly used and universally accepted method for image file compression. The JPEG is a lossy form of compression, meaning that information is lost during the compression. JPEG files have a .JPEG file extension. See also *lossy*.

Kelvin Abbreviated with K, it is a unit to measure color temperature. The Kelvin scale used in photography is based on the color changes that occur when a theoretical black body is heated to different temperatures.

LCD (Liquid Crystal Display) The type of display used on most digital cameras to preview your photos and display menus and shooting data. The 3-inch screen on the back of the A700 has a resolution of 640 × 480.

light meter A device used to measure the amount of light in a scene. The readings from the light meter can be used to determine what settings produce a proper exposure. The A700 has a built-in light meter.

lossless A form of computer file compression that allows the original data to be reconstructed without losing any of the information. This is useful when it is important that no changes are made to the information. See also *compression* and *TIFF*.

lossy A form of computer file compression that reduces the file size by removing data. The file will not be an exact match to the original file but close enough to be of use. This form of compression suffers from generation loss. Repeatedly compressing the same file results in progressive data loss and image degradation. See also *compression* and *JPEG*.

low key A description used to describe a photograph with a darker tone overall.

macro lens A specialty lens that allows for extreme close-ups with a reproduction ratio of 1:1, creating life-size images.

Manual exposure mode In this mode, the photographer determines the exposure by setting both the shutter speed and the aperture.

megapixel A description referring to the amount of pixels that a digital camera sensor has. 1 megapixel is equal to 1 million pixels.

memory card The removable storage device that image files are stored on. In the A700 the memory card can be either a CompactFlash card or a Memory Stick Duo.

Metering modes The method the camera uses to determine what light to use in the metering process. See *Multi-segment metering*, *Center-weighted metering*, and *Spot metering*.

middle gray A tone that represents 18-percent reflectance in visible light. All reflective light meters, including the one in the A700, are calibrated to give an average reading of 18-percent gray.

Mode dial The large dial on the top left of the camera that is used to set the shooting mode for the camera.

Multi-segment metering The light meter built into the A700 divides the entire scene into 40 segments used to measure light.

noise Extra unwanted pixels of random color in places where there should only be smooth color. Noise is created when the signal from the image sensor is amplified to match the ISO characteristics of film. The higher the ISO in a digital camera, the more noise is created.

noise reduction Software or hardware used to reduce unwanted noise in digital images. See also *noise*.

normal lens A lens that produces images in a perspective close to that of the human eye.

overexposure Allowing more than the recommended amount of light to reach the sensor, causing the image to appear too light and with less detail in the highlights.

panning A method that involves moving the camera in the same direction and speed that the subject is moving, resulting in an image where the subject is in acceptable focus while the background is blurred.

pixel A contraction of the words *picture element* that describes the smallest unit that makes up a digital image.

prime lens A lens with a single focal length.

Program Auto mode In this mode the camera sets the shutter speed, aperture, and ISO to achieve the correct exposure in the same way as it does in the Auto adjustment mode. The photographer can adjust these settings for more control over the exposure, giving a higher level of user control over the exposure compared to the Auto adjustment mode.

RAW A file type that stores the image data without any in-camera processing. The A700 uses a proprietary file type that needs to be processed by software before it can be used.

rear-curtain sync The ability to fire the flash at the end of the exposure instead of at the beginning. This freezes the action at the end of the exposure.

red eye A condition that occurs when photographing people with a flash that is too close to the lens. The light is reflected from the person's retina, which is covered with tiny blood vessels thus the red, back toward the camera's lens.

Red-eye reduction A flash mode that fires a short burst of light right before the photograph is taken, in the hopes of causing the subject's pupils to contract and lessening the amount of light that can be reflected back. The Red-eye reduction on the A700 is only available with the built-in flash.

reflector Any surface that can be used to redirect light. Specialty reflectors for photography come in different sizes, shapes, and colors and are designed to reflect light onto the subject.

resolution The number of pixels counted either vertically or horizontally in a given area.

saturation In color, it is the intensity of a specific hue.

self-timer The ability of the camera to take an exposure after a predetermined amount of time when the Shutter button has been pressed. The A700 has two self-timer countdowns, one for 2 seconds, and one for 10 seconds.

sharp A way to describe a well-focused image.

shutter A movable cover that controls the amount of light that is allowed to reach the sensor, by opening for a specific length of time designated by the shutter speed.

Shutter button The button that is used to move the shutter out of the way, so a photograph can be taken.

shutter speed The amount of time that the shutter is open and letting light reach the image sensor.

Shutter Speed Priority mode In this mode the photographer sets the shutter speed and the camera sets the aperture.

side lighting A method of lighting where the main light source is to the side of the subject.

silhouette An image or scene where the subject is represented by a solid black object against a lighter background. See also *backlighting*.

slow A description referring to the maximum aperture of a lens. Lenses with a maximum aperture of f/8 are considered very slow. See also *fast*.

Spot metering The only area that the camera uses to meter the light is a small area in the center of the scene.

sRGB A color space created by Hewlett-Packard and Microsoft to more closely match display devices. sRGB is the standard color space used on the Internet. See also *Adobe RGB* and *color space*.

stop A term of measurement in photography that refers to any adjustment in the exposure. When stop is used to describe shutter speed, a 1-stop increase doubles the shutter speed, and a 1-stop decrease halves the shutter speed. When stop is used to describe aperture, a 1-stop increase doubles the amount of light reaching the sensor, and a 1-stop decrease halves the light reaching the sensor.

Super SteadyShot Vibration reduction technology that is built into the A700. The camera can shift the sensor to match the movement of the camera body, resulting in sharper photos when using longer shutter speeds.

telephoto effect A photographic optical illusion that occurs when using a long focal length lens where objects can appear closer together than they really are.

telephoto lens A lens with a focal length longer than normal.

TIFF Tagged Image File Format. A lossless file format for images that is universally acceptable by image editing software. See also *lossless*.

tonal range The shades of gray that exist between solid black and solid white.

top lighting A method of lighting where the main light is placed above the subject.

tungsten light A light source that produces light with a color temperature of approximately 3200K.

underexposure Allowing less than the recommended amount of light to reach the sensor, causing the image to appear too dark and a loss of detail in the shadows.

vibration reduction See *Super SteadyShot*.

warm A descriptive term for an image or scene that has an orange or red cast.

white balance An adjustment to the colors that the camera records to match the lighting of the scene.

wide-angle lens A lens description that refers to lenses with shorter-than-normal focal lengths.

zoom lens A lens that has a range of focal lengths.

Index

Continued

Continued

Guides to go

Colorful, portable Digital Field Guides are packed with essential tips and techniques about your camera equipment, iPod, or notebook. They go where you go; more than books—they're *gear*. Each $19.99.

978-0-470-16853-0 978-0-470-04528-2

978-0-470-12051-4 978-0-470-11007-2 978-0-7645-9679-7

Also available
Canon EOS 30D Digital Field Guide • 978-0-470-05340-9
Digital Travel Photography Digital Field Guide • 978-0-471-79834-7
Nikon D200 Digital Field Guide • 978-0-470-03748-5
Nikon D50 Digital Field Guide • 978-0-471-78746-4
PowerBook and iBook Digital Field Guide • 978-0-7645-9680-3

Available wherever books are sold

WILEY
Now you know.

Wiley and the Wiley logo are registered trademarks of John Wiley & Sons, Inc. and/or its affiliates.
All other trademarks are the property of their respective owners.